PARTY LIKE A
ROCK STAR

even when you're
poor as dirt

PARTY LIKE A
ROCK STAR

even when you're
poor as dirt

CAMPER ENGLISH

alyson books
los angeles
Celebrating Twenty-Five Years

Manufactured in the United States of America.

This trade paperback original is published by Alyson Books,
P.O. Box 4371, Los Angeles, California 90078-4371.
Distribution in the United Kingdom by Turnaround Publisher Services Ltd.,
Unit 3, Olympia Trading Estate, Coburg Road, Wood Green,
London N22 6TZ England.

First edition: June 2005

05 06 07 08 09 a 10 9 8 7 6 5 4 3 2 1

ISBN 1-55583-877-4
ISBN-13 978-1-55583-877-5

Library of Congress Cataloging-in-Publication Data

English, Camper.
 Party like a rockstar : (even when you're poor as dirt) / Camper English.
 ISBN 1-55583-877-4; ISBN-13 978-1-55583-877-5
 1. Young adults—United States—Social life and customs. 2. Young
adults—Recreation—United States. 3. Young adults—United States—Life
skills guides. 4. Young adults—United States—Finance, Personal.
 5. Nightclubs. 6. Parties.
HQ799.7 .E64 2005
646.7'0084'2—DC22 2005043632

Credits
Cover photography by Nabil Elderkin/Stone/Getty Images.
Cover design by Matt Sams.

CONTENTS ★

Introduction — viii

Author's Note: Read This or I'll Beat Up Your Sister (A Note About Email) — ix

★Chapter 1: Are You Ready to Rock? Going to Shows Without Blowing Your Budget
- The List — 1
- Getting In — 3
- The Inside Guide to Saving Money — 7
- Smoking Is the New Schmoozing — 8

★Chapter 2: Getting Into Clubs for Free
- A Short Primer on Nightclub Economics — 11
- Free and Easy: The Basics — 12
- Negotiating the Line — 15
- Excuse Me, I'm on the List — 17
- Other Ways to Not Pay — 20
- Who to Know and Blow — 22
- Other Jobs That Get You Into Clubs for Free — 26
- How to Infiltrate a Scene on a Budget — 29

★Chapter 3: Look Like a Million Bucks for Slightly Less Than That: Fashion and Style, Hair and Beauty
- Basic Strategies for Dressing Yourself — 31
- The Miraculous One-Shirt Wardrobe System — 34
- Tricks on Thrifting — 38
- Some Shopping Strategies for Buying New Clothes — 41
- Beauty Call — 44

★Chapter 4: Crashing, Throwing, and Going to Parties
- Throwing Your Own — 49
- The Stock-My-Bar Party — 49
- The Raging Kegger (or Partying for Profit) — 52
- Other Types of Parties — 54
- Getting Ready: Party Preparation — 61
- Crashing Other People's Parties — 68
- How to B.Y.O.B. When You're B.R.O.K.E. — 71

★Chapter 5: Getting Trashed Without Spending Your Cash
- When to Drink — 73
- Where to Drink — 79
- Get the House Hookup: How to Brownnose the Bartender — 82
- Getting Loaded for Less — 87
- Wild, Wet Group Action! — 90
- The Bar Party — 94
- How to Get Strangers to Buy You Drinks — 96
- Doing Drugs — 99

★Chapter 6: Dirt-Cheap Dates and Cheap Tricks
- Dating: The Standard Model — 101
- A Bunch of Other Low-Cost Dates — 102
- Dating for Drinks and Dinner — 105
- Cheap Sex — 107
- Sex Sells — 110

★Chapter 7: Keeping Busy:Other Entertainment
- The List of It — 113
- Better Than Cats: Dance, Theater, Opera, and Symphony — 114
- Cable Access — 118
- Discount Cinema — 119
- Home Theater: Movie Rentals — 123
- Art Galleries and Museums — 125
- Blah Blah Blah: Talks, Readings, and Lectures — 126
- Books: Reading Writing — 127
- Magazines — 129
- Cheap Shots — Discounts on Sporting Events — 130
- Other Free Events and Entertainment — 132

★Chapter 8: Fancy Feasts:Saving on Sustenance
- Plan of a Snack — 135
- Food for Free — 137
- Other Tips on Eating Out — 139
- Group Dynamics — 141
- Mooching Off the Masses — 142
- Where Food Is Cheap — 144
- When Food Is Cheap — 144
- Screw the Coupons: Practical Food Shopping Tips — 146
- Lunch Break: Food at Work — 149
- Be a Bean Counter — 150

★Chapter 9: Fun Money: Earning Extra Income and Selling Your Stuff
- Scalping Seats — 151
- Quick Cash — 152
- Selling Stuff Online — 154
- Home Economics: Make Money by Visiting Your Parents — 157
- Occasional Work — 158
- Money on the Side — 160
- Two-timing While You're at Work — 165

★Chapter 10: Save Your Money for Rehab: Dirty Discounts and Other Easy
 Ways to Save
- Government Money — 169
- Utilities — 170
- Reducing Your Rent — 173
- Give Me Some Credit —174
- Members Only — 175
- Don't Bank on It — 176
- Gettin' Around — 176

★Chapter 11: Feeling Groovy: Exercise and Health Care
- Getting Gouged at the Gym — 181
- Working Out at Home — 183
- Get Out of the House — 184
- OK, Join the Gym — 185
- Class Acts — 186
- Goal!!!!! — 187
- Free or Cheap Health Care — 187

★Chapter 12: Fringe Benefits: College Kickbacks and Faux-lanthropy
- Stay in School Forever—Educational Discounts — 191
- Volunteering: Milking Human Kindness — 197

★Conclusion — 200

★Shout-outs — 201

★Index — 203

INTRODUCTION ★

Listen up, party people, there's a lot going on tonight. What are you doing? You're not planning on staying in, are you?

There are shows to be seen, drinks to be drank, dance floors to rock, parties to hit, people to see, and people to do. But first let's go find something to wear and grab some food.

It doesn't matter that you're broke. Who isn't broke? Your limited budget is simply another manageable obstacle between staying in and going out, like the guest-list line and the bouncer. You just need to know where to look for the stuff that's free and how to work your way in to the stuff that isn't. It's easy—I'll show you.

So come on—let's rock!

AUTHOR'S NOTE★

Read This or I'll Beat Up Your Sister: A Note About Email

Sorry for the dramatics, but this is important. In almost every section of this book there are suggested email lists to join for things like contests, giveaways, guest lists, and good information. You'll be reading it and thinking I'm not signing up for all that spam. That's because you didn't read the next paragraph. So read it.

Get a new email account that you use only for mailing lists and entertainment information, and keep your regular email for personal correspondence. You won't have to think twice about checking the "Join Our Mailing List" box on a website when you know those messages won't swamp your regular email account and make you lose your letters from Grandma.

Email accounts are free on sites like Yahoo, Excite, and Gmail. As these accounts tend to give you plenty of storage space, you won't have to worry about checking them every day (or even every month) to keep your inbox under quota. The spam filters will sort out the trash that comes along with the treasure. And if you don't feel like parsing through it this week, you can hit "clear all messages" without fear of losing something important.

Check this new account when you're looking for something fun and free to do or when you've got some free time (you know—all of that space between 9 and 5) to sort through it for contests, giveaways, and guest lists.

It's an email box full of nothing but good news.

Search and Enjoy

In this book you'll see dozens of phrases that look like this: [Search Term: "free day" museums YourTown]. These are what you type in search engine boxes; they'll help you find specific, local venues. (Since I can't list every happy-hour drink special in the U.S. here. Sorry.) They're not just pretty placeholders—make use of them:

★ When the search box contains the word YourTown, that's your cue to put in the place where you live.

★ When there are quotes around any words in the search box, **keep those quotes** when you do a search. They make the search tool find the exact phrase in quotes rather than all the words separately on the Web page in just any ol' order. For example, when you search for "**free crack**" it won't return something irrelevant like "**Crack** open a book and **free** your mind!"

Helpful Example
When you see: [Search Term: "free day" museums YourTown]
You type in: "free day" museums Denver

And all the museums that have free days in Denver will pop up. If you get lucky, someone else will have done the work for you and the search engine will return a website that lists all the free days at all the museums in Denver.

CHAPTER 1 ★

Are You Ready to Rock?
Going to Shows Without Blowing Your Budget

It's far easier to sneak into performances of the rock stars of tomorrow than those of the rock stars of today. In other words, small shows are easier to get into than large ones. If you want to see The Rolling Stones' 85th anniversary tour at the Tetradome, you'll need to be craftier than you would if you wanted to crash the St. Louis All-Trombone Madonna Cover Band playing down at Lucky's.

Whatever the size of the venue you're trying to crash, the method for doing so is the same. In fact, it's the same method you'll use to get anything for free in all the other chapters of this book. Here's the Cliffs Notes version:

Study It. Look for a free show or a discount.
Win It. Sign up for contests on websites and listen to radio stations for giveaways.
Weasel It. Get to know someone who can hook you up.
Work It. Do a few hours' promotion or other work in exchange for entry.
Scam It. Lie, cheat, and steal to get what you want.

So that's the gist of it. Now for the nitty-gritty.

THE LIST

You thought you were getting email spam before? Just wait until you sign up for **bands' lists**. Sure, you'll get a lot of junk like, "Dudes, our set time changed to 10:15 instead of 10:45 so get there early." But for every list you're on, there is one more chance you'll get one that says, "Dudes, the first five people to respond to this email can be on our guest list for tonight's show."

Smaller bands and local acts do most of their own promotion. The e-mails you get when you sign up on their websites (or on the clipboard at one of their shows) will usually contain a list of upcoming appearances and announcements. But it's good info—more than just the shows you already know about, you'll find out when there are low-cover benefit concerts, small shows, and private parties that aren't listed in the paper.

Major artists with Top 10 hits have websites run by their record labels. The e-mails you'll get from them will have a high spam–to–free stuff ratio, so you probably won't want to go through the whole Top 40 putting your name down. You can enter to win stuff like T-shirts, posters, and CDs when new albums come out. National bands usually won't give away local concert tickets—they'll instead hold once-a-year contests where you fly to Paris for the tour opening. Before each new album comes out, your inbox will be flooded with promotional garbage ("Only one week until the release! Sign up for your advance copy today!"). If you can't get enough Justin Timberlake or whoever, go ahead and sign up for their list.

> ★
>
> Swag (noun): free promotional materials (T-shirts, mugs, lighters, posters, hats, thongs, stickers, screen savers, etc.) that are emblazoned, adorned, and embroidered with a company's logo or other marketing message.
>
> ★

Most **record labels** run their own lists, with announcements of upcoming tours, releases, and new groups they're trying to promote. And along with all the hype comes some good giveaways. Don't just stick with the labels you know—sign up for every one you've ever heard of. You can always get off the list later if they're not putting out the prizes.

Record stores that host in-store appearances and signings will usually have announcement lists to promote them. The signings are pretty useless, as you'll still pay full price for their CDs you want signed, but if you can't afford concert tickets, the three-song mini shows are always an option.

It seems that every concert is sponsored by a **radio station** that always has dozens of tickets to give away. Nowadays, most radio stations have websites, with simulcasts and email lists to boot. And you don't necessarily have to listen to win— many of the contests you can enter online instead of on-air.

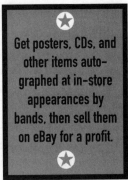

> ★
>
> Get posters, CDs, and other items autographed at in-store appearances by bands, then sell them on eBay for a profit.
>
> ★

Concert venues that host shows often have their own mailing lists. This is especially true of small and midsize venues that do a lot of local booking.

Sometimes you'll hear about last-minute additions to the lineup, secret shows, and discount nights, and sometimes they also give away tickets.

★★★★★★★★★★★★★★★★★★★★★★★★★★★★★★★★★★★★
On the Radio

Major commercial radio stations have tons of tickets to give away, but they also have a large number of listeners. There is a huge competition for good tickets, and your chances of being caller number 1,348,223 are pretty slim. College radio stations, on the other hand, give away great tickets to alternative-rock shows—and there are fewer people fighting for them. So turn on K-FRAT and try these tricks.

★ Listen to shows early in the morning before most students are awake.

★ And on weekends, especially Saturday and Sunday mornings.

★ Call in a lot if you like the show, and try to get to know the DJs. Then if you call and ask for a favor, you've got a better chance of it happening.

★ The colleges that are the most remote from the concert (suburban schools that sponsor shows in the city) have more tickets and fewer listeners than the stations in town. Listen to those rather than the in-town broadcasts.

★ Even if you can't get into the show you want, maybe you'll get some promotional swag to sell on eBay.

★ Some bands perform free lunchtime shows at universities to promote their concerts later the same evening. You'll hear about these secret shows on college radio stations.

★ If you host your own show, which you may be able to do without being a student, you'll get to keep all the swag and tickets for yourself.

★ When you intern at radio stations (whether small or large), you get a ton of hookups. And as an official radio station employee, you can talk your way in at the door of shows even if all the tickets are gone.

★★★★★★★★★★★★★★★★★★★★★★★★★★★★★★★★★★★★

GETTING IN

So, you didn't win tickets to see Grand Drunk Railroad despite the 200 email lists you subscribed to and the 24-hour radio airplay you subjected yourself to for the last two weeks? Don't sweat—there are plenty of other ways to get inside the show.

Get there early. A lot of tiny live-music venues operate as regular bars or pubs until showtime. Show up early to get in before they start charging a cover.

WORK FOR IT

Usher. Many midsize concert venues run usher programs. You work for a couple hours seating people during the opening acts, then as the main artist goes on, you're released from your duty and can see the show from the standing section. These programs are usually under-the-radar and not easy to find. Search online for "usher" and the venue name. If you don't find anything, try calling the ticket office or any other phone line you can find. Keep in mind that only venues with reserved seating will need ushers at all, so don't waste your time on the others.

Promote. For most shows playing in smaller-than-arena venues, band representatives put up posters on telephone poles around town to promote the performances. If you're willing to work a few hours, you can get in that way. Send email to the band directly (if it looks like they check it themselves) or try to get in touch with their label. Ask if they need anyone to be on its "street team" putting up posters and dropping off flyers in record stores. You'll get free admission and probably a CD in exchange for your efforts. The hard part is finding the right person to ask.

Other skills you can trade the band for entry:
★ Web site design or mailing list management
★ Flyer/poster design
★ Lighting or sound for smaller shows

Be a roadie. If you can make contact with the band, ask if anyone is needed to help out for the show. You can either be a roadie, loading and unloading equipment before and after the performances; or if the band trusts you, you can sell their T-shirts, posters, and CDs at the merchandise table in small venues. Contact the band in advance and see what you can work out.

SCHMOOZING YOUR WAY INSIDE

Butter up the bands. This is Schmoozing 101, people: When you like what someone does, express your appreciation. Over time, turn your fandom into a casual relationship, then start milking it for freebies.

When you're at a small show where the band is milling about before or after they go on, approach the members and tell them how great they are. Don't necessarily go for the lead singer—she gets all the attention anyway. Tell the drummer (the most down-to-earth of all band members) "I really like your stuff," "Great show," or "You guys were great. Do you have a mailing list?" Introduce yourself so

that when you next see him you can say, "Hey, I'm Camper. We met after the show at Baby Frank's. Great show again."

Should you see any of the band members in any other setting, approach them there as well. You can find a lot of rockers hanging out in music equipment stores, record stores, and also on "service industry nights" at dive bars. (Those are Monday and Tuesday nights with cheap drinks.) Feel free to contact the band via email and ask, "Hey, what time are you guys going on tomorrow?"

Then after they know who the hell you are, ask if they have any space left on their guest list or if you can work promoting or being a roadie in exchange for admission.

BEG FOR IT

You didn't buy a ticket to the Black Zinfandel concert because your friend's sister's boyfriend usually works the lights and he said he could get you inside but now he's out with the flu. So now what? Go to the show anyway and use your charm to get in.

Butter up the sponsor. Look around the block for the van of the sponsoring radio station. Knock on the door and be very friendly and forward with them. "Hi. Listen, I'm a schmuck for asking, but I really want to see Black Zinfandel and I didn't get a ticket and now I can't afford one. Is there any way you guys have any tickets or space on your guest list? I love this group so much blah blah blah, I'd hand out your promotional stuff at the show blah blah blah..." Just keep talking and they may give in—they do have that extra ticket. It's all about being excited and sincere enough to talk them into giving it to you.

Work the artists. A less attractive option is looking for the band's tour van or bus and begging anyone sitting inside it for passes. The opening bands are usually more accessible. (Tell them you'll scream and cheer when they play.) Being a groupie isn't just about sleeping with rock stars; it's hearing them play, then sleeping with them if they're any good.

★

Corporate Suck-ups

When giant bands tour giant stadiums, giant corporations like IBM, Microsoft, or SBC often sponsor the shows. If any of your friends or your friends' parents work for these companies, see if they can get tickets through the human resources department. The sponsors sell them at a heavy discount or give them away to employees for free.

★

Work the techies. The sound check for larger shows is usually around 4 P.M. Show up at the venue and look for the light and sound guys, then beg them for a pass. You may even run into the band members, and you can try your story on them too.

Work the bouncers. A last option is to beg the bouncer to let you inside. Note: It probably won't work unless you're kinda hot. Stare at him with puppy dog eyes and try to be as blond as possible.

GETTING IN AT ANY COST

Sometimes the show is sold-out and you didn't win any tickets and you haven't slept with anyone important enough to get you on the list. So now you're just going to have to pay up. Start early, looking for people who bought a ticket for a friend who canceled. Look on the band's website to see if they has a fan discussion board (also known as a "bulletin board" or "forum"). Also look at eBay, music websites like MTV.com, and community websites like CraigsList.org for tickets.

Either before the show or online, you can buy scalped tickets at a markup. Just make sure they're legitimate before you hand over your cash. Look for the group of friends selling a spare ticket, rather than the shifty guy on the corner.

Or bribe the bouncer. If the show is general admission, there is a fair chance you can pay him to let you inside. Approach him on the sly and be direct. "I'm really desperate to see this show. Is there any way you could arrange for me to get in?"

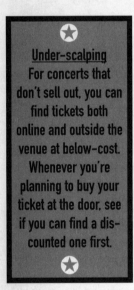

Under-scalping
For concerts that don't sell out, you can find tickets both online and outside the venue at below-cost. Whenever you're planning to buy your ticket at the door, see if you can find a discounted one first.

★★★★★★★★★★★★★★★★★★★★★★★★★★★★★★★★★★
A Few Good Scams

Press on. Call up the band's record label and say you work for a local newspaper or music website. (If the band isn't signed yet, contact them directly.) Ask to be put on the press list so you can review the show.

Be a marketing agent. Try to talk your way in by saying you work for a promotion agency. These are marketing agencies that represent tobacco,

liquor, beer companies, and trendy beverages like Red Bull and Sparks. They pay bars and clubs good money to put up ads or use napkins and coasters with their brands on them in the venue. At the door, say you're there to "check out the demographics of the venue" for potential sponsorship. Dress like an industry faux-trendoid trying to fit in: Wear all black, including trendy funky-framed glasses and a black leather jacket.

It's all about the labels. Say you're with a record label and you've come to check out the band. That's not as easy as it sounds—things get tricky when you have to talk the talk.

At least get some free loot. To get CDs call the record label and say, "I'm a promoter interested in booking [the band]. Can you please send me a press kit?" That kit should come with the music. Just make sure you have some numbers to give them about your imaginary club's capacity and size.

★★★★★★★★★★★★★★★★★★★★★★★★★★★★★★★★★★★★★★

THE INSIDE GUIDE TO SAVING MONEY
Whether it's a rock show or a disco and whether you paid outside or not, you don't want to blow all your money after you're in.

Free Checking
Save yourself the aggravation of waiting in line twice at the coat check as well as the 3 bucks it costs. Wear a cruddy old coat that no one in their right mind would want to steal. Then stash it somewhere on top of or behind the speakers, on the seat of a booth, behind a chair, or wherever the darkest, most out-of-the-way corner of the club is. Even if someone throws up on it back there, at least it's not your good coat so you can leave it behind. And of course, if you know the DJ or the bartender, ask him to stash it for you.

The "Ground Score"
You can find cash, change, and drugs on the floor so often in party venues that there is even a term for doing it. At clubs and rock shows look down at the dance floor every now and then for things that have fallen out of people's pockets. The best ground-score location in the world is in the mosh pit at punk shows—you'll find jewelry, clothing, and sometimes a few teeth down there. And beneath the bar you can frequently find rumpled-up bills. People pull money out of their pockets and loose bills fall to the floor.

Bring a Flask

How wrong is it that drinks at clubs and shows are more expensive and usually weaker than those at bars? You pay to get in (in theory), so why do they want to rip you off twice? Fight back by bringing a flask full of booze. Then you can just order a Coke at the bar and add your own rum in the bathroom, or chug it straight from the bottle in the stall. This doesn't work at any large venues that do a pat-down of your clothes, of course. But where they use the metal detector wand instead, you can get through using a cheap plastic flask from the drugstore, as long as it also has a plastic cap.

> Warning: Drinking from a flask in the bathroom stall is not very classy.

Visit Your Neighbors

There are a couple of reasons anti-smoking laws are good for you. In the first place, your clothes don't stink like an ashtray after a night out, so you don't have to wash your jeans after wearing them once. But more importantly, more clubs allow in-and-out access so that people can go outdoors to smoke. Use that opportunity to run to the little dive bar next-door and do a quick shot at half the club's price.

> ★
> **Here's the ticket**
> Some clubs are stupid enough to use generic "Admit One" tickets as their VIP drink tickets. Keep a few of each color in your purse or wallet, just in case.
> ★

SMOKING IS THE NEW SCHMOOZING

Sure, they give you cancer and make your hair smell bad, but cigarettes also bring people together. For the purpose of this book, that's you and people with hookups you want to get to know. The time it takes to huff down a smoke is enough time to start a conversation with anybody.

Now, asking a person for a cigarette is no way to make a friend. At the 10 bucks per pack that they cost today, bumming a smoke is akin to asking for a car loan. Instead, play with fire: Always carry a lighter but never use your own. Then you've got an excuse to go up to strangers to ask for a light, and strangers can always get a light (and a conversation starter) out of you.

Don't be afraid to do some minor stalking. When you see a favorite band member, club VIP, DJ, or just some hottie with whom you want to score, make for the cigar lounge, stand near your target, and ask for a light. And when you're walking up to the club it's always good to have a cigarette to finish while you

engage in small talk with the bouncer outside. Maybe if you're funny he'll find a reason to let you in for free.

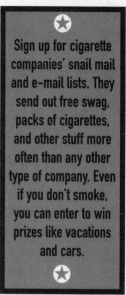

Sign up for cigarette companies' snail mail and e-mail lists. They send out free swag, packs of cigarettes, and other stuff more often than any other type of company. Even if you don't smoke, you can enter to win prizes like vacations and cars.

Warning: if you don't smoke already, don't start just because it's a good way to make friends. And whatever you do, don't take up fake cigarettes. Nobody respects anybody who smokes cloves.

Death and Taxes

If you're a smoker, you're paying something like a buck a pack in taxes, and those taxes fund commercials and other programs used to educate you to the dangers of smoking. You never learn to quit, but you can at least learn how to get a tax exemption on duty-free cigarettes.

Do you get hit up for cigarettes a lot? In some bars pulling out a pack of smokes is like throwing a bleeding baby into a tank of starving sharks. If you want to save money, switch to menthols or some other nasty brand that nobody likes.

Though we most commonly associate duty-free cigarettes with international jet-setting, buying them at the airport is not a guaranteed bargain. In other countries smokes are not necessarily less expensive than in the U.S. In the U.K., for example, you'll be paying more for cartons in the duty-free than you would back home. But in Bangkok you'll pay half price. It's not a great cost savings to book a flight to Asia just to get cheap smokes, but when you've got friends visiting from there, tell them to front you a carton.

There are also good bargains to be had within the U.S. In tobacco states such as Kentucky, the average pack of cigarettes costs a lot less than in New York City. So when you're visiting home (or a friend from there visits you), pick up some smoky souvenirs.

Or harness the power of the Internet and buy them online. There are approximately 30 gazillion websites that sell cigarettes for a third less than in your local liquor store.

Getting Into Clubs for Free

Despite its shallow and unsavory reputation, nightclubbing is quite a productive way to spend time. You can hang with your friends, make new ones, flirt with strangers, make out with them in the corners, showcase your outfits, reveal yourself to be a style icon, hear music you know and get turned on to new stuff that you don't, shake your ass on the dance floor, and even get some exercise while you're at it. You can accomplish so much in such a small space that clubbing is basically multitasking in glam.

And besides, what else are you going to do on a Monday night? Go to church?

Unfortunately, the experience doesn't come cheap. There are cover charges, coat checks, inflated drink prices, and cab rides when you miss the last subway train home. If you're not careful, you can accidentally spend all your money inside a disco and have to walk home three miles through the snow at 4 in the morning. Not that I'd know.

But there are also hundreds of ways to save money, as you'll soon see in this chapter. You can get in without resorting to lying (not that you're above that) by being smart about when you show up, getting to know people who work inside, or working at a job that pays you to go out at night. You can also scam your way through the door with some smooth talking, a forged business card, or a quick step around an unobservant bouncer.

A Short Primer on Nightclub Economics

But shouldn't you have to pay for all these pleasures a hot, sweaty, overcrowded firetrap of a discotheque can bring? Shouldn't you do your part to ensure the DJ can buy new records, that the decor stays fresh, that the bathrooms are cleaned, and the lights stay lit? Of course not. You should get in for free every time, because your glorious presence ensures that other people pay full admission price to be in the same room with you.

Warning: Paying for clubs is what people from the suburbs do.

Clubs are filled with two kinds of people: fabs and filler. Fabs are the hot babes, buff studs, celebrities, and socialites. The other 80% of the attendees, who aren't very special, are the filler. They're there to suck off your vibe. So as long as you

make an effort to be the life of the party and a nightlife icon, you shouldn't feel obli-
gated to pay to get into it.

FREE AND EASY: THE BASICS

You don't have to be a good lay, a good liar, or a good dresser to get inside some
of the best clubs for free. The following tips can save you the cover charges with
minimal effort and no deception.

Get on the (Mailing) List

Sign up for every email and snail-mail list for every venue and every person
involved with the club scene in your town. In addition to the standard announce-
ments about who is playing what, where, when, and for how much, these lists often
offer placement on the guest list for the first few responders, reduced entry fees if
you have a printout of the email, and random drawings for CDs, free admission and
free drink tickets (or trivia contests to win the same). Once you've spent a few
hours doing that, you should be able to get on the guest list for one or two events
every week just by checking your email. Join the lists of each of the following:

★ The nightclubs and bars that host DJs have lists of what's going on each
week. Find a newspaper or website that lists every venue in town and, if the club
doesn't have a link on there already, do a Google search for each club's website.
Then put your name on their mailing lists.

★ Popular DJs spinning at those clubs and bars also send announcements
about where they'll be playing each week. Search for the website of each DJ you've
heard of and do the same.

★ The promoters who book the DJs may throw parties in multiple venues.
You'll find their websites as a link on each club's website.

★ Event-listing websites, such as CitySearch.com and DigitalCity.com, and
any locals-only nightlife websites try to list all parties at all venues. They'll have
weekly "best-of" e-mails that may include contests for free entry or giveaways.

[Search Term: "club listings" YourTown]

[Search Term: nightlife YourTown]

[Search Term: nightclubs YourTown]

[Search Term: "dance clubs" YourTown]

★ Newspapers, especially alternative weeklies such as The Village Voice or
the L.A. Weekly, do the same. Look for their "promotions" page and sign up for the
weekly updates. That's where all the free passes are.

★ The record stores where DJs buy vinyl often sponsor parties.

[Search Term: "record stores in" YourTown]

★ Liquor and cigarette companies try to look hip by throwing big parties where you get free booze and smokes. When you see their ads in newspapers or magazines, look for their websites.

★ Pick up club flyers that are stacked by the hundreds in every trendy store in the trendy part of town. You'll find a lot of nightlife people, places, promoters, and sponsors' information on them. Grab one of each, put the info into your search engine, and keep signing up for lists until your inbox explodes. If you're hearing about the same party from the club owner, one or two of the DJs playing there, the event promoter, and a sponsoring newspaper, you've got four times the chance to win a spot on the guest list.

In addition to potential passes, there is tons of good information on the average club flyer. You'll learn about "no cover before" times. Some clubs offer reduced admission all night when you bring the flyer. Sometimes there are discount-drink specials listed only on the flyer. Every time you walk by a record shop or trendy clothing store, pop in and grab one of each. They make good bathroom reading.

Show Up Early

Small clubs and bars that host DJ nights usually don't start charging a cover until after 9 or 10 P.M. Go 10 minutes before that time and get in free. There may only be six other people in the place, but that creates an excellent opportunity to brown-nose those who can hook you up later—the DJ, bartenders, and security staff. Larger clubs also offer reduced or free admission for the first couple of hours they're open. You'll find most local venues and parties with no-cover times by searching for the generic terms "no cover before" and "free before" in your town.

[Search Term: "no cover before" YourTown]

[Search Term: "free before" YourTown]

Become a Weekday Warrior

Venues that are packed full with a $20 cover on Saturday nights are often begging for business on Mondays. Also, some of your favorite DJs play at bars with no cover charges early in the week. You can hit the same clubs and hear the same DJs for a lot less money when you go out before Friday.

Just Ask

You can be so bold as to ask promoters for a space on the guest list. If you send them an email the day before the event, they may just say yes. Try something like "Hey Vinnie. I'd really like to check out your Thursday night party at Oasis2000, but I'm low on funds. Is there any way you'd put me on the guest list if I promise to try

to bring a couple paying friends?" What's the worst that can happen? They'll say no and still not know who you are.

Signs That a Club Will Suck From the Line Outside

When the outside is this bad, the inside isn't going to be any better. Spend your money someplace else.

1. The VIP line is longer than the regular line.
2. All the women are carrying purses.
3. And shivering because they all left their coats in their cars.
4. All the boys are wearing backpacks.
5. Or wallet chains.
6. They've come in separate boy-girl groups because they're only going out to get laid.
7. The bouncers are wearing suits.
8. There are more than six bouncers, and they all have headsets.
9. The club's sign is made of blue neon.
10. Or the marquee says LADIES NIGHT.
11. The club has clear glass windows.
12. It's before midnight or after-hours, and there is still a line down the block.
13. The people getting picked out of line for VIP entry are all skanks.

Signs a Club Night Will Suck From the Flyer

Save yourself the trip to any club night that advertises itself in the following ways:

1. The hoochie on the flyer has boobs bigger than her head.
2. The gay club flyer has a generic shirtless porn star.
3. There are different prices for men and women.
4. There are more than three music categories listed (house, reggae, salsa, hip-hop) but only one room in the club.
5. Salsa music is listed at all.
6. "Upscale attire required."
7. You've never heard of anybody on the flyer.
8. They advertise Jell-O shots as a selling point.
9. There is a champagne toast at midnight and it's not New Year's Eve.

Signs a Club Won't Suck

1. The DJ set times are listed on the flyer.
2. One of the DJs is pictured on the flyer.
3. More than one of the DJs is from out of town.

NEGOTIATING THE LINE

There are two kinds of lines outside nightclubs. In the orderly queue, regular patrons line up on one side of the entrance and the VIPs on the other. The VIP line is shorter and is given priority. At some venues the bouncers will upgrade certain people from the regular line to VIP status and let them in with less waiting.

The other type of line, which isn't a line at all, is a swarming blob of patrons surrounding the entrance like jackals on a carcass. Everyone vies for the door person's attention, and patrons are allowed inside in the order of fabulousness.

Neither type of queue is fun to wait in, but it's the nature of nightclubbing to create a bitchfight for status. Your goal is to get in as quickly as possible. The tips below should help you accomplish that more easily.

> ⭐
> Getting in fast doesn't mean you'll get in for free. It's still a cost savings, though—the less time you spend waiting outside the club, the more bang you get for your buck out on the dance floor.
> ⭐

Dress for Success

The longer the line, the better you need to look to skip it. Dress up glam but not tacky, skin-baring but not slutty, and daring but not dangerous. You should also respect the dress code—at most venues you can never wear sneakers or jeans (despite the fact that they're the most comfortable to dance in) unless they're made out of gold. If the bouncers are picking people out of line, you'll have a greater chance of being chosen when you don't look poor.

Or Be a Fabulous Mess

The most outrageous drag queens don't have to pay admission into anything, ever. Club kids in oversize stupid outfits add ambience to the dance floor—and don't pay, either. In most cities, these people act as "hosts" and are paid in cash and drink tickets to show up. But don't just slap on a wig and expect to get in— do it up big.

Warning: The average drag queen can kick your ass, and do it with a six-inch heel.

Go Vertical

The taller you are, the better your chance of getting noticed over the top of the crowd. Wear platforms or your stripper heels.

Girls Rule

Straight clubs want beautiful women inside, because it keeps the men coming and buying drinks for themselves and for the ladies. If you got it, flaunt it. And if not, find some beautiful people to befriend. When your group of hot chicks approaches the door, they're going to let you all right in rather than make you all wait because of the one ugly dude. (Just make sure that when the bouncer asks "How many?" they include you.)

If you're alone and happen to see two or more beautiful, unescorted women walking toward the club, say hello and ask them if they will let you go inside with them.

When approaching the club, arrange your posse in order of most to least sexy so that the bouncers will see the hot people first and (hopefully) let you all in.

Guys Drool

The bouncer is not going to let a group of six guys in the club together, even if they're stepping out of a limo. Let some women in between your group.

Start at the Front

Don't automatically walk to the end of the line and wait patiently. At the very least, walk by the front and make eye contact with the door staff. If you're looking real good, they may just wave you in. For the same reason, always exit the taxi at the front of the line. The bouncers will check to see who is getting out, in case you are an important celebrity who must be whisked inside. Try to fool them into believing that's what you are.

Try the List Line First

If the regular admission line is ridiculously long, try using the guest-list line as a way to get in faster. (Use one of the tricks in the next section.) When they tell you your name's not down, try to get in with paying but without waiting. "Darn. Did he

turn in a list at all? OK, sorry, anyway...do I need to wait in this line or can I just pay here?" If you look good and they believe your story, they won't force you to go to the end of the paying line.

Warning: You may feel somewhat moted when you get kicked out of the ViP line into the regular line. Prepare for rejection.

The Bribe

If getting inside quickly is more important than getting in cheaply (or the line is long and you left your jacket in the car and it's snowing), you can bribe your way in. Walk up to the bouncer with a bill ($20 might get a couple of you in) tucked into your hand so that he can see it, and shake his hand to give it to him. Say, "Is 20 good for three of us?" If it's not, he'll tell you. You'll still have to pay the cover, mind you. It's not exactly frugal, but if it saves you a doctor's visit due to the pneumonia you would have caught waiting in the rain, it's worth it.

Hot Wheels

Another expensive admission trick is to appropriate a limo. Go around the corner and look for one outside a fancy hotel. Pay the driver 10 or 20 bucks to drive you to the front of the line. The bouncer should take notice and let you in—not because he thinks you're famous but because he thinks you'll drop some serious cash inside.

At clubs with front valet service (Hello, L.A.!), get the friend with the hottest car to drive your group.

★★★★★★★★★★★★★★★★★★★★★★★★★★★★★★★★★★
Excuse Me, I'm on the List

Talking your way into a club is not easy, even for the best liars among us. At the big venues they won't let anyone in who wasn't on the list in advance, unless you happen to be a rock star. At smaller clubs the doorman may also be the promoter who you're pretending to know, and you'll get busted in your big fat lie.

The Basics: Act like you're supposed to be on the list but that there must have been some oversight. Club people do frequently forget to put names on lists or to turn them in at all, so this is not unusual. Introduce yourself to the door person: "Hi! How are you? I'm Camper English, I should be on the guest list." Be pleasant and confident to start with—you thought

everything had been taken care of. Then act surprised to find that you're not there (not mad or incredulous—"Don't you know who I am?" is cliché). If the door person believes your story, they may let you in for free anyway.

Often, trying to scam your way in will fail and you'll be forced to wait in the line and pay like normal people. That's OK—consider each rejection a learning experience. But if you act like a jerk and get caught in a really bad lie, they might bar you from coming in at all. It's best to be polite when lying.

Name-dropping

You don't need to be on the list at all when you drop the right name. Act like you're a friend of someone important (like the owner, bar manager, or high-level employee). Often the simplest name-drop works ("Is Alicia here tonight?"), or try a longer intro ("Hi. Alicia told me to stop in tonight. I'm not sure if she put me on the list or not. Can you please check for me?"). If they believe you, they might let you in even though you're not.

Warning: if you try to drop the owner's name and they actually call him out to the door, you're screwed if you don't really know him. Have fun on the curb.

Know Thyself

No matter what form your lie takes, make sure you know who you are and who is your hookup. In most cases it's best to use your real name rather than pretending to be someone else. They check IDs for proof.

Then make sure you know whose list you're on—that's the first question they'll ask. Tell them you're on the list of the club's manager, owner, a DJ, or the promoters...and don't just say "the owner"; say "Vincent Weinerschnitzel." You've got a better chance when you're preemptive: "Hi, I'm on DJ Buffy St. John-Pierre's list, my name is Camper English."

The Early Bird

If you have a friend or acquaintance who you know will be on the guest list, go to the club before he arrives and use his name. If the door staff lets you in without checking your ID, you'll both be set. When your friend comes later, he can still show his ID for proof: "My name is right there on the list. What do you mean someone used my name?"

On the other hand, if they then ask to see your ID to validate that your name matches what you just told them, you can still avoid getting kicked out, and possibly still get in for free. Say, "Oh, I'm not him. He's coming later, but I'm on as his plus-one." (Meaning: on the list as "Camper + 1 guest.") They probably won't let you in, but they'll feel less inclined to bar you from the club forever for trying to scam them.

What List? The DJ's List

DJs almost never turn in their guest lists until they arrive at the club in person. Show up before you expect her to arrive and say you're supposed to be on her list. (It's best to use a local favorite rather than the out-of-town superstar.) When they tell you that she hasn't shown up yet, you'll be surprised. "Oh, I thought she was coming in earlier. I don't need to wait for her outside, do I?"

Peeping Tom

If you are dealing with an inexperienced or overwhelmed staff, they might let you spy the names on the list. This allows you to say that you're someone whose name you can read. "Yep, there I am. John Smithson. I can see my name right there." This doesn't work if the list girl is dating John Smithson.

Warning: Some clubs have banished patron lists—complete with Polaroids of the people on it.

Barging In

There is one case where being a pushy jerk at the guest list is effective—when the list line is huge and the list girl is overwhelmed. This happens when everyone at the party is on the list, at events like liquor company-sponsored parties, club night premieres, and awards shows. In these situations, hundreds of people have to be looked up on paper, leaving the door people flustered. Tell them your real name and say you RSVP'd early; that you drove in from the next town over just for this; your friends all signed up and at the same time and they're already inside; have them look up your friends' names on the list and say you signed up at the same time; and so on. If you stay there, clog the system and keep persisting—they'll usually just let you in rather than hold up the line any longer.

But Wait, There's More

If you work inside a club, you'll get in for free. (Duh.) And anyone you know who works inside can put you on the list. (See "Who to Know and Blow" for tips on

befriending the right people.) And if you work in the nightlife industry in some other capacity—see "Other Jobs That Get You Into Clubs for Free" for details—you'll not only get to go to different clubs, you'll get paid to do it.

Other Ways to Not Pay

Copy the Hand Stamp

This is always a favorite with the under-21 crowd who can't get in no matter what the cost. If the club has an in-and-out policy (where you can leave and reenter the club after going outdoors to smoke or whatever), they'll have a system for proof of payment, be it a hand stamp or a bracelet. Find someone who's already paid, or have one of your posse go in and leave quickly to meet you around the corner. Then:

★ Lick their hand and press it against yours to transfer it, or just press their hand to yours if the stamp is still wet. This won't work if the stamp has text on it—it will invert the image and lettering and you'll look dumb with 12 REVO on your hand.

★ Bring a felt-tip pen in the same color as the stamp's ink—usually purple, dark blue, or black—and try to duplicate the pattern someone else has on their hand. If it's too dark, wet it and blot the ink with a paper towel from the bathroom.

★ Put masking tape on the stamp to make a copy of it. Then use your marker (or dark lipstick from a Goth girl, in a pinch) to fill in the design on the piece of tape. Then transfer it to your hand. This one works even with text because the image is reinverted when it goes on your hand.

> ★
> **Easy Greetings**
> 1. Do you have a light?
> 2. Didn't I see you at that Super Psyonic show last night? That party rocked.
> 3. Which DJ is spinning now?
> ★

★ If a club night has a custom stamp, but one that they use every week, do the above tape trick and save the tape to use the next week.

Keep Your Bracelets

Other clubs use color-coded plastic or paper bracelets to indicate that you've paid and are of drinking age. At the end of the night, wait until you get home to cut off your bracelet. (They are meant to rip and get mangled

if you try to just pull them off or slip your hand out of one.) Then bring your collection to the club next time, scope out what color they're using, and tape that one together on your wrist.

Go in Through the Out Door, Out Door

If there is a separate line, entrance, or just a space between the door staff where people go in and out from smoking, try to slip in through that crack. They assume everyone in that line has been inside already and won't check as thoroughly for your hand stamp or bracelet. It helps if they don't see you walk up to the club in the first place. Sidle up to a group of smokers and start up a conversation or ask them for a light. Try to let security see you after that point. When your new friends go back inside, walk in with them. Hold up your arm while looking at the bouncer and giving him the "hello" nod. If you don't look down at your wrist, neither will he.

Or try this classic: In the rare case that a club has an unguarded back door, patio, or smoking lounge, have your friend inside call you on your cell phone and let you slip in at an opportune moment. Sadly, this rarely works anymore, as fire codes usually demand that an alarm goes off when you open emergency exit doors.

Play DJ

If you've got a record crate or DJ bag, you can sometimes get in even when your name's not on the flyer. First try to hold the bag in front of you (acting like it's heavy and full of records) and walk right in. If they hesitate, try "DJ Funky Brunch told me to come down and tag-team with him."

Special Delivery

Deliver a white label to the DJ. A white label is a record in a white sleeve with a barely legible, if not blank, sticker in the middle of the vinyl. They are basically tester records that DJ-musicians put out to gauge the crowd's response or to try to get funding from a label, or it's a secret surprise mix that's a present from DJs to each other. Anyway, you don't need to know all that—just hold up your fake records and say "I have a track to drop off for DJ Monkey Punch" and they'll let you walk right in.

★★★★★★★★★★★★★★★★★★★★★★★★★★★★★★★★★

Haggle

Bargain with the door person—the prices don't have to be absolute. This tactic works best in small, uncrowded clubs, when you're with a couple of other people. If admission is $6 each and you're with three people, offer them 15 bucks for all of you: Say "Will you take 15 for the three of us?" You may be surprised at how often they will. And the club still makes more money than they would if none of you went in.

Helpful hint: Ladies' nights always suck.

By the same token, if you're a guy with a group of women on some "ladies night" when it's reduced or free admission for women but costs money for men, you can bargain with the bouncer: "I'm here to escort these three beautiful women. None of us will go in unless we all get in without paying."

WHO TO KNOW AND BLOW

No matter how good you are at scamming your way into clubs, it's always easier to get inside when you're legitimately on the list. And the best way to get on the list is by knowing people who work at the club, or working there yourself.

The General Strategy

1. Half the trick to living large, both inside clubs and out, is knowing a few good tips. The other half is knowing a lot of good people. Get to know everyone you can.

2. Pay compliments. Everyone likes a happy customer. Tell the DJ you liked his set; the bartender you enjoyed her appletini; the promoter that his party rocks. Then do it again next week. Eventually, they'll remember you and the free stuff will start coming.

3. But don't be annoying. Don't bother anyone who is busy working. Talk to the door staff when there isn't a line behind you. Don't try to strike up a conversation with the bartender when the crowd is three-deep. Wait until the DJ has finished his set to tell him how much you liked it. It's easiest to meet a club's employees early in the night when there are less other people around.

4. Cross-pollinate. If you recognize someone who works at one venue (spinning, serving drinks, working the door) hanging out in another venue, go out of your way to make their acquaintance in the new place. When you meet people where they're not working, they more readily think of you as a friend when they see you at their workplace—where they can give away freebies.

What follows are some of the most common club staff positions, what you can get from knowing people in those positions, and some approaches to approaching them.

THE OWNER

The Job: Owns the club.

The Hookup: Unlimited everything, but only if they are present at the venue. Many club owners are on-site only occasionally, so you can't just show up randomly and ask for your pal.

The Approach: It's easier to sleep with a club owner than to get him to respect you, so if you've got the right gender/orientation combination, you might just want to be a whore to get in the door. Otherwise, club owners are businesspeople, and they like hanging out with other professionals. If you can do something for them, maybe they'll hook you up.

Do I want this job? Sure, if you've got a couple hundred grand lying around.

THE BOUNCER

The Job: Outside: checking IDs, taking money, sometimes picking people out of line, and filtering out the riffraff. Inside: keeping an eye out for illegal activities, guarding exits, and breaking up fights.

The Hookup: Free admission when working outside.

The Approach: Whether you're dressed to the nines or just one of the regulars in line, always be exceedingly friendly and make small talk with the bouncer when he's checking your ID, and get him to look at your face so that he'll remember you. Compliment his shoes or tattoos, flirt with him outrageously, or just say, "What's up, good to see you again!"

Another good opportunity to chat up the bouncer is in areas where they aren't working so hard, such as standing around guarding the smoking entrance. (They get asked for cigarettes a lot, so offer yours.) Always talk to staff when they look bored.

Do I want this job? It's more of a job for people who don't enjoy going to clubs than for those who do.

THE GUEST-LIST PERSON

The Job: Some combination of working the guest list, taking your tickets or cash, and/or stamping your hand.

The Hookup: Free admission and, occasionally, drink tickets. Many list girls

work the door at a variety of clubs, so knowing them may net you several nights of free entertainment a week.

The Approach: These people get hit on constantly and it gets old, so don't bother with that. Persistence is key. Make small talk with the list person if you can, especially if you see her inside: "Do you know when DJ Doody is going on?" And when you see her working or partying out at a different club, make sure to say hello there as well and reintroduce yourself.

Do I want this job? Sure, if you can get it. Working the door at one club is basically an all-access pass to every other club in town.

THE BAR/CLUB MANAGER

The Job: Scheduling, hiring, and firing staff; ordering the alcohol; dealing with vendors; opening and closing the venue; and choosing which promoters own which nights.

The Hookup: Anyone on management level has unlimited guest-list access and drink tickets. However, they don't hang outside the club's front entrance and often don't bother with the guest list. Thus, they're the most useful in hooking you up with drinks and passes to future events once you're already inside. They're usually friendly and social, but busy too. If the club has VIP cards, you can get one from them.

The Approach: Club and bar managers like people who treat them like people rather than freebie dispensers. Go with that approach when speaking to them. On the other hand, it's their job to give free things to influential people. If you consistently come and bring lots of beautiful people, you've got a better shot.

Do I want this job? This is more of a career position than a part-time job. You'll probably need experience as a head bartender before you can get it.

THE PROMOTER

The Job: Throws the individual parties on specific nights (weekly or monthly) at a club, choosing and hiring the DJs, making and handing out the flyers, and getting the right crowd to attend.

The Hookup: Free admission to their parties, which may be in different venues on different nights of the week.

The Approach: Promoters always want to hear, clichéd as it is, the line "Great party!" However, each person they let in free means less money they earn, since they make their profit at the door. But if you've made the promoters' acquaintance and you see them regularly, you might ask them to put you on the list for a future party and get their contact info. Tell them you'll bring paying friends.

Do I want this job? If you go out a lot, yes. Promoters get good hookups at other venues all over town. On the other hand, it's a lot of work, and few promoters actually make any real profit.

THE BARTENDER

Job: Slinging drinks.

The Hookup: Free drinks!

The Approach: In clubs, the music is usually too loud and they're too busy to have long conversations. Talk to them early on in the night and get to know them while they're working at bars instead—most of them have multiple jobs. See the chapter on drinking for better tips.

Do I want this job? Oh, hell yes. Bartending is not hard, you can make 50 bucks or more an hour, and you can have another job or go to school while you do it.

THE SOUND OR LIGHTING TECHNICIAN

The Job: The techs run the lighting system or control the sound in large clubs.

The Hookup: guest-list access wherever they work, including clubs. The technical guys are the secret clubbing gold mine because nobody worships them like they do DJs and they're not easy to find in the club. Techs know how to party, where the after-hours club is, and how to throw down on their nights off.

The trick to getting in with them: The techs are regular guys who love the music. So music is a safe topic. Or ask about their job and how they like it.

Do I want this job? This is a job for people who like wires and high voltages and climbing up tall ladders. The pay is generally less than they deserve in clubs, but that can also be a stepping-stone to concert-tour lighting, where the real fun and cash is.

Most DJs smoke pot, so share your weed and make a friend.

THE DJ

The Job: Mixing the music.

The Hookup: Free admission. The DJs get free drinks but only for themselves.

The Approach: Make friends with the warm-up DJs who spin earlier at night. They have fewer fans and aren't jaded yet. When you see them hanging out at the bar afterward, say "nice set," ask where else they spin, etc. Be a fan first and a friend later.

Do I want this job? You don't want to be a dance music DJ. There is too much competition and you have to spend half your income on new records to stay current. On the other hand, if you play whatever retro music is trendy now (like Latin freestyle, Italo-disco, or new wave), you'll spend less on records and nobody expects you to beat-match. That's where the profits are better.

OTHER JOBS THAT GET YOU INTO CLUBS FOR FREE

For many of us, what we do at night is far more important than any job that forces us to get up at unreasonable, pre-noon hours. And if you're toiling for The Man all day only to blow your paycheck out at night, why not combine work and play into one?

CANDY AND CIGARETTE GIRLS

The Job: These are the (usually) women who wear old-fashioned or outrageous uniforms and sell cigarettes, candy, and glow sticks in clubs. They carry their wares on a tray with a strap that goes around their neck, roaming from club to club or staying in one large venue all night.

Pros: You get into any club you want without paying and can hit tons of them each night. You'll also make tip money while you're at it.

Cons: You have to wear a silly outfit that doesn't allow you to blend in with the crowd and enjoy yourself. Also, the tray you'll be carrying is heavy, and you can't just stick it in a corner and go dance.

CLUB TOUR OPERATOR

The Job: Club tour guides arrange transportation (a bus or limo) and no-waiting free admission to several clubs over the course of one night. They usually cater to business tourists and hit the biggest, most mainstream clubs. They send a guide along with the group.

Pros: You should be able to charge a decent rate from the customers, yet get reduced or free admission from the club.

Cons: You don't get to have any fun yourself. You're a babysitter.

FLYER DISTRIBUTOR

The Job: These people work for the promoter, handing out flyers inside and outside clubs, and leaving them in stores for people to pick up. Doing this for a company that owns multiple clubs or promoters who throw multiple parties can save you a bundle, because you get free admission all over the place.

Pros: You get in free everywhere you promote, and possibly a few bucks for

your time. (If you really like a certain club night but don't want to pay for it, contact the promoters and ask them if you can hand out flyers or hang posters in exchange for admission.) There is also a promoter courtesy among smaller club venues—you can get into other clubs for free to promote a non-competing party. If you have a stack of flyers that you picked up from the record store down the block, they won't know the difference.

Cons: You may have to run all over town to drop off flyers. And unless you're also getting paid, three hours of work probably isn't worth saving a $10 cover.

LIQUOR PROMOTIONS

The Job: Liquor companies send out representatives to bars and clubs to hand out coupons redeemable for discounted drinks with their brand of liquor in them.

Pros: After you're done with your shift, you can hang out and party like a normal person.

Cons: You need to make a quota each night, so you end up acting like a pusher. You don't get to choose your venues, so you'll probably get stuck somewhere awful.

CIGARETTE PUSHER

The Job: Like the liquor promoters, cigarette companies give out free packs to encourage people to try their brand and to put their names on a mailing list.

Pros: Free cigarettes. And the bartender will let you drink for free in exchange for packs.

Cons: Each transaction takes time and often involves heavy electronic equipment. You'll have to put your stuff out in your car then come back in after your shift is done if you wish to actually enjoy yourself.

SAFE-SEX EDUCATOR

Nonprofit organizations pay people to go into gay clubs to pass out condoms and educational pamphlets. They often set up tables to answer questions.

Pros: Getting into gay clubs for free and chatting up strangers.

Cons: There is usually tons of sex education training involved, and it's more like charity work than a job.

SPECIAL ASSIGNMENT: Nightlife Reviewer / Photographer

Writing bar/club reviews or taking party pictures is a way of getting paid to go out. And not just to nightclubs—you can get into concerts, sporting events, art

shows, fairs, theater performances, and everywhere else that has a cover charge. The press includes photographers and writers for daily newspapers, alternative weeklies, DJ or music magazines, style magazines, clubbing websites, Internet magazines, and the like.

One drawback is that you only get to review a club night once, so you won't be able to go to your favorite spot without paying every week. Also, you can't get your friends in for free. The press angle works well for loners.

The easiest way to get into clubs as a reviewer or photographer, of course, is to really be one. There are a million rinky-dink nightlife websites for which you can write. Get your foot in the door at a small club website that won't pay you at all. (Nightlife writing pay is crap anyway. It's not about income; it's about access.) Find a venue online and ask for a chance to work for it.

All of these tips for writers and photographers also work for good liars.

Plan ahead. Ask in advance to be put on the guest list rather than talking your way in through the door. Contact the night's promoters a few days early. Email works best if you can find one. "I'm a writer for NightFunMagazine.com, and we're updating our listings of your Sex Traxxx night. I'd like to come down this Friday to do a quick review. Can you put me on the guest list so that this is possible? Thanks, and please let me know." If you want to bring a friend, ask to have a "plus-one" so that you can "bring a photographer."

★

Club Courtesy

When you work for a nightclub in any capacity, you might have cover charge immunity at other venues in town (as long as the owners don't hate each other). Bring your pay stub as proof of employment and talk your way in. Industry courtesy applies to other entertainment professions too—the staff at concert venues, movie houses, and performance theaters can get into other similar venues. Ask your manager where this strategy works, but don't be afraid to try it out all over town.

★

Work the door. If you haven't made advance plans with the promoters, be prepared for some fast-talking. If you're a writer, have a pad and pen out in plain view, with some of the club's information already written on it. If you're a photographer, bring a camera, or at least a camera case with a six-pack inside.

Walk up to the guest-list person and say, "Hi, I'm here from Night Fun Magazine to do a review." You might also jump right into asking some questions that you'll write down ("Does the night start at 9 or at 10? What's the normal cover?"). Once they begin treating you like press, they sometimes forget to check if you actually are press.

And better yet, carry backup documentation. First try talking, but if they doubt your credentials, hand them your business card as an afterthought—it always seals the deal.

Make your own press credentials. Freelance writers and photographers for newspapers, magazines, and websites don't get business cards from the publications they represent—yet security staff frequently ask for one. So they make their own. Either create a generic card that lists your occupation as Nightlife Writer (or Photographer), or a publication-specific card with the newspaper's or website's logo on it.

To do that, find a business card company with an online card—designing tool. Copy and paste the company logo from the website of the paper into the business card application. Presto! You're an official employee of the New Nightlife Times.

[Search Term: business cards online]

HOW TO INFILTRATE A SCENE ON A BUDGET

Get to know the players in any scene and you'll get hooked up with everything from entry to alcohol. The steps below are a cheap and easy way to do that.

1. Go to the early weeknights, when DJs play at smaller bars.

2. Mingle your ass off and get to know everybody there:

(a) Ask the DJs where else they spin, and ask the other people in the bar what other nights they like going to.

Make Friends With...

★ **Older Nerds in Flashy Clothes**
Chances are they have money to spend, trying to look cool and impressing people by buying them stuff.

★ **Drag Queens**
They're horrible bitches with wonderful hookups.

★ **Drug Dealers**
But only ones whose drugs you're not interested in. When you're their confidant as opposed to their customer, they'll take you along for the ride. Not only are they making money while out with you, they usually get in free and get free drinks.

(b) Say "What's the cover there?" in a pained way that shows money is a factor. Hope for a hookup.

(c) If you're new in town, say "I'm new in town." People like to share their insider's knowledge.

3. Go to one of the recommended clubs. Find the people you met and reintroduce yourself: "Hey, I'm Camper. We met at Sugar Bar." Ask if there is anything good going on that week/weekend. Talk about that.

4. Go back to the small bars the next week and solidify your friendship.

5. Repeat and expand your circle. Eventually you'll know everyone you need to know to get in where you want.

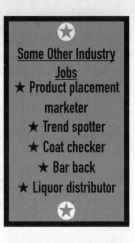

Some Other Industry Jobs
★ Product placement marketer
★ Trend spotter
★ Coat checker
★ Bar back
★ Liquor distributor

CHAPTER 3★

Look Like a Million Bucks for Slightly Less Than That: Fashion and Style, Hair and Beauty

If you spend all your money on clothes, you won't be able to afford to go out and show them off, and that would be dumb. When you're in the old ravers' home, what are you going to treasure more—that you had a lifetime of experiences or a closet full of expensive outfits?

That's not to say that you should hit the clubs every night in sweatpants. Looking good is an important part of any rock star lifestyle. It builds self-confidence, helps you meet new and exciting people for the purpose of friendship and romance, grants you access to better parties and clubs, and makes people more free with their freebies.

It doesn't take any more time or effort to look good in low-cost clothes than in designer jeans. Besides, the most expensive labels on the market can still look like crap on the wrong people. Just shop in different places and keep your eye on the style instead of the label.

BASIC STRATEGIES FOR DRESSING YOURSELF

Writing about developing personal style is kind of like singing about probate law. But here goes: Basically, if something looks good on you, try to figure out why that is. Is it the color, length, style, pattern, or tightness? Then wear more things with those features. But beyond the not so helpful advice of "Wear what looks good on you," there are some general strategies that work well on most everybody.

Look Good Naked

Style is independent of body size and shape. You can look like a superstar or a color-blind jester no matter how big or small you are. For proof, check out Oscar night fashion.

That being said, if you've got the body of a god, you can walk around with almost nothing on and people will be less likely to notice that your short-shorts are from last season. When you look good naked, you'll usually look good with your clothes half off. A hard body gives you to room to unbutton your shirt, show off your tattoos or navel piercing, or wear micro-miniskirts.

Beyond crowd-pleasing nudity, looking trim and fit gives you a lot more outfit

options than only being able to shop in the plus-size section of the store. (And those clothes cost more.) Most thrift store clothing tends to be on the smaller end of the size spectrum, so you'll fit into more stuff there as well.

The Base Layer

The place to spend your money on clothes is on the very basics—understated shirts, pants, jackets, and skirts. Get them in good-quality, nonfading solid colors. You can wear a different combination of a small set of basics every day of the week (black and white, khaki and blue, gray and black) and nobody will even notice you're repeating until they start to smell. You can always add flair on top to distinguish one day's look from the next, as you'll see in the "Miraculous One-Shirt Wardrobe System" section.

Basic, solid colors are easily interchanged, but if you spill wine on your lavender floral-print pants, the matching top will become an orphan. With realistic colors it's easy to add a new item or get rid of one when it's old, rather than throwing away the whole outfit. Keep to a muted color scheme, then splash on the color with accessories.

On the other hand, when a piece of clothing looks really good on you, there is something to be said for buying it in every color. If it's a classic style that won't become passé anytime soon—a button-down shirt, polo shirt, T-shirt, simple blouse, good pair of work pants, dark denim—then don't be afraid to get more than one of the same thing.

Signature Style

If your goal is to be recognized when you're out on the town, consider adopting a signature style. A lot of celebrities do this—think of Bono's sunglasses, Punky Brewster's mismatched sneakers, or Ashton Kutcher's trucker cap. You can do the same thing on a smaller scale—always fasten your belt on the side, wear tons of bracelets, two watches, dress in monochromatic color schemes, get a rack of gold teeth, etc. If you have a noticeable fashion affectation, people will always recognize you as "that girl with the roller skates" or whatever it is you choose.

On Being Trendy

It's the nature of trends to come and go quickly, and should you buy into too many of them, you'll suddenly be left with an entire closet full of outfits that are so last season. The solution to the fickleness of fashion is not to ignore it, but to buy wisely. Look for these sure signs something is too trendy to last:

★**Asymmetry** Remember the "asymmetrical 'shroom" haircut that Bobby Brown was sporting in the late 1980s? Hilarious! The off-the-shoulder Flashdance look? Tragic! Anything asymmetrical, like a shirt with one sleeve or a backpack with one strap, goes very out of fashion after a few years and doesn't came back until after a 20-year banishment.

★ **Bite-size** The lipstick-size Jordache purses of the 1980s disappeared until the mini backpack reared its ugly head in the late 1990s. Baby-doll T-shirts lasted a lot longer because they show women's belly buttons and everybody wants to see those. Miniskirts come and go, but mid-length dresses stick around. Daisy Dukes are always a no-no, even when they're in style.

★ **Oversize** Likewise, extra-large clothing is also a passing fancy. Raver jeans, billowing sleeves, belt-able sweaters, shoulder pads, shorts so long that they're culottes—these can't last too long before someone realizes that they're hideous.

★**Stuck in the Mid Length** Shirts will always come in two flavors: short-sleeved and long-sleeved. It's all the stuff in between and on the extremes that changes from year to year—sleeveless, three-quarter-length sleeves, zipoffs/cutoffs, that kind of stuff. The same is true for half-shirts, skorts, pedal pushers, ultra-low-rise jeans, and flats.

★ **Stereotype Chic** Other than hippie clothes like tie-dyed tees and Guatemalan sweatshirts (which seem to continually appeal to college students and/or burnouts), ethnic-style clothing is also cyclical. Is it "French sailor" this year or "Italian gondolier"? (I can never keep those straight.) Is that a bolero jacket or matador-inspired coat? Even American styles come and go. Are you supposed to be a trucker or a lumberjack, and aren't we supposed to be cowboys for fall anyway?

★ **The New Black** "Everything brown! Throw out your tan! This season is all about a darker shade of khaki." Whatever they're calling the new black (or green or pink or whatever) will never replace the old black or green or pink or whatever.

★ **Patterns and Treatments** People, let's never have another acid-wash era. We can accomplish this together. It's OK to buy patterns—just don't get carried away with them. Classic patterns like tweed, plaid, and argyle come back on a much shorter rotation than do polka dot, paisley, and neon anything. Anything too new will get real old real fast.

This is not to say you need to ignore fashion trends completely. Part of being a hipster is being hip. But when you know the look you want probably won't last more than a year, you may as well skip the designer labels and buy the less expensive

version of the same thing. Buy your trendy clothes a fraction of the price at places like Urban Outfitters, H&M, in dozens of shops on Melrose Avenue in Los Angeles, and basically anywhere else they're playing obnoxiously loud club music in a clothing store. If the clothes don't last through 20 wash cycles, that's OK—neither will the trend.

Predicting the Future

Here's a simple style tip: Escalate whatever style is trendy now and suddenly you'll be fashion-forward. When you notice that something is becoming the hot new look, don't buy what everyone else is wearing—that will be marked-up anyway. Think of the natural extension of that trend and find it at thrift stores where the clothes are cheaper. Some examples:

★ **Similar Labels** When one brand is coming back in vogue, shop for close relatives. Lacoste prep shirts will surely be followed by Le Tigre and Munsingwear. Jordache will precede Sergio Valente. Puma before Le Coq Sportif.

★ **Similar Styles** When the military look comes back, you can try a uniform like "postal worker" or "airline steward." Vegas swinger begets lounge singer. Is the golf look back? Then it's time to ask "Tennis anyone?"

★ **Extremer** When you hear that miniskirts are back in, start rocking a micro-mini. Hoop earrings are the new thing? Look into some giant squares. Flannel? Go with thermal. Frayed edges? Invest in fringe. Isn't this fun?

THE MIRACULOUS ONE-SHIRT WARDROBE SYSTEM

There are two important things you must know about The Miraculous One-Shirt Wardrobe System before its secrets can be revealed:

One: It's not miraculous.

Two: It's not about the shirt.

The Miraculous One-Shirt Wardrobe System could otherwise be known as "accessorizing wisely," but that wouldn't sound as fancy. The operating theory is that you only need one shirt to have a week's worth of outfits. You simply add on accessories to make it look different each day. On Monday you're working an urban cowboy thing, on Tuesday you're a biker, on Wednesday you're going for corporate casual, on Thursday you're a disco sexpot, and on through the weekend. Just start with a good base layer and add to it. Not only does this system give you a lot of options, it saves a lot of money on shirts.

Invest Wisely in Accessories

Accoutrements often get more notice than the clothes they're dressing up. If you're walking around with a sombrero embroidered with the words SLAVE TO FASH-ION on it, nobody will notice the big spaghetti stain on your shirt. (Actually, that is a very clever way to hide stains. Keep a sombrero in your desk at work for emergencies.)

Unlike clothing, accessories not only last forever; they come back into fashion on shorter cycles. They also still fit when you gain 100 pounds, and they don't take up as much space as big-girl clothing. In other words, accessories are forever.

Even if you're a label whore, you'll save money when those labels are on your baubles rather than inside the collar. You'll still get to showcase your favorite designers and won't have to worry about ruining them at the cleaners. There is no point in buying this season's Burberry argyle print jacket when you can buy a plain black jacket and accessorize it with a much less expensive Burberry scarf. And when that pattern becomes passé, you can lose the scarf and update the jacket with whatever is hot next year.

How to Dress Yourself in Two Easy Steps

From head scarves to toe rings, there are dozens of different accessories wearable by people of both genders (and those in-between genders that are becoming hip). When you're getting ready to go out, just think about what you can do differently from yesterday—even if you've got the same outfit on.

Step One: Put on your base outfit—that one shirt and pants.

Step Two: Add some stuff to it. Here's what you've got to work with:

THAT ONE SHIRT

Without buying any accessories, you can change the look of your one shirt by **rolling up the sleeves; buttoning,** unbuttoning, or leaving it all the way open; **tying it up** country-girl style; **tucking** or untucking it; leaving it wrinkled or **ironing** it flat.

HEAD

Start with the standard: **makeup** for women (and men who are rock stars). There are endless ways to wear it to change your face to society matron, ethnic goddess, or retro hipster. Experiment on your nights off with new looks, get something different done at the makeup counter in the department store, or ask your neighborhood drag queen for some tips.

Your whole face changes with a new set of **glasses or sunglasses.** Go

big for that incognito-celebrity look, or small and round to pose as an intellectual. You can always just use them to hold back your hair. Or forgo the frames and get **colored contacts.** Other things that freak your face are funky **earmuffs** in the winter or **headphones** for your MP3 player. Or if you're feeling cra-za-zy, you can decorate your mouth with some fake **gold teeth** or glue-on **vampire fangs.** Add some **earrings** on top. Have a selection of studs: ones that dangle, different colors of metal, etc.

> Warning: Tattoos are free in prison, but that doesn't mean you should stab somebody to get there.

HAIR

If you change your hairstyle, you can change your whole look. Women have a heck of a lot more options when it comes to taming the mane, and a lot more accessories to do it with. Stick in some **barrettes, combs, clips, chopsticks, ponytail holders, flowers, headbands, hair wraps, bows, beads, pins, scrunchies, bungees, Afro picks, or tiaras** to change your style from day to day. If you don't have much hair, you can add in some **extensions**, or **dye it or streak it** any color of the rainbow. Around Halloween stock up on **colored hair spray and hair glitter** for temporary hair flair.

Sport a **bandanna** or **scarf** and you won't even have to shower. Wear them like a bad-boy biker or a '60s Stepford housewife. **Hats** come in a ton of styles—golf caps, bowler hats, bucket hats, baseball caps, visors, cowboy hats, beanies, skullcaps, ski caps, fishing hats, berets—and those are just the ones that fit men. And why not try out a wig while you're at it? They're pretty darn expensive, but they're doubly glam.

ARMS AND HANDS

Keep a stockpile of different leather and cotton **gloves** and **mittens**, or change the look in the warmer seasons with gloves designed for seeing the opera, driving a roadster, golfing, weightlifting, or challenging someone to a duel. On your wrists, you can pretend to be sporty with some stylish terry cloth **sweatbands**, or dress up in a **bracelet** or two or 200. You don't have to buy those in gold of course—you can wear anything from rubber bands to charm bracelets to a bike chain to telephone cords to actual jewelry. Or put on a **watch** or just a groovy retro **watchband**.

On your fingers, stack on the **rings** and slather on **nail polish**. With those accessories you can pretend to be married, or even French! Up on your arms, you

can show off or hide your **tattoos** (be they real or press-on), or wear an **arm-band** over your shirt or an arm bracelet like Hercules.

OUTERWEAR

Beyond the coats, mittens, gloves, and **scarves** to keep out the cold, you can accessorize on the outside with things like **purses** and **pocketbooks**. Or bring a **bag or backpack** to add to your look (and store a secret six-pack). In that genre you've got messenger bags, book bags, athletic bags like Camelbaks and bowling bags, camera bags, beer coolers, map bags, army bags, and even (God forbid) fanny packs. Handheld accessories can include **lighters, cigarette cases, lipstick tubes** or other **makeup holders, fancy pens, cell phones, portable stereos, PDAs**, digital or traditional **cameras, umbrellas**, or even a **cane** or other walking stick.

Warning: Two-thirds of these accessories are out of style right now.

WAIST

Riddle your middle with a **belt** that has a fancy **belt buckle**. Guys can get fun interchangeable trucker buckles. You can also try something unusual for a belt, like a necktie, scarf, chain, or cord. Add some zoot to your suit with a **pocket watch** or **wallet chain**.

FEET

The funny thing about women's **shoe** obsessions is that only other women (and foot fetishists) care. On the other hand, a guy might own a $10,000 collection of vintage Air Jordans, but he would never wear them. Regardless of your gender, collection, or obsession, you should buy footwear to stand out. Try six-inch heels, platform shoes, thigh-high boots, blue suede shoes, cowboy boots, shit-kickers, high-tops, flip-flops, slippers, sandals, ski boots—you get the idea.

Dress your ankles in brightly colored or other contrasting **socks, tights, stockings**, or **panty hose.** When you sit down they'll poke out from beneath your pant leg and add depth to your style. If your feet are showing, slap on a few **toe rings** or **toenail polish.** Accessorize your shoes or sneakers with differ-ent **shoelaces**, or help show them off **by rolling up your pant legs** or cutting them off altogether.

NECK AND TORSO

The neck is a sexy body part, both to mortals and vampires. You want to have a

wide variety of **necklaces,** from gold lockets and pearls to puka shells and plastic. You can get a lot of use out of one chain with a collection of various **charms and trinkets** to hang from it. You can also try different lengths of chains, from ropes that hang to your belly button to choker chains.

Hide your hickeys with a winter or summer **scarf**. Guys can get fancy with a **necktie, bow tie, cummerbund, handkerchief,** or **pocket square.**

BEDAZZLE

Attach **buttons, pins,** or **brooches** to your shirts, ties, pants, coats, hats, or the strap of your bag or backpack. If you want permanent changes, add **patches** to your knees and elbows, or **iron-ons** to your T-shirts, hats, and bags. When your clothes get old, experiment with **dyeing** them. **Bedazzle** them with rhinestones and gems, or **add fringe** to the sides. Sew an extra row of contrasting **stitching** or a random stitch pattern across the front of your shirt for an avant-garde look.

TRICKS ON THRIFTING

Perhaps you're not convinced that you only need one shirt in your wardrobe. Suit yourself, but do it wisely by shopping at thrift stores. Likely, you already do. But just in case...

A Few Reasons to Thrift, If You Don't Already:

★ Used clothing is cheaper. That's the "thrift" part of thrift shopping.

★ You're probably not going to walk into the Gap and find a purple cowboy jacket with foot-long yellow fringe hanging off it, but you've got a much better chance of that at the local Salvation Army. Thrift stores carry more fun, wacky items than regular mall stores. They make great party clothes, and since they're so inexpensive, you can take a chance on something outrageous that you may only wear once.

★ You can buy dirt-cheap used clothing that doesn't quite fit and have it altered for less than the cost of buying it new. You can also afford to have non-washable items professionally cleaned.

★ What's old will always be new again eventually. Why buy a brand-new retro-look outfit when you can get a better-made original at half the price?

What's Where

Save yourself time by targeting the right types of stores. **Consignment shops** are not thrifty in any way. Generally they sell designer-label suits and

dresses that you'd wear out to the symphony, so if you don't plan on hitting the symphony anytime soon, you can skip those shops.

Vintage-clothing stores carry presorted used clothing. They buy their stuff both from secondhand shops and from people (like you) selling their cast-offs. These places can either border on consignment shops in the price and quality of the clothing (many wash or dry-clean their items before putting them out on display) or they can be a thrifter's bargain paradise. You'll certainly pay more for the same clothing that you could find at the Salvation Army, but on the other hand, you won't have to sort through a hundred dirty pairs of grandpa polyester action slacks to find a single pair of jeans.

Then there are the generic **thrift stores** like Amvets shops, Salvation Army stores, and other fund-raising organizations that take donations of clothes rather than paying for them. They usually sell not just clothing but also kitchenware and furniture.

Dollar-a-pound or other shops leave the sorting to you. They price everything the same—all pants are 5 bucks, shirts cost $2 each, and so on. There is a high ratio of crap–to–good stuff, but if you have the time to invest sorting through tons of clothing (sometimes just piled on the floor), you can find great bargains in these places. Oftentimes you'll be combing over the merchandise at the same time as the vintage-clothes buyers, which means that if you show up at the same time they do you'll have as good a chance as anybody to get the sweet stuff.

Warning: Don't freak out or anything, but people have picked up scabies at certain ultra-nasty dollar-a-pound stores.

Where to Go

The trendiest thrift stores will have the worst prices on the hot line of the moment—they mark them up to match the demand. Likewise, upscale stores that specialize in designer labels won't have good prices on those labels. The smart way to thrift-shop is to seek out the stores that specialize in the opposite of what you're looking for—buy your Gucci in the ghetto and your Puma in Pacific Heights.

Stores in the sticks or suburbs will have the best bargains on ironic hipster wear. A "Big and Beefy Steakhouse Girls' Softball Team" T-shirt might be reduced in the Midwest, but it would fetch a pretty penny and some hipster cred in the city. If you've got a car, take your weekend shopping trips in the outer suburbs. And make sure to budget some time to thrift whenever you go back to East Nowhere to visit your parents. The farther you are from anyone with fashion sense, the better fashion you'll find.

Warning: That story about finding syringes in thrift store shoes is an urban legend. Athlete's foot, on the other hand...well, just spray some antibacterial stuff in there first.

When to Go

By Sunday afternoon all the best clothes have been picked over by hundreds of hands. Thrift stores replenish their stocks often—go on the day when they put on the new stuff to find the best selection. Ask a clerk when that is: Chances are it's Thursday or Friday, as the stores stock up for the weekend crowds. Make your shopping day Friday afternoon and you'll be a step ahead of everyone else.

You can also make out better if you go to the same place frequently. If there is a store you can hit every week during your lunch break, keep going regularly. Soon you'll be able to recognize the new items, and you can be in and out of the store in five minutes rather than pouring through every rack for an hour.

> ★
>
> Knowing how to sew allows you to alter clothes that you get at the thrift store, make your own curtains, cover your upholstery, and repair damaged or ripped clothes.
>
> ★

★★★★★★★★★★★★★★★★★★★★★★★★★★★★★★★★★

Cost Cutting

As things in thrift stores are individually assigned prices by individuals assigned to give them prices, there can be variations in a certain thing's pricing. Sometimes you see a shirt marked up so high, it makes you question the sanity of the individual who priced it. Forty bucks for a "Hang Ten" T-shirt? Are you kidding?

Some seasoned thrift shoppers try to get a second chance on the item's pricing by cutting off the $40 tag and taking it to the counter. "This doesn't have a price tag on it, how much is it?" they ask. They hope that the person at the register will offer it at a lower price.

Of course, many thrift store managers are just as savvy as the shoppers and institute the policy that they will not sell anything that doesn't have the price tag on it. If that's the case, you can always rip off the tag and go the next day to see if it's priced more sanely.

★★★★★★★★★★★★★★★★★★★★★★★★★★★★★★★★★

Wifebeater Swapping

It is important to make friends with people your size so that you can borrow their clothes. When you have plans to meet up before hitting the town, say, "Do you have anything I could wear out tonight? All my clothes are at the cleaners/boring/covered in cat hair." Or consider entering into a sexual relationship with a transvestite or a person of your same sex—you'll double your wardrobe in an instant.

But if you don't want to change your sexual preference and your friends don't trust you enough to let you borrow their clothes, you might consider throwing a clothes-swapping party. The simple version goes like this: Everyone brings all the clothes that they'd normally donate to the Goodwill store. Throw them into a big pile and everyone takes their pick. (At your apartment, you get first dibs.) The host then takes all the unwanted clothing to the donation store the next day (or tries to sell it to vintage shops).

Other people with more expensive wardrobes might instead consider a point system for swapping. Everyone assigns point values to clothes they bring (3 for a suede jacket, 2 for designer jeans, 1 for shirts, for example), and you take home as many points' worth of clothing as you bring in. This is so nobody gets screwed by the hobo who shows up.

SOME SHOPPING STRATEGIES FOR BUYING NEW CLOTHING

The List

Seek out email lists for each of the stores at which you shop and the labels that you wear. Common brands like Polo and Tommy Hilfiger have websites with sale sections, and email lists with occasional contests and sweepstakes. You can also find a few bargains on sites for department stores like Macy's, Saks Fifth Avenue,

Many thrift stores (and, less so, vintage stores) have regular sales to clear out inventory. Others have a rotating sale day when things with green price tags are half-off on Thursday, red-tag items are half-off on Wednesday, etc. Should you see an item you want to buy before it's a sale day, you can try to be sneaky and hide it within the store so that nobody else will find it and buy it first. Stuff it in the sleeve of an ugly coat or shirt, inside an old-lady purse, or in the XX Small section. Then hope it's still there when you come back for the sale.

and Nordstrom. Look for the "On Sale" link. Often, promotional e-mails offer "secret" free-shipping sales for online orders.

Another incentive to get on the lists of designers you like (especially local ones) is to hear about sample sales. Some websites list all of them in a given city, such as NYSale.com or NYMetro.com (New York magazine's site). But if you don't live in New York you can still snoop out sample sales by searching for shopping-related bulletin boards online. Put up a post like "I'm going to do some shopping in the city this weekend. Does anybody know of any sample sales?" You may be surprised how easily people share their secrets.

Designer Duds

For high-end fashion, designer discount stores are the way to go. Places like Filene's Basement, other department stores' "basement" shops, Century 21 in New York, and even Marshalls have many of the big brands at less than half price. Most of the clothes are from previous seasons, and the ones that aren't might have weird stains or holes in them. Inspect everything carefully and try it on before you spend your money.

Warning: 30 gross people may have tried on your new clothes before you did. it's always good to wash before wearing.

All That Glitters Is Not Gold Lamé

What do teenage girls, gay men, and strippers have in common? (I mean, besides the same taste in music, television, and men.) They all have gaudy fashion sense. The stores that cater to these crowds specialize in items like satin pirate shirts, see-through skirts, and rhinestone covered backpacks. And though 85% of it is heinous crap, you can find some great glamwear within the rest. Shop at the discount stores and websites for these populations, like International Male, Delia's, and Frederick's of Hollywood. You'll find fun shirts in teen boutiques, costume jewelry at the mall's accessories shops, pleather pants at the gay clubbers' stores, and cheap stockings and shoes at the strippers' salon.

Think Young

Thanks to the fattening of America's children, slim or small adults can find fun clothing in the kids section of department stores. An adult who wears size medium can fit into a kids XXL without a problem. Not only are kids clothes cheaper than those for adults, they also come in designs like insects and soldiers—perfect to wear out to the drum-and-bass club.

Insert Tired Early-Bird Reference Here

Much like at thrift stores, designer discount stores start packing their racks and putting out the new merchandise before the weekend. Go to those stores on Thursday for the best selection.

Online Shopping

The big problem with online shopping is that you can find great sales, but you won't know if something fits until after you buy it. But thanks to South American shoplifting rings and other embezzling practices, you can find a lot of new clothing on eBay below retail prices. Those bad people steal clothes then resell them to nice people like you. Go into upscale retail stores and try on the clothes. When you find what you like, write down the label, size, and style, then look for it online.

Off-season Shopping

The best time of year to shop for accessories is Halloween. Actually, it's November 1—the day after the holiday, when everything in those temporary-costume shops and drugstores is marked down to half price. Stock up on colored hair spray, body glitter, cheap wigs, slutty stockings, fake nails, false eyelashes, etc.

For other weather-sensitive clothing, shop the off-season, when stores clear out their shelves for the next season's styles—do it despite the fact that you can't wear them for two more months until the weather changes. Get your winter clothes in February and your swimsuits in August.

Warning: Dude, change out of the khakis before you hit the bars!

Don't Worry About Work Clothes

People spend a lot of money to look good at work. And though that may help a few people move up the ladder into middle management, for the average Johnny Cubicle, dressing well gets you nowhere. Unless your job is high-profile or in a flashy industry like advertising or design (and you deal with clients), you might as well spend your money on clothes you'll wear going out and having fun rather than for toiling for The Man.

However, most employers don't want their workers sitting around in their underwear, so you've got to put up some sort of presentable front. The easy way to do that is to wear vintage clothes to work. They're presentable, well-made, and in a world where every other employee is slathering on Banana Republic, you'll stand out as a style icon.

Guys who wear dress shirts every day can save in two ways. First, buy all your

shirts at affordable places like Mervyns and Ross, rather than mid-level stores. It's only work, after all. Second, always wear an undershirt and return the button-up to the closet when you get home. That will save you money on dry cleaning and effort on ironing.

<p align="center">Warning: Novelty ties—never.</p>

Haggling for Clothing

Oh, yes, you can bargain for clothes—probably not at Bloomingdale's, but definitely at small boutique stores. There the salespeople are also managers, and they have the authority to mark things down. They know by how much they can reduce an item and still make a profit, or how badly they want to get rid of something that's already on sale.

> ★
> You can also haggle in shoe stores. The smaller and more expensive the store, the better the bargains you can get.
> ★

Haggling for better prices on clothing is pretty similar to haggling for a stereo at the electronics store. Know how much you're willing to pay for something and be willing to walk away if you don't get it down to that price. You have the best chance to bargain for items that are already on sale as opposed to the new lines of merchandise just put out. At boutique stores there are always sales staff hovering around to help you out. Talk it over with them and express your hesitation as a way to open the bargaining process. Try these lines to get started:

- ★ "I really like this, but I don't have that much to spend."
- ★ "Can you come down on this price?"
- ★ "I love this. I'd buy this if it were [on sale/$10 less]."
- ★ "Will this be going on sale soon? I just can't afford it at this price."

BEAUTY CALL

For every $1.99 bottle of generic shampoo there is a $29.99 version with a fancy label and pretty much the same ingredients. The same goes for skin care products, hair gels, toothpastes and soaps, and services like hairstyling, facials, and electrolysis. Now, some people enjoy spending a lot of time shopping for the latest exotic beauty and makeup products and then spending a lot of money on them. It is not my job to convince those people that they're crazy—only to show them that there are alternatives.

Drugstore Shopper

Department stores carry top-of-the-line beauty products that you won't necessarily find at Walgreens. But they also carry other brands that you can—at huge markups over drugstore prices. If you see a particular product that you like, search for it online before you spend money to help Neiman Marcus keep their chandeliers lit. Even pharmacy sites like Drugstore.com carry a few designer products at good prices. To make up for the shipping costs you have to pay, they often throw in free samples of other products.

What the Department Stores Are Good for

At the beauty counter you can always get some free makeup to wear with what you've got on. If you act really interested, they might hand you some samples for the road. "I have to be careful because something in certain perfumes really irritates my skin. Do you have any samples of this I could bring home to try first?" If you do actually purchase an item from the makeup counter, ask if they have samples of other products they think you'd be interested in. The more money you appear to be willing to spend, the more generous they get.

Smells Like Rip-off

Duty-free cologne/perfumes are not much of a savings. Don't make a spontaneous purchase at the airport unless you know for sure that it's less expensive than at the department store where you usually get it.

Free Gift With Purchase

Department stores always have "free gift with purchase" specials on particular beauty products. Frequently the gift bag is worth more than the cost of the product itself—like $50 worth of goods free with a $20 purchase. Give the product to your friend for her birthday and keep the free stuff for yourself. Or see what the refund policy is if it "irritates your skin" so you can return the product and keep the bag.

Whenever you stay at a **hotel,** don't wait till the last day to take home the mini bottles of shampoo, conditioner, and lotion. Put them in your suitcase every day and you'll get a set of new ones the next. Grab the soap, shower caps, tampons, and maybe some of that supersoft toilet paper too.

Shampoo It Yourself

If you don't care how many botanicals are in your conditioner, you can make it yourself. Search online for recipes and see what pops up. There are instructions out

there for creating homemade shampoo, conditioner, makeup remover, shaving cream, facial mask, wart remover, bug-bite soother, sunburn cream, bubble bath, and much more.

[Search Term: "make your own beauty products"]

There are entire books, magazines, and Web sites devoted to saving money on hair care and beauty supplies. The tips here are mostly unisex basics. Do a Web search for "save money on beauty" and you'll find a lot more good advice.

HAIRY SCARY

Most women treat a $40 haircut like it's the bargain of the century. Then they go and have their bangs bleached and dyed and it's another $60 and then they repeat the process every five weeks. Stop that insanity!

Routine Maintenance

Even if you simply must see Robert (pronounced "Robear") for the magic he works on you locks, don't get the full treatment each time. Most expensive stylists will allow you to stop in for "just a quick trim" between appointments. (If not, dump him like a one-night stand.) You can also tune up your professional dye job at home between appointments. Just apply more of the same color that the salon uses (ask Robear where to buy it or if they sell it) over the old stuff. Your roots will continue to grow, but your wallet won't shrink at the same rate.

Get Schooled

Beauty or haircutting schools advertise deeply discounted haircuts (and dye jobs, perms, and other treatments) so that the students can practice on real live heads. Other beauty schools will give manicures and pedicures or do body waxing and other hair removal. The downside is that the service can take two hours rather than 40 minutes at Robear's.

[Search Term: "beauty school" YourTown]
[Search Term: "hair academy" YourTown]
[Search Term: "discount haircuts" YourTown]
[Search Term: "barber college" YourTown]

Want a whole bunch of **free stuff**? Type "free trial size" into your search engine and sign up to get beauty products, breath mints, condoms, snack food, office products, and more.

Other Schools That Give Guinea Pig Discounts:
★ Dental school
★ Massage school
★ Acupuncture school
★ Alternative medicine/herbal medicine school
★ Body-piercing studios during "demonstration workshops"
★ Veterinarian schools (for your pets, not for you)

You Should Be a Model!

Salons seem to be constantly looking for male and female models for hair shows. You get a free haircut in exchange for coming to their show (usually at night) to display your head for the audience. It will probably take up several hours of your time, so be sure to ask about that up front. Also make sure they tell you what style or cut they're planning to do in advance so that you don't get stuck with something you can't fix if you don't like it.

DIY—Do It Yourself

For the cost of one haircut you can buy a barber's electric razor to use for the rest of your life; this is a good option for men with short hair. When you get really good at it, you can start cutting your friends' hair in exchange for beer.

If You Got It, Sell It

If you're ready for a big change and are going to cut off a foot's worth of hair, you can sell it for use in wigs or hair extensions. It pays pretty good money—starting at something like $10 per inch. But you've got to have the right kind of hair (blond is a negative in this circumstance) and it must be in excellent condition. Do some research on the process or ask your stylist what he knows.

Most beauty product lines have their own Web sites and online stores, but the discounts you'll get by joining their e-mail lists aren't great. You'll get the occasional free-shipping offer but also a lot of spam in between, like "Shop early for Arbor Day gifts!" Don't bother spending too much time searching for Web sites outside your regular brands'. On the other hand, when a company launches a new brand or product, it'll often offer free samples. So when you see a product's big new print or television campaign, find the Web site and see if you can get some of it.

CHAPTER 4★

Crashing, Throwing, and Going to Parties

THROWING YOUR OWN

There is no point in paying rent on an apartment if you're not going to throw parties in it. You might as well sleep in the bus station, shower at the gym, and save yourself a boatload of money. But you also don't want to go broke throwing a throw-down by hiring a caterer and a live band and buying all the booze yourself. That would make you a great host but also a total sucker.

The four most important words on your party invitation are B.Y.O.B.

The Stock-My-Bar Party

It's nice that you want to show your friends a good time at your party and all, but you can also do that while using them to refill your liquor cabinet. If you do it right, you'll end up with more booze left over at the end of the night than you had to start with. All it takes for successful execution is a bit of manipulation of the guest list, a good sense of timing, and some magically disappearing ice.

Who to Invite

The best guests are friends most likely to bring liquor and least likely to stay long enough to drink it.

★Your coworkers, especially the married ones who never go out. If you have a close-knit company, invite everyone from your boss to the secretary. Make a special request to your superiors, because they can afford to bring expensive booze but they won't stay very long to mingle with the common folk.

★ Your former classmates, people you haven't seen in a while, lame friends, people in rehab, and other people who don't get out much. These people will come at 9 P.M. and leave by 11 or whenever things start getting crazy—for them an after-hours party means after 10 P.M. And you'll have their bottle of tequila to drink after they've gone home.

★ People you don't really like who try to buy your friendship. They bring the best booze.

★ Couples with children. They'll be thankful to get out of the house but still not able to stay very long before feeding or changing time.

★ Your friends who live far away. Encourage them not to drink and drive. Discourage them from crashing on your couch.

★ Your cocktail party friends who will get all dressed up only to stop by on their way to another fancy function.

★ Avoid inviting too many after-party friends who think it's OK to show up at 3 in the morning empty-handed with six other people.

Saving a Stash

Even if you only have alcoholic hipster friends who won't arrive until after midnight or depart before dawn, you can still ensure that you have leftovers left by making it appear that you've run out of crucial ingredients.

★ As the party goes on, secretly rearrange the kitchen under the guise of cleaning it. Stash some of the liquor bottles beneath the sink or in with the recycling bin when you're picking up empties, so that people won't find them even if they look through your cabinets for more.

★ Be discreet and don't hide the full bottles that someone else brought; start stashing the half-empty ones instead.

★ True lushes will not leave as long as vodka remains. Make sure this "disappears" earlier than other liquors. When there is only bourbon, Drambuie, and butterscotch schnapps left, people will stop drinking and leave soon after.

The more coworkers you think will come to your party, the earlier you should start it. This is so people can stop in directly after work but end up leaving before 9 P.M. to walk the dog or get dinner. When you invite coworkers, make sure to leave before they do to "set up." If you carpool with them, they're less likely to stop off at the liquor store on the way.

★ If people have brought beer and left it in the refrigerator, shift some of it down to the vegetable crisper, where it's out of sight.

★ Don't put out (so much). Buy as many cups and mixers as you think you'll need but only put out three quarters of them. Hide the rest and only bring them out if you want people sticking around.

★ No ice is n'ice. People are not all that willing to drink warm gin after you run out of ice. During the party keep the ice out in a bowl conveniently located next to the drink counter. It will melt faster this way and you'll run out sooner. Or you can always throw it out the window when nobody is looking.

★ Hide or dump the mixers for a similar result.

★ Never bemoan the fact that you've run out of ice or cups—just let it happen. If you make noise about it, your kind friends may volunteer to go out and get some from the store. Damn those do-gooders!

Getting Guests to Leave

Whether you're making sure that leftovers are left or you're just tired and want to go to sleep, there are many subtle ways to hint to your guests that they should get the fuck out.

★ Mood music. Change the music to something slower and quieter to make people tired.

★ Light up the night. Start increasing the lighting in the other parts of the house (the kitchen, bedroom, hallway) so that it chases people into one last room. Then when one group leaves, the party feels empty and the other people get the hint.

★ Or not. So try the opposite—start putting out lights. Blow out all candles and turn off all the lights in the side rooms. When it gets down to you and 10 guests sitting in a dark room they'll either catch a clue or it will turn into an orgy. So that works out either way.

★ Reverse psychology. Force everyone do shots of something strong and horrible (that you don't want to keep around the next day), like Goldschlager. Make a big deal that everyone has to do one. Some people would rather leave than drink a puke-inducer. Or you can try the direct approach: "Hey, let's all do one shot for the road!"

★ At 12:30 or 1 A.M. (or later, if your last call is after 2 A.M.) move the party to a local bar ("Let's all go to the Drinkin' Dive!"). Then turn off the stereo and put on your coat. This is the only way to get cokeheads out of your apartment.

In the Early Evening...

The party that starts and ends early will more likely result in guests leaving liquor for you to drink on your own later. But the early-evening party can also go horribly awry—people may get wasted early, skip dinner, and drain your liquor cabinet instead. The goal then is to invite people over for cocktails yet give them a good reason to leave at a reasonable hour.

Make your gathering a warm-up event to something else, like a rock show, movie, or group dinner. Don't provide any food bigger than hors d'oeuvres because people might pig out, skip dinner entirely, and stay at your place digesting. Tell your friends that you bought advanced tickets or made dinner reservations so they can't stay.

Even if you pull that off, you must diss your friends as soon as the after-party activity is done. Otherwise, they might designate you the host of the after-after-party and finish off the stuff they brought over earlier.

The Raging Kegger (or Partying for Profit)

Anytime you throw a keg party, you need to charge admission at the door to recoup the cost of the beer. If you overadvertise or charge a little more, you can come away with some cash to keep.

The kegger works best when your peer group is college-age people or eternally youthful rock-and-rollers: people who like to drink cheap beer in mass quantities. Even if you charge 10 bucks for unlimited beer, they'll still spend less for the cover than for three Bud Lights at a dive bar. But you can make a profit charging a lot less than that.

The risk with the kegger is that you could buy all of the alcohol in advance and not have enough people show up. So in order to ensure a profit (or just to break even), you have to ensure a crowd.

Invite far more people than could actually fit inside your house. Send out an email a couple of weeks in advance to everyone in your address book. (Send it blind carbon copy—("bcc:")—so that no one can see that 300 of your other friends are also the guests of honor.) Then send a reminder two days before the event.

Also make flyers with all the relevant information on it to hand out at bars, clubs, walking down the street—whatever. Include the cost and benefit ("$5 Cover. Unlimited beer"). Since you'll be charging admission at the door, you do want random strangers to show up. But on those flyers you need to promise more than just a party that guests have to pay for. Promise a blowout.

★ Provide musical entertainment. Have a friend who's a wannabe DJ spin. Or you can just make mixed CDs or tapes and call yourself DJ Awesome. That's good enough to put on the flyer.

★ Know someone in a band that needs a captive audience? Your party is a perfect opportunity for them to play (for free). And all the band members will tell their friends to come, increasing your numbers.

★ List other forms of entertainment and other bonuses, even though they may stretch the truth. Know any party tricks? Then there's a live magician performing. Can you juggle? Then you can list jugglers. If you change outfits, you're practically putting on a fashion show. Own a dog? That's a petting zoo right there. You'll have themed rooms at the party (kitchen-themed, bedroom-themed), a balloon drop (figure it out), and dancers.

Calculate the Cover Charge.

★ A standard keg of domestic beer, which is actually a 15.5-gallon half keg, holds about 150 12-ounce cups of beer. If each person drinks four beers on average, one keg will serve 37 people. (Four beers per person may be a little low, but all the Atkins Diet zombies afraid of carbs will drink less.)

★ Including the host and other people who won't pay to get in, you'll probably want to round it down to 30 people per keg.

★ Microbrews and imported beer have different keg sizes. They're also far more expensive so it would be harder to make a profit. If your friends are whiners, you can always go with an ironic hipster beer like Pabst Blue Ribbon.

★ Decide how much beer you need. The number of guests you can expect to pack your party divided by thirty is the number of kegs you'll need.

★ Calculate your costs. Figure the cost of the beer, cups, ice, tap rental, bucket rental (goes around the keg to keep it cold), and tax. Some big liquor stores have a delivery and pickup service, and even provide cups. [Search Term: "keg delivery" YourTown]

★ For a keg of domestic beer and all the fixins, you're looking at a little over $100 per keg, or $3 per person to almost break even. Make it $5 at the minimum.

> ★
>
> Don't try to throw a profit-making party with liquor drinks unless you're charging per cocktail. If you want to offer unlimited hard alcohol, you need a good variety of liquors, mixers, and ice. There are a lot more ingredients, so the initial costs are higher and the profits are lower.
>
> ★

★ Then decide how much profit you want to make—if you charge too much, people won't come. Charge too little and you'll lose money. It's better to shoot for a fairly small profit and overpromote the party than to ask too much and get nobody there.

Be Prepared

★ Buy plastic cups around 12 ounces in size. Anything too big encourages waste, and anything too small only ensures a big line at the keg all night.

★ Have a backup plan. If you go through the first keg by 10 P.M., you had better be able to get another one, or your unsatisfied drinkers will riot and burn down your house. Do some research to see if stores have a delivery service, or see until what time they're open so that you can pick up another keg if you need it.

★ Make sure you have a way to keep the keg cold. Many stores rent plastic

trash cans that fit around a keg and hold ice. That's the easiest way to work it. You can also keep it cold in the bathtub until party time, but that's not a great place to store it the whole evening (read: pee splatter). To fit a keg in the refrigerator you'll have to take out all the shelves and the vegetable crisper, but then you'll have to deal with keeping the door open all night.

★ Charge admission at your front door, not at the keg. Have your friends agree to shifts collecting money. Don't let these be your popular friends or they'll let everyone in for free. And be discreet—you're in a lot more trouble with the police if you're caught selling alcohol illegally than just throwing a loud party.

★ If you do have beer left over the next morning, call a bunch of your friends and have a finish-the-keg party. This one is free, of course.

Secure Your Stuff

For any big and semi-open invitation party, you don't want to leave your diamond jewelry sitting out for someone to steal.

★ Designate at least one room (one that locks) as the secure room in the house. Put anything you're worried about in there. Label the door with a sign that says "Private" or "Do Not Enter."

★ Just closing the door on a room doesn't mean that people won't go in it to make out or snort rails. If the door doesn't lock, put your valuables in the closet. They're not likely to ransack your apartment so much as be tempted by what's sitting out.

★ Don't worry about your stereo; worry about your iPod. People aren't going steal anything big (unless your party is raided by a street gang). It's the little things that will go missing.

★ Sweat the small stuff. The things to stash are CDs, DVDs, cell phones, jewelry and other accessories, cameras, small electronics like MP3 players or zip drives, and headphones.

Other Types of Parties

Perhaps you're not out to turn a profit or trick people into stocking your liquor cabinet but merely want to show your friends a good time. This section holds a few (hundred) ideas for old and new ways of doing that. A party doesn't have to be 50 people crowded into your kitchen drinking Kool-Aid and vodka out of plastic cups. It's any gathering of people, whether there is booze around or not.

Every party should have a purpose, or at least some sort of theme. Give your guests a reason to come and something to get psyched about. When given a choice between a regular party at someone's house and a "schoolgirls and truckers" theme party, which would you pick? Exactly.

Arts and Crafts

At an arts and crafts party, guests not only have an activity to do while at your house, they have a take-home gift to cherish for all time while thinking fondly of you. To keep the costs down, have guests bring most of the materials, while you provide the equipment (such as your oven or scissors) and the inspiration. It's hardest to plan for parties where everyone needs to bring something specific (Jane brings the glue, Dick brings the glitter), because if someone doesn't show up the whole project can go down the tubes. Instead, stick to crafts where everyone brings the same thing—a hat to decorate, a mug to paint, a pumpkin to carve.

Clothing decoration. It's fun to mangle your clothing when you do it in a group. Have everyone bring something to dye or decorate and something to decorate it with. Then put on your new outfits and go out to a bar and freak out the crowd.

★ Tie-dye. You provide the equipment, everyone brings a T-shirt to color and a packet of Rit fabric dye.

★ Iron-ons. Buy a packet of iron-on T-shirt transfer paper and have guests provide a shirt or other fabric item to decorate. Download images (use the Google images-search function for a good selection) from the Web and print them out on the transfer paper. Then heat up your iron and get to work. Just make sure you let the shirts cool before you put them on—you don't want to burn your nipples.

★ Bedazzler. Add some Reno-style pizzazz. Cut your shirts into fringe, glue on rhinestones, use puffy paint, and other fun stuff. Then put on some Van Halen and rock the party like it's 1982.

Record bowls: Hipster craft alert! You can turn old vinyl records into bowls in about 10 minutes. Get a bunch of records in the super-discount bin at the local thrift store. Then follow instructions you can find online; you need only one oven-safe bowl and an oven for this craft. Also get some 45s—they make great ashtrays. [Search Term: make bowls out of vinyl records]

Contest party. Everyone creates a drawing, painting, or other craft. Then hang them up and hold a contest for Best Use of Irony, Most Original, or other categories. The artworks could include:

★ Drawings or coloring-book art

★ Finger painting

★ Play-Doh sculpture [Search Term: make your own playdough]

★ Face painting or fake tattoos

★ Protest sign—making party. War getting you down? Host a party the night before the big protest and have everyone create signs and banners. If there's no current war going on, make up an issue to protest just for fun.

★ Kids crafts. Check out thrift stores and garage sales for old crafty games such as Spirograph, Shrinky Dinks, Lite-Brite, stuff like that. Put out a range of projects throughout your house for people to play with.

Holiday decorating: Holidays create excuses to do cheesy crafts.

★ Easter. Host a bonnet-decorating brunch or an Easter egg–painting party.

★ Xmas. Make popcorn garlands, popcorn balls, do-it-yourself stockings, snowflake-cutting art, Christmas cards, or ornaments. It's tacky, and you know you like it anyway.

★ Halloween. Have a pumpkin-carving party. Pumpkins can be pricey, so make sure your invitation says it's B.Y.O.P. List the nearest gourd stores to make it easy on your guests. Provide votive candles so that everyone can light their jack o' lanterns when they're done. Bake the seeds for snacks.

★ Valentine's Day. Have a card-making party. Or if that's too lame, make pipe bombs instead.

Warning: it's a bitch to get glitter out of shag carpeting.

Contribution Party

A contribution party is a theme party where the theme is "people giving you stuff you want."

★ Bottle and a glass. Everyone brings a bottle of wine and a wine glass to leave behind.

★ Wine and cheese. People love the idea of a good old-fashioned, high-society, snob-rific wine-and-cheese party. Guests bring one bottle of wine and one kind of unusual cheese. You provide bread, crackers, and maybe olives. Hopefully your friends are all lightweights, leaving plenty of vino and queso behind to feed your fancy lifestyle for weeks to come.

★ Finger Food. You must be able to eat it with your hands—no utensils allowed.

★ Desserter. Everyone brings a dessert to share. Then you all fall into a deep sugar coma.

★ Art salon. Guests bring along a drawing, painting, or other piece of artwork to decorate your walls. It can be coloring-book art or a thrift store purchase.

★ Plants. Plants make great decorations. And when you kill them you don't feel as bad as when you do a kitten in. Give guests enough time to take clippings from their home plants, let them sprout, and put them in a pot for you.

★ House warmers. Ask your guests to bring something to contribute to your home in a theme—a cup or glass, refrigerator magnets, posters, board games,

books, magazines, canned food, board games, cleaning supplies, whatever! Stick to one theme, though, or you'll get a big pile of garbage.

The Food-Making Party

Dinner parties are far too expensive and labor-intensive to host. Instead, have your friends bring ingredients to add to a group food project.

★Pizza party. Make the crusts in bulk in advance, and have everyone bring two toppings to adorn them with. Make the crusts small so that everyone gets their own mini pizza.

★ Make your own sundae. Guests bring one pint of ice cream and one topping. You may need to assign different toppings to different people to make sure you get whipped cream, sprinkles, fudge, butterscotch, cherries, and bananas.

★ Burritos or nachos. You provide the tortillas and rice. Assign your friends different things to put inside, like cheese, meats, sour cream, guacamole, salsa, onions, tomatoes, and black and refried beans. It's the same set of ingredients for nachos.

★ Sushi. This only works if your friends will buy quality fresh fish. You provide the rice, the seaweed wraps, the soy sauce, and wasabi. Everyone brings fish, cucumbers, tofu, and the other ingredients. (And a bottle of sake, of course.) Give a rolling demonstration and let the crowd give it a shot.

[Search Term: roll your own sushi]

★ Soft pretzels. These are not only easy and fun to make, but the ingredients are dirt cheap. You just need yeast, flower, salt, sugar, and eggs. Your guests won't have to bring anything. Mix up the dough, then have everyone knead it into shapes before baking. It's like arts and crafts that you eat! Tell your guests to bring fancy beer instead.

[Search Term: soft pretzel recipe]

The Swap Meet

At a swap party, everyone brings similar items to trade. This works best when all of your friends are just as poor as you.

★ Clothing. If you're sick of your old clothes and are about to donate them to the Salvation Army, throw a trade party instead. Everyone puts their clothes in a big pile and then you can battle for the good stuff. For an upscale variation on this, see Chapter 3.

★ Porn. You can pretend you don't own any and be stuck with the same material forever, or you can get together with your liberated friends and trade. Bring magazines, videos, and DVDs to swap.

★ Movies, music, and books. You know how you bought that Queer as Folk Season 1 DVD that you'll never watch? Or how you have all those books that you already read? Or those CDs you've been planning to sell back to the used record store for a third of their value? Everyone has a collection that can be thinned out. You may as well get a fair trade on your stuff rather than a raw deal selling them to used record shops or bookstores.

Outdoor Parties

If you live someplace urban where your patio, lawn, or other outdoor area makes you special, host a barbecue or garden tea party, giving your friends a chance to see nature while also getting shitfaced.

★ Beware the barbecue. Even if your friends bring salads, meats, and drinks, there are still tons of basics at a barbecue that the host has to provide. You'll need the grill; charcoal and lighter fluid; spatula and grill brush; condiments like ketchup, mustard, and relish; plates, cups, and napkins; and ice. Also, nobody ever remembers to bring rolls for the hamburgers and hot dogs, so you'll need those too. Barbecues are fun, but make sure you can afford it before you send out the invitation.

★ Sangria! In the summer a big vat of sangria is the perfect daytime drink. If you instruct your guests to bring cheap wine to contribute, you can take care of the rest. Buy lots of fruits like limes, apples, lemons, and other fruits to put in it. Cut them all up that morning and leave them to soak in a starter bottle of wine. Sangria is also a great drink when you don't want your guests to stay very long—it makes people sleepy after two or three servings. And you get to keep the unused booze.

[Search Term: "sangria recipe"]

Theme Parties

Parties with themes are better than parties without themes. Costumes make great conversation pieces. Decorations hide your cinder-block furniture. And when everyone looks stupid, you can all lighten up and have a good time.

★ Boring-people parties. If your friends are stuck-up snobs and won't dress up, make the party something snobbish in theme, like a high-society party (so they can wear that suit they love), a black-tie party, an opera party, a black-and-white ball, or something along those lines.

★ Party-themed parties. You may not be able to afford the airfare to Carnaval, but that shouldn't stop you from celebrating it. Host a local version of Mardi Gras, summer in Ibiza, the Love Parade, the Republican National Convention, or foreign holidays like Bastille Day or Burning Man.

Dress-up ideas. In seventh grade we learned that the face paint the boys wore in The Lord of the Flies was a mask behind which they could become anonymous savages. In your apartment, a costume is a mask behind which guests can become raging drunks.

★ Cowboys and Indians. But why does everybody choose "cowboy"?

★ Circus Performers. Anyone who doesn't come in costume has to wear clown makeup.

★ Kings and Queens. Sponsor a make-your-own-crown contest.

★ Sailors and Soldiers. Make sure to play "In the Navy" by the Village People at least once.

★ '70s, '80s, '90s, Last Year. Remember when life was simpler and gas cost a nickel and the grass was greener and unicorns roamed the land?

★ Rock Stars, Groupies, and Paparazzi: Any excuse to wear leather pants.

★ Authority Figures. Go as a strict teacher, a nun, a coach, a senator, a dominatrix, or a newscaster.

★ Wig Party or Hat Party. Everybody wears one. The best gets a prize.

★ Opposites. Dress as your opposite, either in mind-set or in gender. Everybody loves a tranny.

★ White Trash. Go back to your roots.

★ Hookers and Pimps, Bimbos and Himbos. In a perfect world, we'd all be skanks.

★ Prom Party. Have "The Time of Your Life" all over again.

★ '40s party. Bring your own 40-ounce beers that will get warm before you finish them.

★ Party Animals. Dress as your favorite creature and practice some interspecies make-out.

★ Jocks and Cheerleaders. Dress in protective gear and give out medals for what your guests would win the gold in. (Mine would be "Getting People to Buy Me Drinks.")

★ Sports Events. There are plenty of other party-worthy sports events besides the Super Bowl. Throw a Kentucky Derby day as an excuse to drink mint juleps; have everyone wear big fancy hats and place offtrack bets. Or feast on strawberries and champagne at a Wimbledon-watching mixer and dress in your best tennis whites.

Kids parties. Regress to your childhood with one of these:

★ Back-to-School or Naughty Schoolgirls. The drunkest guest has to wear the dunce hat. Put out a chalkboard for doodling or host a "What I Did This Summer" essay contest.

★ Teenage boys party. Borrow a video game console like Nintendo or Sega. Eat sugary junk food and stay up late. Sleep in the living room and watch bad soft-core movies from the early 1980s.

★ Pajama party. Wear your jammies to the jammy-jam. Or make it a teenage girl sleepover and do facials, paint your nails, and talk about what jerks boys are. Note: Prank calling doesn't work in the age of caller ID.

★ Summer camp. Serve s'mores toasted over the oven and pop some Jiffy Pop. Everyone can tell scary stories about their time in rehab.

Old-people party. Celebrate the quick descent into senility while wearing your polyester slacks. Everyone brings ingredients for 7-and-7 s, manhattans, sidecars, and whiskey sours.

Performance party. Everyone takes turns being the entertainment.

★ Artists and Poets Salon. Everyone in black berets! Guests bring a piece of their art to hang, or a poem or story to read.

★ April Fools' Party. All guests have to tell their favorite joke.

★ Karaoke. Download songs in advance and print out the lyrics to save yourself a rental on a machine.

'Tis the season.

★ Throw a fall harvest party with spiked hot apple cider. Also, bob for apples in the sink.

★ Or how about a spring party to lighten the mood at the end of winter? Decorate with prominently placed plants and have everyone wear green.

★ Opposite Seasons—throw a spring break party in winter. Turn up the heat, have everyone wear shorts and Hawaiian shirts, and make tropical drinks. Or throw a winter sports party in the hot summer. (You'd better have air-conditioning, though—nobody wants to wear a ski jacket when it's 80 degrees out.)

★ The anti-party. Every year someone throws an Anti-Valentine's Day Party. How very. Do something different with an anti-Christmas party, anti-Irish party for St. Paddy's Day, or a Motherfucker's Day party.

Multiple-space parties. If you live in an apartment building, dorm, or apartment with several roommates, create a theme that can be tweaked between each room or unit in the building.

★ Colors. Each unit picks a color as its theme. One apartment is the Blue Room, serving blue foods and blue drinks. And so on.

★ Countries. Go international with an around-the-world party. Each room takes one country to represent with drinks and decor. Enjoy vodka in the Russian room and rum in the Puerto Rico.

★ Movie themes. Choose a movie with several different settings and build a party around that. At a Wizard of Oz party you can have rooms for the Emerald City, the Lion's Jungle, Tin(foil) Room, a Gothic Witch Room, and so on. Other movies with potential are Charlie and the Chocolate Factory, Barbarella, and Alice in Wonderland.

Getting Ready: Party Preparation
The Invitation

Now that you've chosen a theme, occasion, or other reason to throw your party, you've got to make sure that everyone knows about it, people actually show up to it (but not too many people), and that they bring some booze along so that it doesn't end up looking like an intervention instead.

Handouts

Make flyers for invitations when these three conditions are true:

1. You don't know how to contact people electronically. If you have email addresses for everyone you know, you can get the word out and save a tree. But if you have a lot of casual acquaintances that you see out at the bars, clubs, shows, and elsewhere, a flyer is the best way to give them the 411 without trying to yell it over the band.

2. You don't care how big the party gets. Putting your address and other information on a flyer doesn't mean that you're going to pass it out to random strangers, but there is certainly a better chance that random strangers will show up.

3. It's B.Y.O.B. You can't afford to get the whole town drunk.

Put not only your address and cross street on the invite but also your phone number; if someone forgets the address or can't find it, they can call. Then if someone does, make them bring something extra: "Hey, can you do me a favor? Can you stop by the store and pick up some cranberry juice on your way?" What are they going to do, say no?

What to Include

★ Don't forget the obvious: your name, the location with cross street and apartment number, the date and time the party starts, and the occasion for the event.

★ Make it pretty. A better invite will get a bigger, better crowd. "Party at my house on Saturday" typed hurriedly on an email does not entice people to dress in costume, to bring you presents, or even to bother showing up. Use graphics.

★ If you want people to bring friends, say so.

★ An introduction makes a difference. "On the occasion of this Saturday, on the ides of March, Emperor Camper English invites you to a celebration of the loyalty of friendship at his Imperial Court Toga Party. Please bring a bottle of your favorite poison with which to spike the punch bowl."

★ "Costume required" sounds a little heavy. Instead, scare people into submission. "Though costumes are not required for admission, anyone without one will be forced to wear the guest sweater/cleanup/endure endless ridicule."

★ Say "B.Y.O.B." without saying "B.Y.O.B.":

"Please bring a beverage to share."

"Bring a bottle of something to add to the punch."

"I'll provide the mixers, you provide something to mix with them."

"We'll put out some starter hooch, but please bring some to add."

"Don't show up empty-handed, bitch!"

Setting Up
Sizing Up

To throw a big party in a small space:

★ Move all the non-seating furniture (like the television and CD rack) into one room, like the bedroom. Back all the seating up against the walls to make more room.

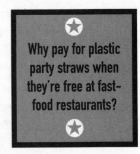

Why pay for plastic party straws when they're free at fast-food restaurants?

★ Establish a coat chair or closet instead of the bed so that people use the bed for seating.

★ To make your bed seating-friendly, put one or two chairs facing it so that everybody isn't looking in the same direction.

★ Clear out the kitchen. Everyone always hangs out in the kitchen.

★ Put all your knickknacks and keepsakes away to create more surface area for drinks, snacks, and ashtrays.

★ Or have the party at a friend's place. Unpopular people with large apartments are practically begging you to use them.

★ Start the party early so that people come and leave in shifts.

Music, Please

Prepare your musical mix in advance. Pick out your favorite party tracks and burn a bunch of CDs in the week before the event. Throw in a few crowd-pleasers in between your hipper-than-thou hits.

★ The night of the party, put away all your CDs except for the ones you wouldn't mind hearing. The last thing you need is some drunk indie-rock nerd pawing through your collection, playing unlistenable B-sides, and mixing up the jewel cases. (I hate that guy!)

★ Or if you have a friend with better taste in music than you, ask her to take DJ responsibilities for the night. Music geeks think this is a great honor, even though it requires them to stay chained to one spot for the whole party.

★ If you trust your guests not to spill drinks on your keyboard, download songs to a jukebox program, then let them pick the tracks they want to hear. This only works when you have a good set of speakers hooked up to your computer, but it's fun and interactive.

Live and Direct

Live bands are tricky to plan for, but they can turn a party that rocks into one that rawks. If you've got friends in a group looking for exposure or who owe you a favor (because you so can't afford to pay them), let them play—provided you plan for the following:

1. Bands take up a lot of space, not just for themselves but also for their instrument cases, speakers, and groupies. Your studio apartment is not big enough.

> ### ★
> ### Filler Friends
> Tell a few of your best friends to come early to help you set up. Then you'll have some filler people there so that you're not sitting there freaking out by yourself, wondering whether anyone is going to show up while you're drinking all the liquor to calm your nerves. You do want to remember your own party.
> ### ★

2. They need a lot of electricity (unless they're acoustic), so you must live someplace with an electrical system that doesn't blow out when you blow-dry your hair.

3. If the band knows how to rock, chances are they also know how to drink. Make sure your party is more of a kegger rather than a polite gathering so they won't drink you dry.

4. A live band will make your party be louder and more likely to get busted. Book a band at a loft in the warehouse district, not in an apartment above an old lady.

The Bathroom

★ Take your good prescription drugs and embarrassing hemorrhoid creams out of the medicine cabinet.

★ Light the bathroom with candles—scented, if you have them. These provide

good lighting, hide how dirty you left the bathroom, and aren't anywhere they can accidentally burn down your house.

★ Leave a pack of matches sitting next to the candles. The sulfur in matches masks bad smells, so if a guest creates one, hopefully he'll have the sense to light a match. If you have room-deodorant spray, leave it out. A glass of white vinegar also helps to absorb smells, but you run the risk of a guest spilling it or drinking it.

★ Any shower towel you leave in the bathroom will become a hand towel or spill towel for your guests. Stash them in your bedroom, unless you want to do laundry the next day.

★ Put out plenty of toilet paper.

Mood Lighting

★ You want to keep the lighting low enough so that none of your guests is tempted to pull out a book, but not dark enough so that they couldn't read a CD cover if need be. That means no overhead lighting unless you have a dimmer.

★ The kitchen should be the only semi-bright room so that people can tell they're not mixing a Drano-and-tonic.

★ Beware fire hazards. If all your guests have to remember your party by is the charred remains of what was in the coatroom, they're going to be pissed. Never try the "scarf over the lampshade" trick with those $10 halogen lamps—they're notorious for catching things on fire. Don't put candles near anything that burns, nor anywhere there's carpet. (Your carpet won't catch on fire, but it's a bitch to get wax out of it.)

★ Colored light bulbs cost less than new lamps, and you can now find them in 99-cent stores. They work in the bathroom and anywhere you have overhead fixtures to tone down the white light.

> ★
> ### Ice, Ice, Baby
> Don't buy bags of ice when you can make it for free in your freezer. Start a week early and keep dumping the cubes into plastic freezer bags. By the time the party comes around you'll have plenty.
> ★

Miscellany

★ Check, please. You'll need a place for people to drop their coats and bags. Normally it's your bedroom, but if you're tight on space and the party is small, you can designate a chair. For big events clear out a hall closet, put in hangers, and leave the door open for guests to hang their coats.

★ Trashy. Put out big trash bins, and leave the box of extra trash bags some-

place visible like on top of the refrigerator. Also put out a box for recycling next to the trash and put in a starter can.

★ Prepare to Get Dirty. Also put out paper towels and any dish cloths, rags, or sponges so that guests will clean up their own messes.

★ Ashy. Decide where you'll allow smoking—only outdoors, in one room, or everywhere. Put out ashtrays in those areas and spread the word.

★ Bzzzt. If you live in a multiunit building and don't want guests accidentally ringing your neighbors' bells, put a small indicator by your buzzer, like a piece of tape with your last name on it. You probably don't want to write PARTY on your door-bell or you'll have the whole neighborhood up in your crib.

Save on Starter Drinks

Even if you've clearly labeled your party B.Y.O.B., you've gotta have some sort of starter bar out so that it doesn't look like a church meeting when your guests arrive. But that can get expensive really fast. You need a couple of bottles of booze, enough mixers for the whole party (nobody remembers to bring them), cups, and ice at the very least. It's hard to get started for less than 50 bucks, and it's easy to accidentally spend $100. Here are some ways to bring those numbers down.

A Bad Mix
If you've got a friend who's a DJ (and really, who doesn't) who will come play, make sure you set up the turnta-bles somewhere high enough where no drinks will be spilled on them. Vinyl and vermouth don't mix.

★ Your starter booze at the very minimum should include a bottle of vodka. (And you need something to drink while you wait for people to show up.) Next should be a bottle of gin, followed by rum or whiskey. If you're planning a big blowout, feel free to buy low-quality booze. After the good stuff (that other people bring) is gone, guests won't be too uppity to chug directly from the plastic bottles lying around.

★ It's super ghetto, but nobody will know you're doing it, and that makes it OK: Water down your own liquor so that it looks like you put out more.

★ Buy the mixers in bulk. Juice at the corner convenience store costs four times what you'll pay in the grocery store. Mixers should include, in order, tonic water, cranberry juice, and orange juice.

★ Instead of buying fresh juice in the carton or bottle (at 4 bucks apiece), buy it frozen. Pick up some pitchers at the dollar store to put it in or save up empty bottles to use before the party.

★ The cheapest mixer of all is Kool-Aid. It costs about 10 cents per packet, plus sugar at about the same price. The flavors that mix the best with booze are ones that are supposed to taste like real juice—cranberry and lemonade.

★ To avoid spending on mixers at all, tell people to bring beer. Specify that on the invitation: Ask people to bring "beer," "a 40," or "a six-pack," not "drinks" or "booze." Clean out your fridge to make room—if you can't provide orange juice, the least you can do is provide room to keep the beer cold. Also, fill up the sink or a cooler with ice to make easier access.

Punch Me

The least expensive way to provide starter booze is in a party punch. You'll save both on mixers that you don't buy and the dirt-cheap liquor you put in it—nobody sees the ingredients if you make it in advance.

★ Use a large spaghetti pot as your punch bowl. If you don't have one, look for punch bowls in thrift stores. Or pick up a new bucket from the dollar store and wash it about 30 times before you use it. The bigger the bowl, the better, as you won't have to keep adding stuff to it all night.

★ To make the punch, start with Kool-Aid and frozen orange juice. Use a dark-berry flavor of Kool-Aid: People are less likely to drink blue punch than red. The OJ gives it texture.

★ Lemon, lime, and orange slices floating in the punch make it look fancy, yet they'll cost about a buck total.

★ Then add vodka and/or rum to the juice. Initially, make the punch weak with your low-quality liquor. (Hide the bottle afterward.) As guest arrive, tweak the mix by adding their liquor to increase the strength.

★ Don't be shy about trying new combinations. White liquors work well together in a punch—vodka, triple sec, rum—but sometimes you can get away with adding whiskey or tequila as well, if that's all you have around.

Tropical blender drinks sound like a great idea for your tiki-themed party, but the reality is not so sunny. The average blender only holds a few cups' worth of booze, so making it the main attraction will ensure that you're trapped in the kitchen all night blending up batch after batch of it. Frozen blender-ready drink mixers are delicious but crazy expensive. If you want a tropical drink theme, you're better off with margaritas on the rocks.

If the party is small, use regular glasses rather than disposable cups. You'll be helping to save the environment and a couple bucks that you can better spend on hangover cures. At a larger event, leave out a black Magic Marker next to the cups for people to write their names on them. It will save on repeat cups when people lose them, and they'll also double as name badges to make guests' introductions easier.

★ If you screw up and create something that tastes nasty, you can fix the punch without adding more of your precious liquor. Sugar will cure most punches' problems. Just dump a bunch in until it's sweet enough to overcome the flavor. If the punch is too sweet already, take it down a notch by adding orange juice, cranberry juice, or tonic water. Even wine works to tone down a sugary punch.

★ Colder punch tastes better. Keep it in the refrigerator or freezer until the party starts.

Party Mix

Not only do party snacks keep the guests happy—they also prevent some of them from throwing up.

★ Popcorn is dirt cheap, and you can make it in advance. Get the kind you can pop in bulk on the stove or in a microwave popcorn popper (if you can still find one)—it's far cheaper than the microwave stuff in the bag. Even if you decide to buy it rather than pop it at home, it only costs a few bucks for a bag the size of a potato sack.

★ Other cheap snacks are pretzels and tortilla chips, available in super-bulk sizes from the MegaGigaMart. Should you decide to serve salsa with your chips, make it yourself or buy it in the gallon jug. Anything small and gourmet is a rip-off—what do they think is in that stuff, diamonds?

★ Place bowls of your snacks throughout the party rather than just in the kitchen. Everyone crams in the kitchen, so putting snacks elsewhere may help ease congestion.

★ If you're going to go all fancy and put out a variety of foods, learn to present them attractively. You'll find better tips online than I can give here.

[Search Term: "party food presentation"]

★ If you make delicious hot snacks, be sure to make a lot of them. If you tempt people with a few treats, they'll ransack your kitchen looking for more.

Mr. and Ms. Clean

A spotless apartment may impress your anal-retentive friends, but you'll have to clean it a second time after the party is over anyway. Save time with a combination of low lighting and a cursory cleaning of the top surfaces.

It's easiest to clean up the kitchen before the next morning. At least collect all the bottles and put them into the recycling bin, stack up the glasses by the sink, and put the trash into the trash. Try to mop the kitchen floor that night—no matter how drunk you are, the process will be easier when the beer spilled on it is still wet. The next morning the spills will be hard and sticky and you'll have a hangover. Let the people on crystal meth help you clean up—they'll do a thorough job.

CRASHING OTHER PEOPLE'S PARTIES

At a great party you get free booze, food, entertainment, a scene, and perhaps even a dance floor on which to shake your moneymaker. Of all the forms of free entertainment in this book, you have to put the least effort for the most benefit at parties. But what do you do when you're all dressed up with no place to go?

Though there are people who crash parties to drink the place dry, eat all the snack food, and hassle the other guests, those people are called "assholes." When you crash a party you should always bring something to it—if not beer, then at least a good attitude. It's about joining the fun, not pillaging and burning. At some self-invited soirées you win, thanks to a good crowd and a good party. And at others you get icy stares from the yuppies before they throw you out. Treat it like a game—sometimes you score, sometimes you commit a party foul.

Where da Party at?

You'll find parties ripe for the crashing in student neighborhoods (when you're of college age), and they're easy to sneak into since half the people don't know each other anyway. But there are always other party parts of town in urban areas. They're usually located a block or two from a street with a strip of trendy bars on it.

Walk around and keep your ears open for the sounds of the thumpa-thumpa-thumpa of the DJ and your eyes peeled for party people. They'll be looking at the street numbers and probably carrying a brown paper bag from the liquor store. Follow them to the source.

"I'm With the Band"

Try to blend in right away. If you've followed someone inside, talk to them on the way through the door and everyone will assume you came together. If

you entered on your own, walk up with a big smile to someone right away. Introduce yourself and be overly friendly. Engage that person in conversation, turn that into introductions to other people, and soon you'll know more people there than the host.

If you get questioned in a suspicious way, tell them that you're meeting your friend there. Choose a name for your friend that's common where you are, like Chris or Amy (or Ashley or Dakota). If they get all "Who the fuck is that?" about it, you can always pretend you were mistaken: "Well, I sure hope it's the right party. She said it was at 16th and Valencia. Isn't this Steve's house?"

OTHER PARTIES YOU CAN CRASH

Not having an invitation to a party is no reason not to go to one. You're a social juggernaut, after all, and a welcome addition to anywhere you happen to be. With that attitude in mind, you can walk into other people's parties and drink their booze.

Wedding receptions are not always that fun, but they often have an open bar. Just put on some nice clothes (and by "nice," I mean "uncomfortable") and hit the nearest rental hall. There are venues in every town that hold receptions every weekend—search online and several will pop up. There is usually a sign outside with the bride and groom's names on it—memorize that and you'll be able to talk your way through the door even if there is a guest list. Say you're a friend of the groom's from work, or that you flew all the way in from Dallas so you're positive your name should be on the list someplace.

[Search Terms: "rent wedding reception" YourTown]

Working in teams is a great way to get free stuff. If you've got a temp job at a convention center and can make a fake pass for your buddy, she can go in, collect a bunch of freebies (usually a tote bag, a ton of pens, paper, T-shirts, and maybe some software if you're lucky) and you two can split the loot.

Likewise, your caterer friend can call you from his cell phone and tell you if he's working at an open-bar party, industry event with take-home samples, or fund-raiser with gift bags. Hotel staff may have a good line on private events and dinners. Anyone who works in arts nonprofits can put you on the fund-raising events list.

Other corporate or entertainment events, like movie premieres, launch parties, employee appreciation nights, fund-raising parties, or retirement

brunches happen by the hundreds all the time. These are not so hard to crash—the hard part is knowing when and where they are. Rooms in hotels and convention centers, or conference rooms at office buildings are easier to get into than those you enter from the outside door. Once you're inside the building, people assume you're there for the party and don't check ID.

[Search Terms: "available for parties" YourTown]

[Search Terms: "venue rental" YourTown]

[Search Terms: "event rental" YourTown]

At corporate and private events they'll either have a guest list, which they might not check if it's a shindig they don't think anyone is going to crash (like the North Dakota Accountants Society), or else they'll ask for your employee or conference guest badge at the door. Pretend to be a bumbler who forgot to bring his ID. Tell them you left it in the hotel room or rental car. People who work the door at these events hear this excuse all the time, and they're not good at saying no.

If the person in charge of the list has a computer terminal in front of them, you'll have to use someone else's name to get in. Before you hit the door, memorize the name of the hotel where you're staying (the closest one to where you are) and the name of a guest. You can read that off someone else's badge or off a sign displaying the featured speakers in the lobby. "I left my badge in my room at the Radisson. I'm Joe Accountant, I spoke earlier today."

> ★
>
> Think of the host's medicine cabinet as a way to get to know her better. Does she have a problem with nerves that requires a Valium prescription? A toothache that necessitates Vicodin? Back problems that lead to muscle relaxers? Too bad for her but great for you. You might come out of the bathroom with a new understanding of your friend and a couple of capsules for an off night.
>
> ★

Corporate Christmas Parties

Company holiday parties are an easy score for drinks because everyone is so chock-full of Christmas spirit they let their guards down. Many times, these events take place in smaller rooms or parts of restaurants and bars. If you're in a bar and you spy a private party happening, go make friends with one of the drunks waiting for the restroom. It will be easy to convince her to buy you a shot when she's not paying for it.

Street Fair Parties

During every street fair, people who live above those streets throw parties. You always see them all hanging off the fire escape hooting. Keep looking up and try to catch people's eyes, and eventually you'll get invited to join in the fun. And because it's a spur-of-the-moment thing, nobody will mind that you didn't bring anything to share.

General Door Strategies

For other high-profile nighttime parties, celebrity events, private restaurant functions, and at some nightclubs you can avoid the front door security altogether. Find a side door, knock on it, and hope someone opens it. Tell them you went out for a cigarette and got locked out. Once you're inside, people will assume you belong there and will be too embarrassed to make a scene kicking you out.

Where's the Last of the Beer?
★ In the vegetable crisper of the fridge
★ In the freezer (liquor bottles)
★ On the side of the couch in a bag

Some crafty partyers in New York and L.A., where there are tons of celebrities with entourages and paparazzi around, invented the glom-on approach. When someone famous begins to walk in through the velvet ropes, stick close to the celebrity or attach yourself to her party. The security won't want to pull you off Madonna and involve her in an incident—they're more likely to give you the benefit of the doubt and let you in.

HOW TO B.Y.O.B. WHEN YOU'RE B.R.O.K.E.

When it's the end of the month and you can't afford basic necessities like hair dye, let alone a $40 bottle of Belvedere for your friend's fancy party, you don't need to stay home crying about it and drinking the mouthwash. Just get a little creative with what you bring along.

If you can't afford (or don't want to bring) a whole liter of Grey Goose, go with novelty liquor. Choose something at the store that's cheap and that you've never heard of. If nobody knows what the heck it is, nobody will know that it only cost $3.75. And though it may taste like ass, it will still make a good conversation starter.

With advance planning, you can show up with something that will actually impress rather than confound your hosts. Make infused vodka at home—it's as easy as dumping some berries into the bottle and letting it sit for a few weeks. Do this with a jumbo jug of vodka and split it into smaller jars later to take to individual

A gcod place to stock up on novelty booze is on your way back from vacation. Buy liquors with foreign labels on them. Suddenly you're no longer cheap; you're exotic!

parties. Make sure to leave some berries (or coffee beans or lemons or whatever) in the little bottle for maximum visual effect.

[Search Term: "make infused vodka"]

On the other hand, if you're hitting a party where you don't know if you need to contribute a cocktail beverage, bring something but don't whip it out. Buy a bottle or six-pack and put it in your backpack rather than leaving it in the liquor store bag. Scope out the situation when you arrive at the event. If there is enough to go around, leave yours in the coatroom and take it back home when you leave.

CHAPTER 5★

Getting Trashed Without Spending Your Cash

Alcohol is a magic potion sent from heaven to cure the ills of the world. It can lower cholesterol, reduce the risk of heart disease, and possibly provide protection against stroke, gallstones, and type 2 diabetes. It also decreases the pain and suffering caused by falling down after getting too drunk. But don't go get wasted for the health benefits alone.

When used properly, booze also lowers social and physical barriers to meaningful interaction, such as inhibitions and underpants. It increases communication, however slurred the words might come out. It makes smart people act dumb, and dumb people think they're geniuses. In short, everyone wins.

That's not to say that there's no downside to drinking. Beer isn't free, after all. The cost of drinks is often the largest portion of your dinner bill or your night out. Moreover, with too much boozing your recreation (getting drunk) can become an occupation (being a drunk), and that's not a wise career move.

Alcoholic excess can also turn bad in the short term. Booze comes in many flavors, colors, and strengths, and none of them is any fun to throw up. You can have too much of a good thing.

In this chapter you'll learn when and where, who with, and how to reduce or rid yourself of the cost of getting drunk. Knowing when to call it quits is an exercise left to the reader, but whenever you retire for the evening, the advice here should ensure that you have enough cash in your wallet for the cab ride home.

★ **Always drink responsibly—liquor is expensive.**

WHEN TO DRINK
Early Bird Special

The sooner you start drinking, the better, because happy-hour specials only run until 8. Practically every bar open during after-work hours on weekdays sponsors some kind of drink special. And after a whole day toiling for The Man, you deserve a refreshing beverage at a bargain price.

The standard happy-hour special is something along the lines of all domestic beers on tap for 3 bucks and all well drinks for 4, but don't let that limit you. Different bars have different happy hours depending on their needs.

Basic Bar Vocabulary
Well drinks are
the cheap liquors that
are kept beneath the
bar ("in the well").
They're what you get
if you don't specify a
more expensive,
name-brand liquor.

Top-shelf drinks
are the ones kept on
the top shelf, of
course. The most
expensive liquors go
on the top, and they
decrease in quality
and price on the way
down to bar level.

Double Happy
Some strip clubs have
midweek happy-hour
specials that combine
low drink prices with
full frontal nudity.

★ Trendy restaurants have $2 cosmopolitans when they're normally $8, to get people in the doors before the 8 P.M. early-seating time.

★ Dance bars (bars that host DJs) extend their happy hours until 9 or 10 at night to attract an earlier crowd to their dance nights.

★ Venues known for a full range of complicated cocktails advertise specials on drinks they can make fast and sell by the bucket. Where most people order five-liquor blended drinks, they'll sell single shots for half price.

Cater your search to your drinking habit. There are no discounts on premium liquors in many bars, so if you only drink from the top shelf, look for the place with "$2 Off All Drinks" or something similar. The same is true if you prefer microbrews to macro, or wine to anything.

[Search Term: "best happy hour" YourTown]

[Search Term: "happy hour special" YourTown]

[Search Term: "happy hour" YourTown]

Though seeking out the best after-work drink prices is a noble and rewarding personal project, this task, like laundry, is often best left to other people. There are great resources for happy hour and other bargain booze locations in drinking club mailing lists. In most urban areas there are both happy-hour drinking groups and dive bar clubs: Their members are experts in finding cheap or free booze and open-bar special events. Generally they use a Yahoo! group or other email list service to send out announcements. All you need to do is search through their online archives for hidden deals.

[Search Term: "happy hour" "drinking club" YourTown]

[Search Term: "dive bar" "drinking club" YourTown]

[Search Term: "drinking group" YourTown]

Even if you start out a little late, ask about the specials ("Is it still happy hour?"). If you're 20 minutes past the cutoff, most bartenders will still give you the discount. They get the same amount in tips, so what do they care?

Liquid Lunch

Food, schmood. Who eats? While upscale restaurants try to rip you off with inflated drink prices, downscale eateries use booze as a way to lure you in. A beer in a taqueria or sandwich shop usually costs less than in a bar, and nobody says you have to order a taco or sandwich. Pizza restaurants, bowling alleys, and other sporting centers sell cheap pitchers of beer, even if the only sport you compete in is competitive drinking.

Beyond that, a surprising number of restaurants have their own happy hours that run later than those in bars. A 24-hour diner has the best deals because nobody eats there until they're drunk. In the same place they charge 8 bucks for an after-hours burger, they're likely to have $2 beers until 10 P.M. Check out the diners you never set foot in until 3 in the mornin, but go five hours earlier to see what's on special.

Warning: $1 beer specials are often too good to be true. Make sure they're serving them out of a pint (rather than a shot) glass.

Brand Recognition

Liquor companies spend millions of dollars a year to sponsor everything from happy hours at upscale bars to club nights to art shows to sporting competitions to corporate networking events, all in an effort to achieve name-brand recognition. All you need to recognize is that a liquor company's logo on an event ad or flyer means there will usually be discounted drinks there.

Warning: $2 off a $10 brand-name cocktail is still more expensive than getting the well version.

Whenever you see an ad campaign for a liquor company, go to its website and look for the email sign-up list. (Magazine ads will have the website address—flip through them with your browser open.) Once on the list, you'll get invites to free parties sponsored by that brand. Makers of scotch and other whiskeys in particular tend to throw tasting parties where you can get super drunk for free.

Go Corporate

Large corporations specialize in keeping down the poor, trashing the environment, and influencing politics. But every so often they throw events with free liquor, and that makes it all OK. One such event is the recruitment drive. When businesses are desperate for skilled or specialized workers, they'll try to get them drunk enough

to agree to do their evil bidding. Attend these recruiting events if you see that an alcohol company cosponsors it or that "refreshments will be provided." International corporations trying to hire for high-end positions are the most likely to put out. You know that Local Textile Slaver Inc. won't be giving out complimentary Coronas, but perhaps International DrugCorp will.

[Search Terms: "recruitment fair" YourTown]

[Search Terms: "recruitment drive" YourTown]

[Search Terms: "hiring fair" YourTown]

You can also ferret out free drinks at industry mixers. You'll have to pretend to be an anesthesiologist or attorney or whatever, but the lying gets easier the more you drink. Again, there's a better chance of complimentary hooch if an alcohol company cosponsors the event. Read up on your legal vocabulary, put on a suit, then go schmooze for booze.

[Search Terms: "networking mixer" YourTown]

[Search Terms: "industry mixer" YourTown]

Better Than Cake

Many bars will give out a free shot of something special on your birthday, especially if you bring in friends to help celebrate. It may be a bit ambitious to make a fake ID for each day of the year, but there's no reason you can't hit 15 bars in one night on the one day of the year you're telling the truth. Keep moving from place to place and see what you can score.

Good Art, Bad Wine

Tradition dictates that art show openings at private galleries serve free, low-caliber wine and expensive cheese to attendees. The rock star lifestyle dictates that you go suck down as much of it as you can. Art openings are fun and social and give you the chance to mingle with interesting people in bad clothes and haircuts. Make friends with artists—most of them are poor and very good at getting stuff for free. They make excellent allies.

Get on the mailing lists of every gallery in town and you'll be able to hit an opening more than once a week. (Multiple-artist shows tend to have better food and drink options, so give them preferential treatment.) In addition to joining galleries' email lists online, stop into each one as you walk by—they all have mailing lists disguised as guest registers.

[Search Terms: "art gallery" YourTown]

[Search Terms: "art dealers association" YourTown]

Now Open (Bar)

An opening isn't a Grand Opening unless there's an open bar. Keep an eye out for new or refurbished entertainment venues such as clubs, bars, and restaurants. If you can get an invite to their debut soirées, you'll most likely eat and/or drink for free while you get a first look at the space. These events are meant for press and influential VIPs, so they're not all that easy to find out about. But these places often team up with nightclub promoters and DJs who do have email announcement lists, and that's where you're more likely to learn about open bars. So even if you hate disco, you do like drinking, and that's reason enough to sign up for disco DJ lists.

Score!

You don't need to know a scrum from a scrimmage to score beer specials on game nights. Many neighborhood bars (not just sports bars) show playoff games near the end of each season and sell half-price pitchers of beer and other specials during the event. If you don't care about sports, seek out the venues with back rooms where you can get away from the jocks while drinking Jack on the rocks.

Busted

Events known as "beer busts" are simply keg parties held at bars and other outdoor festivals. You pay at the door for a cup or hand stamp and drink unlimited beer in the time allowed. The beer is usually a cheap American brand, so it's not a good investment if you only drink microbrews. But if you're not so picky, you can get ripped for under 10 bucks. Beer busts are most common in gay bars on Sunday afternoons, but hopefully they'll catch on everywhere. Liquor busts (an open bar with a paid admission) are far less common and much messier when they happen.

[Search Terms: "beer bust" YourTown]

[Search Terms: "liquor bust" YourTown]

Fabulous Finales

In sports bars, you'll find free food at events like the Super Bowl, Final Four, and the World Series. In gay bars, they put out the classy snacks for the Oscars, Grammy Awards, Emmys, and Golden Globes. The best spreads will be in the tackiest gay bars (the ones that host drag shows) and video bars. Also check them out during television season finales for whatever is the gayest show on television at the time—be it Sex and the City, Queer Eye for the Straight Guy, or The Bachelor. Even if there is no free buffet, television is always better with sassy crowd commentary.

★★★★★★★★★★★★★★★★★★★★★★★★★★★★★★★★★★★
Ways to Avoid a Hangover

★ Drink better liquor. Top-shelf booze will cause you less harm than the cheap stuff.

★ Get it on the rocks. The mixer contributes to the hangover.

★ Drink liquor with the least congeners. The darker drinks like bourbon, brandy, rum, and single malt scotches are the worst. Red wines are worse than whites. Vodka and gin—clear liquors—are the best.

★ If you have a queasy stomach, don't mix your liquors. It can come back to haunt you later.

★ If you're planning an epic night, pace yourself by getting a glass of water between every drink. You'll still get hammered but not feel so hungover the next day.

★ Drink tons of water before you go to bed. Sure, you'll have to get up and pee a lot during the night, but it's better than calling in sick to work. (Save your sick days for vacations.)

★ Eat before you go out. Not only will the food help you absorb alcohol at a slower rate, you'll be too full to drink too much too quickly.

★ And/or eat after drinking and before bed. Your choice of dinner should be high-protein foods like eggs and cheese; greasy, fried foods; and breads and grains.

Hangover Helpers for the Morning After, Because You People Never Learn

★ A pain reliever might relieve your headache, but be careful: Some, such as Tylenol, can cause liver problems when taken too close to drinking.

★ Caffeine, on the other hand, helps with the headache, gets you up and moving, and speeds up your system so that hopefully you'll process the toxic sludge inside of you sooner.

★ Keep drinking water. Coffee also dehydrates, so follow your six cups of it with 12 glasses of water.

★ Have an orgasm. It's not always easy to masturbate or have sex when you're hungover, but the orgasm at the end really helps.

★ Soothe your stomach. If you're too sick to eat, try drinking something fizzy like 7-Up. The liquids your mother gave you when you were sick as a kid (Gatorade, Pedialyte) also make good hangover drinks. Thanks, Mom!

★ Eat more grease. Greasy food helps a hangover both the night before

and the day of. A nice cheese omelet with hash browns has an excellent combination of fried food and protein.

★ Hair of the dog. Having a Bloody Mary the morning of your hangover may make you feel a little bit better. It won't cure what ails you, though—only time will do that. But if you're still hurting come happy hour the next day, have a beer to take the pain away.

★★★★★★★★★★★★★★★★★★★★★★★★★★★★★★★★★★★

WHERE TO DRINK
Dig a Dive

You think you're too good to go drink in dive bars? Do you have some outdated notion that they're filled with horrible, smelly, gross old drunks sitting around in puddles of drool and vomit? Then you're pretty much right on target. But there are also several advantages to slumming.

Drinks at the Stinkeye are always going to be several dollars cheaper than those at Souflez. Dives are discount-booze superstores. Sometimes the well drinks are a little nasty—when you see them squeezing Le Vodka into your glass, you have a right to be afraid—but you'll find you can get a top-shelf liquor in a dive for the price of a well drink anywhere else.

Another reason to drink in dumps is that the bartenders pour them strong. A weak drink in a dive is one in which you can taste the mixer at all. Rusty the Longshoreman over there is not chugging his vodka cranberry for the full day's supply of vitamin C in the juice.

Now let's address the "scary" people at dive bars. Sure, they're old and smelly, but that just means that you're now the youngest, best-groomed, and best-looking person in the place, even if you've just rolled out of bed in your pajama bottoms and Twisted Sister concert T-shirt. Hello! And though the other patrons may be undesirable, they tend to have interesting stories to share. You might learn how Little Shirley lost her leg working at the meatpacking plant or what really goes on with your luggage at the airport.

Dive Bar Don'ts
★ Don't ask for drink recommendations.

★ Don't request the 20-year-old single-malt whiskey you usually get. Top shelves in dive bars don't go that high.

★ Don't order drinks with more than two ingredients or anything that requires a blender or special glassware.

★ Don't leave your coat unattended.

Are you feeling female and don't want to get felt up? Don't worry. Unless you're going into the Hell's Angels' Speed Dealing Emporium, the average drunk doesn't have the energy to come over and touch you. The guys in meat market bars think they have a chance. The guys in dive bars are used to decades of rejection. At most, he'll buy you a drink.

Dive bars also have great music. Seriously) The jukebox is often unused, as the patrons are saving those quarters for their next drink. They never update the CDs inside of it, so you'll find the hits of the '70s and '80s—metal, pop, and even show tunes, depending on the type of place you visit.

And speaking of show tunes, gay dives aren't all that different from straight ones. Poverty doesn't discriminate, so neither should you. There are rarely fights in either type of dive, as that requires some hand-eye coordination and the ability to stand without falling.

And finally, the bartenders in these joints are sometimes just as drunk and dejected as the crowd they're serving. That makes them both entertaining and generous—you'll get more free drinks in dive bars than anywhere else. And you'll score even more comped cocktails when you tip well, because the regular patrons don't.

Have a Gay Old Time

Hello, Mary. If the annual parades, unlimited sex, and good hair weren't enough to convince you to turn gay, then just check out the bars. A drink in an average gay bar will be less expensive, stronger, and served in a bigger glass than at the hetero hot spot next door. The bartenders are abnormally attentive, quick, and make killer shots. And if you're a fan of diva house music, you'll find that many gay bars double as dance clubs—and usually without a cover charge.

> Warning: Lesbian bars can either be really good or really, really, really bad.

Luckily, there are no secret ID cards or handshakes to gain entry into gay bars. As a bonus, straight girls won't find themselves surrounded by groping guys only interested in getting some action. And straight guys can find fag hags inside who have their guards down. So really, there's something in it for everybody.

Taste Tours

Most every brewery and distillery in the world gives tours of its facilities with tasting sessions at the end. You just have to go through the motions—"Look, casks! Look, bottles!" until you get to the tasting room, where the real fun begins.

[Search Terms: "brewery tour" YourTown]

[Search Terms: distillery YourTown]

At wine vineyards, you don't need to pretend to care how it goes from grape to grappa to get your free samples—just walk in and order up. Plan your trips on busy weekend days so nobody will notice when you go up for your third sample of each vintage.

Locally, look into wine distributors and specialty stores for free tastings. They don't advertise with big flyers or posters (the events would be swamped with freeloading bums like you), so you'll need to sign up for the stores' mailing lists in person or online.

[Search Terms: "wine store" YourTown]

[Search Terms: "wine retailer" YourTown]

[Search Terms: "wine distributor" YourTown]

[Search Terms: "tasting cellar" YourTown]

[Search Terms: "tasting room" YourTown]

Some wineries also serve free lunch buffets.

It's easy to outfit your whole house with stolen stemware from wineries. Just wear a coat, or cargo pants with lots of pockets.

Guzzle While You Gamble

Casinos give out free drinks to people gambling, whether it's sitting at the slots or dropping big bucks at the tables. The trick is maximizing the number of drinks gained while minimizing money losses from betting. At the nickel slots the drink girls do come around, but not nearly as often as they do at the dollar machines. Even if you sit down at the $5 slots when you see the waitress come around, it will take her 10 minutes to get back to you, and by then you'll be 50 bucks in the hole.

Tip the cocktail waitresses well and the free drinks will come faster.

★ To speed up service, be in the proximity of high-stakes action. As the waitresses come around to the big-spender tables the most often, you can hang around there watching the games. When you see her nearing with the drink tray, throw yourself into her path.

★ You'll also get more drinks after 2 or 3 in the morning, when there are fewer people on the floor and still plenty of cocktail waitresses.

★ Keno is a great game to "play" when you don't really want to gamble but you want to sit around collecting cocktails. The minimum bet is usually a buck, and each game lasts for around five minutes. That gives you a lot of time to sit around and talk to your friends without spending much money. Tip the waitress big and she'll come back fast. You thought all those old people packing into the keno room were lazy? No, those geezers are smart.

★ Or you may decide just to hit the bar and skip the guise of gambling altogether. It used to be that drinks were dirt cheap in casino bars, but that's no longer the case in most of the upscale places. If you want to throw money down your throat instead of into a slot machine, go to the older casinos, where they charge less.

Here's a Tip

Save double by getting a beer in a coffee shop or café with counter service as opposed to a bar with a bartender. In the first place, the drinks in these food-oriented establishments are often less expensive than in bars. And though the procedure is the same as in a bar—you go to the counter, get your drink, and sit down—you're not expected to tip the cashier. Between the low price and the lack of a tip, each beer is $2 cheaper.

GET THE HOUSE HOOKUP: HOW TO BROWNNOSE THE BARTENDER

In 1907 British archaeologists working in Rome unearthed what is likely the oldest written bar proverb. It said, "When you befriend a bottle, you drink for a day. When you befriend a bartender, you drink for life." That's as true today as it is when I made it up.

Bartenders can always give out free drinks, but they also always have a lot of friends, who all were in line before you. This section is about working your way up the free-drink ladder as quickly as possible.

First Contact

Start being social before you even place your first order. "Hey there. How's your night going?" "Is it usually this busy at happy hour?" Then keep the conversation flowing from there. If you're new to the place, mention it and try to learn more. Ask about the history of the venue, like "Didn't this use to be a hooker bar?" "Who caught that fish?" or "What are those drains for?"

Try the Special

Ask for a beer or cocktail recommendation—everybody likes to share their

opinion. "What's your specialty?" However, it's best to give them a starting point: "I'm in the mood for a shot of something fruity. What do you recommend?" "I feel like having an old-man drink tonight. Something with sour mix." "What's a good dark beer—something like Guinness but not Guinness, ya know?" Then turn that taste test into a conversation.

Getting to Know You

Somewhere in your first conversation, introduce yourself ("This is an excellent Flaming Cocksucker. What's your name?"). Then make sure to use the bartender's name each time you enter and leave the bar ("Thanks, Gargamel"). When you come into the bar with friends, introduce them to the bartender ("Becky, this is Gargamel. He makes a delicious Flaming Cocksucker"). Introductions not only solidify your friendship; they demonstrate that you bring the bar business.

★★★★★★★★★★★★★★★★★★★★★★★★★★★★★★★★

Crowded-Bar Etiquette

★ The most efficient bars have lines that form at the bar stands. You should get faster service there than somewhere along the sides. At a club, just stand anywhere.

★ Make your drink decision before you step up to the bar. Don't stand there saying "Ummm. I was thinking of maybe, like, a beer or something?"

★ Don't try to use a credit card for fewer than three or four drinks, and always ask if they take them before you order.

★ Don't order a time-consuming, complicated drink (like a lemon drop) unless you're getting a few of them. You're likely to incite a riot.

★ Watch the pattern of the bartender. A pro mixologist will have memorized people in the order that they showed up. If you see her deliberately going to people in different positions along the bar, you'll want to get her attention as a way to establish your place in line. Make an effort to catch her eye as she's working on another drink. Then just wait your turn.

★ Other bartenders pick a direction and follow it down the bar. Try to grab a spot in the direction he's heading.

★ A scatterbrained bartender, who keeps going to the same spot in the bar rather than moving around or who goes in random order by whoever is shouting the loudest, needs to be shouted at and flagged with money.

★ If a person next to you is ordering the same drink as you plan to, go in on their order. Shout, "Can you make that two?" This works for simple drinks and beer, but if it's a fancy cocktail (which you should never order

at a crowded bar anyway), the bartender will appreciate not having to make it twice.

★ If there are cocktail waitresses at the bar, they always have first priority at the bar stand. As she's stepping up to it, place your order with her. She'll be able to get you the drink fast. Then you can just tip her as you would the bartender.

★★★★★★★★★★★★★★★★★★★★★★★★★★★★★★★★★★★★★

Forget Flirting

Bartenders flirt with everybody, and everybody flirts with the bartender. There's no harm in it, but it doesn't make you special, and don't think you're going to get free drinks out of it. If you do get the green light, however, go for it. Bartenders are great in bed.

On the other hand, dating a bartender is generally a bad idea—unless you're into open relationships. If you had a constant barrage of hotties offering to put out for $5 drinks, you'd take a few of them up on the offer too.

Another ancient drinking proverb states, "A good bartender makes a bad boyfriend."

★★★★★★★★★★★★★★★★★★★★★★★★★★★★★★★★★★★★★
Bad Ways to Get the Bartender's Attention
★ Standing on the stool and climbing halfway over the bar to throw yourself in her path.
★ Flirting wildly. Who doesn't?
★ Slamming down your shot glass loudly to get her attention.
★ Waving money while glaring, as if to say "Is this some kind of joke? I am richer and more important!"
★ Interrupting another person's order with yours.
★ Snapping your fingers to get her attention.
★ Giving him the stink eye, as if to place a voodoo curse for faster service.
★★★★★★★★★★★★★★★★★★★★★★★★★★★★★★★★★★★★★

Brownnose

Bus your own glasses. Bartenders appreciate when you bring your empty glasses up to the bar as you order another round (and at the end of the night when you're leaving). This isn't going to earn you free drinks instantly, but it quickly earns you goodwill. Hookups come not only in the form of free drinks but also in

upgrades. You may get your next Bombay Sapphire for the price of Maude's Bathtub Gin.

Elsewhere...

Bartenders are more likely to hand out freebies to people they know outside of work, even if "outside" only means a different bar. Whenever you see a bartender at a different venue, make mention of it. "Don't you work at Lushies? I love that place!" For every drink you buy a bartender outside their place of employment, you'll get two back when they're on the clock. They can afford to be generous when they're giving away someone else's profits.

Check out service industry nights. These are off nights for waiters, bartenders, and other service workers. They usually take place on Monday evenings at hipster dive bars. They're an easy environment in which to meet bartenders off the clock, and the host bars always have drink specials.

[Search Terms: "service industry night" YourTown]
[Search Terms: "SIN night" YourTown]

Keep It Regular

Many bartenders remember customers by their first names and what they drink. Conversations between them all sound like: "John was asking for you." "John who drinks Stoli on the rocks?" "No, John who drinks Stoli tonics." If you have a regular drink, you'll be more readily remembered.

Wait Him Out

Spend enough time in front of a bartender and eventually you'll get free drinks. If you take up space on a bar stool for hours on end, you'll start slowly collecting freebies. They may be the messed-up drink orders from other people, but beggars can't be choosers. On the other hand, this tactic is totally ghetto and takes forever. You can invest four hours waiting for one free drink, or you can get a job that pays for eight drinks in the same amount of time. The waiting method works best for the unemployed and the chronically lazy.

★★★★★★★★★★★★★★★★★★★★★★★★★★★★★★★★★
You Know You're a Bar Regular When:
★ You've received calls on the bar phone.
★ There's a drink named after you.
★ People know when your song selections are playing on the jukebox.
★ and you can tell who else is in the bar by what's playing.

★ The bartender asks you to keep an eye on the register while he goes out to smoke.

★ You've helped clean up after the place closes, but you've never been paid.

★ The bartender asks, "Where were you yesterday?"

TIPPING TIPS AND OTHER BRIBES

The best way to a bartender's heart is through his wallet. Your charming smile and engaging conversational skills don't mean jack if you're under-tipping. If you're a regular dollar-a-drink tipper and you make friends with the bartender, over time you'll probably get a few freebies. But you can speed up the process when you tip more at opportune times.

The Bare Minimum

If you get coin change back for your drink, pick it up and leave a dollar instead. Save the quarters for the jukebox. If you're paying inflated New York prices, you'll need to inflate the tip as well. Never tip less than a buck, even if it's on a 25-cent beer.

Make Your First Tip the Biggest

If you ignore the rule above, drink #2 will most likely come slower and be weaker. The opposite happens if you super-size your first gratuity. Tip the dollar and the change (or more) for the first beverage and get good service all night. (Then you can leave a smaller tip at the end of the night and it all evens out.)

Tip the Most When the Drinks Cost the Least

This is a great way to build a relationship with the bartender. Tip double at happy hour and you'll be remembered better than when you give the same amount any other time. Also, tip well in establishments where other patrons generally don't—lay down 2 bucks in a dive bar and you'll get free drinks fast.

Don't Go There!
You should also know where you're the least likely to get free drinks. Bars that serve corporate clients are stingy with the freebies, such as those in hotels, airports, downtown, and ones part of a chain—anyplace that gives you a receipt with your cocktail.

Tip More at Open Bar

At open bar (free liquor) events, the staff works twice as hard, yet most people tip poorly—if at all. You'll not only score points by overtipping in that situation, but you can also score VIP status for yourself.

If you're planning on sucking back a bunch of drinks at the open bar, make a first impression that will get you to the front of the line for the rest of the night. When you order your first drink (make it easy to remember, like a Jack and Coke) pull out the total amount you expect to tip for the evening. Hand your big bill to the bartender and say, "Can I just tip you for the whole night in advance? I'll be drinking these. Until what time will you be here? And what is your name?" For the rest of the evening you'll be able to call out "Simone, two more please!" from the back of the room.

Just Shoot Her

If you and your pals are downing lots of shots, offer to buy the bartender one. "Can I buy you a shot?" is all you have to say. This will almost always save you money in the short run. Rarely will the bartender accept your offer and actually make you pay for the shot; usually he'll say yes and won't include it on your bill. Sometimes, he'll decline the offer but still reduce the cost of the round in a "thanks for asking" gesture. And almost always he'll reduce the cost of the next round.

> ★
> ### More Is Less
> In some cities (the good ones), bartenders do "buybacks," where for every three or so rounds of drinks you pay for, they "buy" you a round. There is nothing you can do to guarantee this courtesy other than being a good patron as always.
> ★

GETTING LOADED FOR LESS
Get a Head Start

A six-pack bought at the store costs less than two pints purchased at a bar. That doesn't mean that you should drink at home every night. Just get a head start before you go out and you'll drink less while you are.

Warning: if you chug Kool-Aid and vodka at home and pop a caffeine pill before hitting the clubs, you'll be drunk, awake, and thrifty. Nobody has to know you're ghetto.

Smart Shopping

Gallons of liquor are cheaper than little airplane bottles of liquor. Cases of beer

are cheaper than six-packs. Pitchers of beer cost less than individual glasses. Think big and buy in bulk.

Shop global, not local—corner convenience stores are bad places to buy booze. You can get the same stuff at liquor stores for half the price. (And you can afford the premium brands in real glass bottles.) Supermarkets are also inexpensive, and they have really good sales. Warehouse and beverage stores like Costco and BevMo are even better if you've got a car to schlep it all home.

Warning: it's not cheaper to drink at home when you drink the whole bottle.

B(rew).Y.O.B.

Sadly, brewing beer at home is not much less expensive than buying microbrew at the store—and there is a greater chance of poisoning yourself. Add to that the time and effort it takes to make, and the fact that you're missing out on being in a real bar with real people, and it doesn't seem like such a great idea. On the other hand, homemade beer makes a nice gift for your friends and is a slightly less nerdier project than collecting model trains.

People who live near the wine country can bottle their own wine at a lower cost than buying it in the store—but the process is kind of silly. You go to a vineyard on a special day and fill up empty bottles (that you must bring or buy) straight from the casks. Then you store it in the cellar for a few months until it's ready to drink. So if you're got a cellar and live close to the wine country and you drink premium wine by the case, then this could be an option. The other 99.872% of you can forget about it.

★

The Sympathy Shot
Practice your acting skills by attempting to elicit a sympathy shot. When the bartender asks how you're doing, tell him you just got dumped. Look all sad-like and see if she offers something to cheer you up. Of course, it's not very fun pretending to be miserable when you're celebrating getting a free drink. You might want to wait until you really do get dumped, then milk it for all it's worth.

★

Weak Drinks Stink

At the price you're paying for them, there's no excuse for watery cocktails. If you see your drink slinger mixing you a weak pour, you need to stand up for your right to rapid intoxication and demand satisfaction!

Get Pushy

If that makes you mad, ask for more: "I'm sorry, could you make that a little bit stronger please?" He'll take this request best if your tip is already sitting on the bar. And if he hates you for asking, so what? It's better to walk away with a strong drink and an annoyed bartender than a weak drink and an annoyed you.

Measured Anger

In some venues, weak drinks are the owner's policy and not the bartenders' fault. They may have "measured pours," where the pour cap on the bottle cuts off after one shot goes through it. You can tell because the bottle will be turned upside down but the liquor shuts off. In some states, the law requires the bartenders to prepare mixed drinks using exactly one of those airplane-size mini bottles per glass. That system is not only reprehensible, it's environmentally irresponsible. Do your best to avoid these bars and/or states.

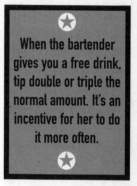

When the bartender gives you a free drink, tip double or triple the normal amount. It's an incentive for her to do it more often.

If you don't have that option, however, at least you can drink beer on tap so you don't feel like you're getting as screwed. You never get a weak pour from a 12-ounce bottle.

Premium Pays

You'll often get a stronger mixed drink if you request better liquor. In some places, if you order a well drink you get a weak one, but a premium brand request gets you a premium pour. This goes on in a lot of froufrou cocktail lounges as well as at most concert halls. In places where the drinks are overpriced to begin with, order a top-shelf cocktail for a buck or two more and it will usually come stronger.

Love on the Rocks

If you get a weak pour in your mixed drink, order your next one on the rocks. The bartender may only pour one shot into a mixed drink, but a rocks glass holds about two for the same price. And with the recent explosion of flavored liquors (especially vodkas), an unmixed drink can taste just as fruity as one with real juice.

Food Complaints

When a nice restaurant screws up, request that it "take care of your drinks." If

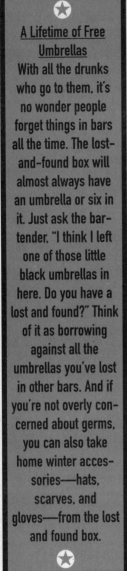

A Lifetime of Free Umbrellas

With all the drunks who go to them, it's no wonder people forget things in bars all the time. The lost-and-found box will almost always have an umbrella or six in it. Just ask the bartender, "I think I left one of those little black umbrellas in here. Do you have a lost and found?" Think of it as borrowing against all the umbrellas you've lost in other bars. And if you're not overly concerned about germs, you can also take home winter accessories—hats, scarves, and gloves—from the lost and found box.

you've made reservations but are forced to wait, any good establishment will give you a round of drinks for free while you do. If it doesn't offer, ask. The same goes if it makes mistakes in the meal—the server brought the wrong entrée or the kitchen put meat in your vegetarian pasta. Its liquid apology is your opportunity to try that $20-a-shot tequila.

WILD, WET GROUP ACTION!

Friendship is a beautiful thing that can be faked, corrupted, and used as leverage for personal gain. It truly is sacred. Here is how to put it to work for you:

Strength in Numbers

When you go out with a posse, you bring a bundle of money to the bartender. If you steer the group to the right place, the bartender might return your favor. Choose a venue that's fairly (but not totally) dead on the day/time you're going to show up. Hence you and your pals will have a big impact on the bar's business and the bartender will be more apt to give you kickbacks.

Make sure she sees who is in charge, because that person (you) can benefit the most. Walk right up and make first contact with the bartender, and try to be the one who orders additional rounds of drinks (after taking up a collection, of course).

Order your drink last, as in "Two cosmo-tinis, one Surfer on Acid, and a Guinness for me." After a round or two she'll reply with "That will be 15 bucks. Your beer is on me." If you're all doing shots, you're likely to get a row of free ones on the house.

★★★★★★★★★★★★★★★★★★★★★★★★★★★★★★★★★

Recommended Experts for Your Bar Trivia Team

Bar trivia contests are more than just semi-hip ways for geeks to show off. They're semi-hip ways for geeks to show off and earn cash

prizes or a large bar tab. The best teams have the right combination of experts:

★ **Music Geek** An intimate knowledge of Top 40 music is a must, no matter how indie-cool they may be.

★ **Sports Nut** Specializes in local teams but has a broad general knowledge—reads the sports page daily.

★ **History Buff** The guy who bores you with politics and current events on a daily basis can be your best friend in a trivia contest.

★ **Pop Culture and Television** Finally, all that time in front of the idiot box pays off.

TRICKING YOUR FRIENDS INTO PAYING FOR DRINKS

Try these well-tested strategies for tricking the ones you love into buying you the booze you love more.

All for Nothing

The best way to assure an entire night of free drinking is to get a guarantee before you leave the house. When your friend calls up, say, "I can't go out tonight. I'm totally broke." When he persists and "makes" you come, he will have to pay for everything. Sweet!

Then again, he may say "I'll loan you the money," or "You can pay next time," or "You're full of shit, I know you got paid yesterday." Be persistent and counter with "I couldn't even meet my credit card minimum this month," "I'm saving up for a hooker," or "Look, I can't afford it and I don't want to go out anyway!" Hopefully, his desire to hang out with you will blind him to your lies.

Make sure to leave your wallet at home, lest he see your gold card and the stack of Benjamins inside.

Other Lies to Tell Your Friends

★ I'm out of cash for tonight. Can you buy this one and I'll get you next time?

★ My ATM card isn't working all of a sudden. I'm freaking out. I know I have money in my account. Can you float me?

★ I think I left my ATM in the machine!

★ I can't believe I forgot my wallet.

★ Oh, no! I can't find the $50 bill I had!

★ I get paid tomorrow. Can you cover me tonight?

Be the Bill Collector

Collect money from everybody before going up to get the next round—not including any of your own—in the total. Your friends will be so happy that you're schlepping to the bar instead of doing it themselves, they won't notice that they're each a dollar short in change. If it looks like you'll have to throw in some of your own, make an announcement like "I think we still need 2 more bucks for the tip."

FINANCIALLY SOUND ROUNDS

When you're out drinking in a group, it is efficient to take turns buying rounds of drinks, especially when you're a group of lazy drunks. Only one person has to stand up and get the order, and none of you will have to wait in line while each pays separately. But buying rounds can easily turn into financial suicide.

It only takes one poseur to raise everyone's bill. Though four out of five of you might be A-OK with well liquor, as soon as the first person specifies that her drink be made with XPZZYKA, the imperial Russian vodka so high on the shelf the bartender has to get out a special ladder to reach it, everyone will change their order to match it. Hey, you all think, I'm not paying for her fancy booze while getting swill for myself! Then everyone upgrades their order to XPZZYKA and a $20 round now costs $40 and all you wanted was a light beer.

> ★
>
> At expensive bars and restaurants, send a girly mixed cocktail back (a third of it empty, of course) if you claim it's "too sweet." They'll gladly pour you a replacement, especially if the waiter suggested the drink and it's sweet.
>
> ★

What you want to do is get out of the round system altogether, or at least to minimize your financial damage while not looking like the cheap bastard that you are.

Warning: Never suggest getting rounds of drinks, because you'll be in charge of buying the first one.

Opting Out

Order your drink last within the round (stall by acting indecisive about what you want) so that you can opt out of the process if need be. If you hear people asking for Grand Marnier when you only want Mad Dog 20/20, make up an excuse to get out of it. Say you're on antibiotics and not drinking (you can always do shots when you're supposedly in the restroom), or order a glass of water "for now."

Or extricate yourself from the rest of the rounds. Go to the bathroom or fake a phone call for long enough that your group gets their drinks and sits down. Order your drink separately. Keep doing that and you'll be responsible for nobody's drinks but your own.

You can also just pay for your drink separately. "Here's 5 bucks for my beer. I can't afford to buy a round, so I'll just pay for this." Not only does that get you out of the round schedule, there's a good chance that your buddy will refuse your cash and buy your drink anyway.

Come in Last

The first person to buy a round will have to buy one drink for each member of your party. The last of the group (you) will buy the fewest drinks, as the lightweights and designated drivers will have quit by then. Also, the guy who gets the first round will be at the front of the line for the next round of rounds.

Check the Board
Always look around the bar before you place an order. Happy hour or not, there might be a sign advertising drink specials.

Throw Off the Timing:
1. Hide and Go Pee

When you're stuck buying rounds, you can at least ensure that you get the last shift.

Try to be elsewhere when the next buyer is schleputized. When you see that drinks are getting empty, excuse yourself to use the bathroom or go outside to smoke a cigarette. You run the risk of not getting your drink refilled when you aren't present, so it's best to hide when everyone knows your regular drink.

2. The Not Quite Ready

Nobody expects the person with the half-full glass of beer to set it down and buy a round for the rest of the group. To delay your turn, drink slower than everyone else. Wait them out and the thirstiest person will suggest another round. When they start taking the order, chug through half your drink and put in a request: "I'm sure I'll finish this one by the time you get back. Can you get me another?"

The Decoy

If and when it comes your turn to buy the round, save money by getting a decoy water for yourself. Then drink it really fast and say, "Who's got the next round? I'm thirsty!"

The Preemptive Round

When you know your round is next, finish your drink fast. Then stand up and ask, "Who needs a drink? It's my turn." All the people not ready will sit out your round.

Drink and Dash

To leave before paying, feign tiredness or illness or drunkenness or a dog waiting to be walked. It would be a little obvious that you're an asshole if you try to jump up and run out just as it's your turn to make the order, so you'd better stop drinking at the previous round. Turn down the drink and say you need to get home soon. Stay just a little bit longer, but make sure to leave when their drinks are still pretty full. If you're still in the bar when it's your turn to buy a round, you need to pay for it even if you've stopped drinking.

THE BAR PARTY

A bar party is a party thrown at a bar, in case that's not incredibly obvious. It can range in scale from a small gathering of friends to a packed blowout with live entertainment, decorations, and dancing. It can be a one-off event or a weekly or monthly regular party.

It is always an opportunity to score free drinks, though. These are easy to throw (compared to club nights) and hard to lose much money at in the process. At worst—if nobody shows up and your DJ cancels—a bar comes equipped with a jukebox and booze so it will go on without you. At best, you can make a profit from the party by charging a cover at the door or taking a percentage of the bar tab.

The Smaller Bar Party

Who and How Many: Ten to fifteen of your friends and acquaintances.

What: You don't need to provide any entertainment for a small party—let the jukebox or the bar's stereo do it for you. A party of this size can be anything from an after-work get-together to a networking group to a drinking club.

How: Get the group there by sending email and talking to friends. Invite your coworkers—those losers need encouragement to go out. If it's a networking or social group of some sort, also post a listing to community websites and business bulletin boards. Hold the event in a place that's not usually crowded at the time you want to meet—you'll have a bigger effect on the bar's business and be able to get more drinks for yourself.

What's in It for You: Call in advance or go in person to set yourself up. Introduce yourself to the bartender (and remember his name) like a professional.

Say something like "I'm thinking of bringing in a group of about 15 people next week at this time. If I do that, would you be willing to comp my drinks?" When you do come in for the party, reintroduce yourself to the bartender first thing.

Or be a nice person and hook up everyone with free food instead. Plan your event at a pub that serves bar food. Give the manager the same line about bringing people down, but instead of drinks ask if he'd put out a few plates of appetizers. Then everyone can share in the freebies.

The Bigger Bar Bash

Who and How Many: If you want to take away more than a few free drinks in return for promoting a party, you need to fill the bar.

What: Throw a theme party and provide some entertainment. It could be a DJ, drag queen act, Jell-O wrestling, karaoke, whatever. Technically, you need an entertainment license to host live entertainment or dancing in most municipalities, but unless it's a huge event nobody should care.

How: Avoid booking bands in small spaces. Not only are there too many people to pay for their services, they require tons of equipment and setup time and they take up a lot of space. Many bars have built-in turntables. Use those instead, even if you want to play rock. Have your favorite band member DJ the party and advertise that. (It allows you to advertise the band's name, as in "John Smith From The Mangled Axles," without paying for the band.)

Overpromote. A bar party can never be too crowded when you're making money on it. Create a flyer to hand out and put out around town. Make one poster-size to hang at the bar (outside, in the bathrooms, the foyer). Put up 8 ½-by-11 photocopied posters on telephone poles in the hipster neighborhoods and especially near where the bar is located. (You can also ask the bar if they'll pay for photocopying costs to promote the event.)

Submit your listing to all of the following: nightlife websites, community events listings websites, local newspapers, and alternative weekly newspapers. Email everyone you know with a slick-looking virtual flyer. Go on clubbing message boards and list your event.

What's in It for You: Though it's hard to lose money at a bar night, it's not very easy to make it either. You've got to be a smooth talker to convince a bar to give you a percentage of its take on alcohol sales for the night. The best way to get that deal is to get to know the bartender or manager before you propose it.

Instead of a percentage, the bar is more likely to let you charge a cover at the door. This allows it to make more money than usual on drinks, and you get to keep all the cover charges. The problem with that is you're asking people to pay for a

place they can usually enter for free. So keep the cover charge low to the point of being insignificant—5 bucks or less. And put signs up around the door so that people who are just wandering in know what they're paying for.

Agree to pay the DJ or other talent a percentage of the door profit rather than a set amount, as this will not only save you from losing money on the night, it will encourage them to help promote the party as well.

If you throw a successful ring-ding, get some corporate sponsorship to increase your attendance and amount of free stuff. Ask a liquor company or cigarette company to "sponsor" the event. They'll pay for advertising in the paper, hand out coupons for cheap drinks or other swag, and maybe pay for flyers and DJs.

HOW TO GET STRANGERS TO BUY YOU DRINKS

After you've slept with every bartender in town and alienated all your friends by tricking them into paying for your drinks night after night, you'll need to expand your circle of scammetry to the public at large. Luckily, there are plenty of vulnerable and/or gullible people in the world from whom you can extract cocktails.

Follow the Money

If your goal is to meet certain types of people for dating, networking, or getting free drinks from, you have to put yourself in their paths. For example, want to hook up with a future rich lawyer? Find the fancy bar closest to a law school and see who's there. Like nerds? Bars near technology companies are packed with rich ones. Want to score with a tourist you'll never have to call again? Drink in hotel bars.

Tourists make excellent one-night stands. You won't have to commit, and they won't perpetuate the rumor that you're a gold-digging whore.

Tourist Traps

People on vacations or traveling for business are often bored and looking for company—and they're willing to pay for it. (That's why they put all the escort-ad boxes near the downtown hotels.) But you don't have to open up a "massage" practice to meet generous visitors. Just show up at the right places and talk to the tourists. They'll pay for your drinks as long as you add local flavor to their trip.

You'll find a lot of them in horrible theme bars. Those are the over-the-top, overpriced, brightly lit places that locals never go to—the ones with the

nice views and expensive drinks, the lounges on top of the tallest buildings in the city, and the "zany" bars that are on the must-see lists for out-of-towners. (For a list of them, check the local tourism board's website.)

Business travelers make good targets because they have company credit cards that don't cost them anything out of pocket. You'll find them in upscale hotel bars after the 6 P.M. meeting gets out. They'll pay for drinks and hopefully your dinner too.

Speedy Greetings

A fast way to make friends at any bar is to walk up to the drink stand, say hello to the bartender, then turn to the left and right and say hello to the people sitting there. Ask what drink they'd recommend, or use a standard friendly greeting like "What brings you out this evening?", "How's your day going?", or "Happy Tuesday." The point is to make quick, casual contact that can turn into a conversation. It's a lot easier to enter a conversation with someone sitting nearby than someone you have to walk up and approach.

Battle of the Sexes

Unfortunately for the fellas, chauvinism is not quite dead. It's far easier for a woman to get a free drink out of a guy than the other way around. Women, you need merely to prove that you have breasts and some sucker will come over offering gifts. (More drinks come with hoochier outfits.) Just sit at the bar alone and look half-interested in what's going on in the room and soon enough you'll be swimming in liquor.

Men, you can cry in your self-bought beer about the lack of equality between the sexes, or you can do your part to right the wrongs of this world and get your fair share of free booze too. Your best bets are women sitting alone at the bar, looking non-hoochie and not trying to prove that they have breasts. Your approach should be that of a drinking buddy and not of a Don Juan looking for action. Sometimes what works in your favor is the element of surprise—women aren't used to guys saying, "Hey, buy me a drink."

Whatever gender you're after, chances are an older and uglier person will buy drinks more readily than will a young hottie who's used to having cocktails handed to him. Hang out in classy older-person's bars and you're more likely to score; besides, old people have the best bar stories anyway. Young men and women at old-man bars (both gay and straight) can make out well. Between the bartenders and the patrons, you can get away with a lot of freebies. On the other hand, they might feel free with their hands.

Flaming Cocktails

Gay guys have double the opportunity to get free drinks. You can go into any gay dive bar and get drinks from an older guy. That's easy. But you can also be strategically "safe" by getting married and other straight women to pay for your booze. Just make it clear that you're a flamer: Don't walk, sashay; don't speak, lisp. The ladies will come to you under the mistaken impression that just being gay makes you fabulous. And while they're getting you drunk they'll try to set you up with their hairdresser. It's OK to wallow in stereotypes when you're using them to your advantage.

The real challenge is finding straight and/or married women alone—they tend not to hang out in hipster bars. They do gravitate toward upscale places like hotel bars, martini bars, and wine bars. You'll also find them at networking and social functions, such as travel writers' or craft makers' groups, book clubs, and film appreciation groups. Look for the wedding ring and go in for the kill.

Drinks From Drunks

If a drunk guy is trying to talk your ear off, you can ask him for a drink and he'll either acquiesce or start yelling obscenities. Either way, you'll have your answer: "Hey, can you buy me a drink? I'm broke" usually works fine. You may have to listen to him rattle on about his wife or job or (heaven forbid) politics, but at least you'll have a glass of whiskey with which to numb your headache.

Scamming the Stupid

There are a million different unlosable bar bets you can use to hoodwink strangers out of cash or drinks. There's no point wasting space here listing them—you can find a few hundred of them online. (Half of them start, "I'll bet you couldn't drink this shot if...") These tricks work best on dumb jocks in sports bars and on people already wasted and gullible—those with the most ignorant bravado.

[Search Term: "Bar bets you can win"]

B.Y.O.Bar

True party entrepreneurs can make a bundle by throwing events in spaces that don't normally sell alcohol. You set up a cash bar and keep all the profits. Galleries, closed office buildings, small museums, unoccupied apartments, warehouses, etc., make good venues for these events. The more unusual the space the better. Because you won't have a legal permit to sell alcohol, you'll have to have a big enough mailing list to get people there without making it public. At 5 bucks a drink, you can make a killing.

Accident-Prone Drinkers

At a crowded bar, get yourself a fake cocktail—water with ice, lemon, and a straw will pass for a gin and tonic. Then force it so someone bumps into you and spills your drink or knocks it out of your hand. "Hey, just spilled my drink! That was full!" If they don't offer to buy another, tell them to. "I think you need to buy me a replacement." Then order a real gin and tonic to replace it.

More Lies You Can Tell

Right after you get a drink and walk into the other room at the bar, set your drink down and pick up an empty one sitting around. (Make sure it looks like yours—straw and lemon, plus the other details.) Walk back to the bartender as you look flustered and tell him, "I just spilled that whole drink. Would you give me another?" If he's cool with it, tip him double for your replacement cocktail and enjoy two drinks for the price of one.

★★★★★★★★★★★★★★★★★★★★★★★★★★★★★★★★★★

DOING DRUGS

If you've ever seen a television commercial, you surely have noted that some drugs are evil and illegal and will destroy your life, and if you even try them once, you'll end up a junkie hooker until you kill your pimp on a meth binge and go to prison forever. Whereas other drugs made by pharmaceutical companies can be far more addictive and/or will mess up your brain and body worse than the drugs in the first category, yet they are legal and good to take as long as your doctor prescribes them. Nonetheless, some drugs that can be prescribed by doctors are illegal in some states and only semi-legal in others, so those drugs are good or evil depending on where you live.

And while the war on some drugs and not others is an important topic to pay attention to, it is tiresome to talk about, and it's outside of the scope of this book. Let's just say that no matter where your drugs came from, you should take the time to educate yourself on their potential consequences and side effects, as opposed to just how high you can get.

Should I Become a Drug Dealer?

Contrary to popular belief, dealing party drugs is not usually a good way to earn a living. Only two kinds of people are able to deal drugs with any success: career criminals, who can find some way to get into trouble without reading this book; and

How to Accept a Drink Offer:
"Oh, you don't need to, but I wouldn't say no."

people who take so many drugs that all their friends come around asking where to score. I can't speak for the former group. The latter group, who turn to dealing to their friends out of convenience, usually end up doing twice as much stuff as they did before they began selling, and therefore make little money over the cost of their increased habits.

The morality of dealing is up to you. It's the practicality that doesn't often work out, given the risk involved.

CHAPTER 6 ★

Dirt-Cheap Dates and Cheap Tricks

DATING: THE STANDARD MODEL

In the standard, old-fashioned heterosexual model, the guy pays for most or all of the date and the woman pays an absurd amount for the clothes, hair, and make-up she puts on for it. But the standard model breaks down when the guy doesn't earn more than the girl, when there aren't heterosexuals involved, or when one person or both thinks that the standard model is outdated, sexist crap.

The sensible alternative to the standard model is paying for dates in proportion to incomes—the person who makes more pays for more. (If you're both loaded, it won't matter who pays, and if you're both broke, both your goals should be spending as little as possible.) The practical problem with the sensible alternative is that math isn't fun. It's just not sexy or romantic to divide up a $34.93 dinner bill by 5/13ths.

Ways to Not Haggle Over the Bill When It Comes

★ "I got paid today—how about tonight is my treat?"
★ "OK, if you're paying for dinner, I'll get drinks/cab/hotel room."
★ "Allow me to contribute."
★ "Here, take this."
★ "I'll take care of things tonight. How about if we go out again, then you can be my sugar daddy?"

Warning: if you expect him to pay, he should expect you to put out.

Advance Planning

The best way to avoid money issues while you're out on a date is to settle them in advance. Traditional etiquette dictates that the person requesting the date pays for it. But that's the case when the question is phrased "May I take you out for drinks?", not "Would you like to go out for drinks?" Rather than argue semantics during dinner, make an explicit advance agreement and get it over with.

You: "Chez LaLa? I think that place might be out of my budget."
Your date: "It will be my treat."
You: "Are you sure? OK."
OR

You: "Chez LaLa? I think that place might be out of my budget."

Your date: "OK. Where do you want to go?"

You: "How about McStinky's?"

Better yet, set up your first few dates someplace cheap (or free) and fun where money isn't a factor, like the park, a museum, or unlimited bread-stick night at The Olive Garden. Then you can see if you actually like each other rather than if she comes with a big-enough dowry.

A BUNCH OF OTHER LOW-COST DATES

Most of the time, what you do on a date is what you do the rest of the time— go out for food, drinks, or some other form of entertainment. That's covered in the rest of the book. Below are a few suggestions for dates out of that old routine. Most of them are a little cute (and thus, not very punk rock), so don't say you weren't warned.

Cook Something Up

Make something hands-on together, like fondue, pizza, soft pretzels, s'mores, taffy, or Rice Krispie Treats. Getting messy together is hot.

82% of New York's hipsters have never even seen the Statue of Liberty.

Let's Pretend We're Tourists

The problem with being chronically hip is that you miss the good parts of what everyone unhip is doing. What are the chances you've seen all of the tourist attractions in your own city? Do something with your date that neither of you has done before. Look at the website for the local chamber of commerce or tourism board and pick out an attraction you've both managed to miss.

Then, if you can't handle being mainstream, dress up like tourists while you do it, and it will be OK because now you've added irony. Ask strangers to take pictures of the two of you. Buy the cheesiest matching T-shirts you can find. Sample the unique local culinary delicacies.

Window-Shopping

Take it downscale and hit a farmers market, flea market, or go on a tour of garage sales. Or instead, grab some breakfast at Tiffany's then go shopping for a new mink coat, china pattern, summer yacht at the boat show, or go drive by the

mansion district and pick out a house. If you want to be practical about it, go thrift shopping or hit the used record store.

Play in the Park

Though public parks are best known as places to score drugs or have anonymous gay liaisons in the restrooms, they also make fine places for all kinds of other dating activities.

Skyrockets at Night
Rent a telescope and look at the stars, or spy on the neighbors having sex.

★ Pack a picnic. It's so hokey it's actually fun.

★ Rent some wheels and go for a spin. Many parks (and beach boardwalks) rent roller skates, in-line skates, bicycles built for two, scooters, and other modes of transportation.

★ Take a hike. Stroll through the arboretum, rose garden, hedge maze, or other public garden during the day, or make it a romantic moonlight stroll.

★ Go the zoo or aquarium, especially if it's Free Day. If it is, act all surprised at your luck.

★ There are easy active sports for everyone. Try tennis (preppies), badminton (blue bloods), frisbee (stoners), catch with a softball (lesbians), rent a paddle-boat (sloths) or canoe (Boy Scouts), play hacky-sack (hippies), knife throwing (carnies), fly-fishing (grandpas), log rolling (lumberjacks), or go climb a tree (ecoterrorists).

★ Bring the dog to the park or beach. Picking up poop together will only strengthen your relationship.

Old Folks

Old-fashioned dates are both cheesy and romantic. While you're at it, make sure to bitch about the kids these days and their damn rap music.

★ Go bowling or ice-skating.

★ Split an ice cream sundae.

★ Check out a drive-in movie together. Just don't make him hide in the trunk on the way in.

★ Put together a puzzle or play a board game.

★ BINGO!

★ Go apple picking, berry picking, or visit a pumpkin patch.

★ Feed the ducks or stone the pigeons.

The Joy of Youth

Acting like a 10-year-old will make you seem fun and innocent, and she'll never suspect you have a collection of leather flogging devices at home.

★ Ride the merry-go-round together and see who pukes first.

★ Hit the playground—ride the swings, go down the slide, take a spin on the whirlybird, sit on the seesaw.

★ Go fly a kite, motherfucker!

★ Play hide-and-seek or ding-dong-ditch.

★ Go to the video arcade together. If Nuclear Skateboard Assault seems a little too modern, try pinball.

★ Play miniature golf, ride go-karts, go to a water park.

★ Build a sand castle. (Watch out for syringes.)

★ Do a craft project, like finger paints, origami, making paper airplanes, etc.

★ Go to the SPCA and shop for puppies.

Warning: Water parks are family fun. Water sports are something else entirely.

If you come up with irresistible ideas for things to do, your date may foot the bill to do them. Make suggestions that you can't afford: "We should rent bear costumes and go mess with hikers in the woods!" When he concurs with the awesomeness of the idea, follow with "But I so can't afford that right now. Damn!" Then watch him fork over the dough.

Classy Broad

Take a class together in something you've never done—salsa, tango, or some other kind of dancing; an intro martial arts class; an exercise class; a knitting or other craft course. You should be able to find a "first one's free" class in any of these categories.

Bar Games

If you do find yourselves at a bar (it happens), play the games there. They'll slow down your drinking and thus save you money. Play darts, pool, pinball, ping-pong, or just pick out songs on the jukebox together.

Volunteer

Score points with your date and improve your karma by doing a volunteer project together. You can plant trees, bring puppies to old people, tutor kids after school, serve food to the homeless, or

clean up the park or the beach. (If you're too cool for that, go beat up old people and kick some puppies.)

The Voodoo That You Do

Go to an occult shop for a tarot card, palm, numerology, or aura reading. While you're there, pick up some love potion with which to dose his drink later. Or make it a dark date and tour the local cemetery, shop for gravestones, or price caskets at a funeral home. (Goths need date ideas too.)

Read the Rest of the Book

It's all about free stuff.

DATING FOR DRINKS AND DINNER

If you're not looking to get married or find an equal partner anytime soon, you can take advantage of the emptiness in other people's lives and turn it into the full-ness of your stomach.

Personals Gain

Want a free dinner? Take out an online personal ad and keep fishing around until someone offers to pay for your meal. Take chances on people uglier than your usual standards; maybe you'll learn a valuable prince-frog lesson or some-thing. End the date politely: "I've had a nice time tonight, but I don't think we're compatible. Thank you so much for dinner. You don't need to drive me home—I'll take a cab."

Warning: Stay away from people with creepy personal ads—
they're always creepier in person.

GOLD-DIGGING

Gold diggers trade their time for cash and prizes—clothes, stereos, jewelry, and even cars and condos if they're really good at it. And unlike cash-only whoring, it's all perfectly legal. Here are a few tips to get you started on your new project.

Your Qualifications

Sometimes being young and relatively hot is enough. You need to look under 30 and be cute, adorable, sexy, or something along those lines. But you'll probably make out better if you're also hip—knowing the trendy little spots where the underground action is. You want to find someone older, successful, and bored—

they're not paying for sex. They're paying to hang out with someone young and un-jaded and fun. Married guys are ideal.

First Encounter

Hang out where older businesspeople do. Try the quieter downtown bars, the bar at expensive restaurants, fancy hotel bars, or upscale lunch places. Dress nicely but also stylishly and age-appropriately—sexy but not slutty. Let him make the first move on you so you don't look like some kind of trashy gold digger.

Play hard to get. On the first date you want him to pay for your drinks, give you his number, and ask you out. You can even claim you're dating someone but that you'd still like to go out sometime just for dinner or something.

Slow and Steady

Ask him lots of questions about his exciting corporate job. Act fascinated. You'll also want to set it up so that you're not going to pay for this dinner, or anything else. "This place is really nice, but I can't afford to eat here." He'll insist.

Flirt lightly, but don't fool around. (The real pros never give up more than a kiss.) Make it seem like a mutual flirtation—pay for the occasional drink when it's cheap. Take him out to trendy events like art openings and funky bars. In return, he'll take you out to expensive restaurants and buy you something to replace that Monet poster you bought in college.

Milk Money

Once you've been out on plenty of pseudo dates, it's time to start dropping hints and play the helpless victim. Suddenly, you're short on the rent this month or your stereo just died or someone stole your MP3 player or you don't have anything to wear to the opera next week. (Do not say "I'll pay you back.")

He'll also be likely to help you out in professional matters such as stuff for school or the business you want to open. Maybe he'll buy you a new computer. Maybe he'll give you money to start up your screen-printing company. Maybe he'll buy you a store franchise.

Nothing Lasts Forever

Don't move in, and don't let things get more involved than a casual, comfort-able romance. ("Let's just keep things like they are now, OK? I don't think I'm ready for anything more just yet.")

Eventually, though, it will end. His wife will find out, you'll turn 30, he'll go

bankrupt or find someone new. Don't put yourself in a position where you can get screwed, like living in an apartment you couldn't afford on your own or having outstanding debts. Enjoy it while it lasts.

Gold-Digging, Part II: The Gay Version

The gay version of gold-digging is pretty much the same as the straight version, except that nobody is fooling anybody. You don't have to trick him into giving you stuff, and he doesn't have to pretend that he's not renting your time in exchange for food, drinks, and gifts.

★ Find him in a piano bar, an upscale gay restaurant, or steal him from another rent boy at brunch. Whether you've strategically located yourself somewhere or you're just somewhere out on the town, he'll approach you. There's no need for subtlety.

★ He'll ask you out on a date. Don't get too drunk, and do not put out yet.

★ The older he is, the more he'll show you off and the less you'll have to take him out anywhere you go. You'll brunch till you drop.

★ You will probably have to put out eventually, no matter how old he is. (Thanks a lot, Viagra.) So put it off as long as possible unless he's hot anyway.

★ You may not be his only rent boy, and he will definitely drop you for someone hotter. Have a nice ride.

CHEAP SEX

Sex can get expensive even when you're not paying someone to have it with you. On the way to a lay, a guy may have to pay for a few dinners, drinks, cabs, and other dating-related expenses. For most women it's a bit easier—they just have to say yes. Then, when it actually comes time to do the deed, there are birth control and disease prevention methods to buy. And if you (stupidly) don't plan for those, there are tests and treatments to take care of what you caught. Here are some ways to bring down the cost of doing the nasty.

Getting There Faster
Lkng 4 R/T Hkup

Though online personals have finally shed most of the negative stigma associated with them, they still don't get enough credit for reducing the cost of dating. With the information you gather from corresponding online, you can pretty much skip the first-date conversation. And if you've got only sex on the brain, and if you're able to find a willing participant, you can the skip dinner and drinks and get right down to business.

You wouldn't be the first straight guy to troll for fag hags in a gay bar.

Trolling

You won't have to buy anybody any drinks if you go out at last call looking for action. That's the hour of desperation, when the people who are already drunk start looking to get laid. Is trolling pathetic? Very. And don't pick up anyone too drunk to remember—that could lead to nasty next-day accusations.

★★★★★★★★★★★★★★★★★★★★★★★★★★★★★★
Where the Easy Girls Are
★ At "Ladies Night"
★ At dance clubs that don't charge a cover and cater to a suburban crowd
★ Anyplace where the drinks are put on slides, served upside down, or set on fire
★ On spring break. Wo-o-ot!
★ At any club that advertises itself as a good spot for bachelorette parties
★ At your friend's wedding reception
★ In Catholic school
★★★★★★★★★★★★★★★★★★★★★★★★★★★★★★

Dark Dating

To make a date go faster from bar to bedroom, bring him to a dark and loud venue. This ensures that you'll have to talk right into his ear and sit close to see him. It makes getting into his personal space that much easier, and getting into his bed just a natural extension.

SEXCESSORIES
Low-Cost Contraceptives

Condoms are free in most every gay bar in the country. Look for them in a bucket near the door, on the corner of the bar, or wherever they stack the flyers and gay newspapers. They're usually decent brands, but you're not going to find any French ticklers or Master Drill 5000s there.

Many major condom manufacturers offer a free sample from their websites, especially when they have a new model to promote. This is how you can get the Sex Machine 2300 and take it for a test ride. Go to the websites of all the major manufacturers and see what they're offering.

[Search Term: condom brands]

Warning: Condoms in the free jar usually expire within six
months. So don't bother picking up 50 of 'em.

Where to Get Free Condoms

★ Gay bars
★ Gay pride celebrations
★ Community health centers
★ Health clinics
★ College health centers
★ Women's health organizations like Planned
Parenthood
★ Homeless shelters
★ Sex worker drop-in clinics
★ Drug addiction program centers

Look for free lube
samples on manufac-
turers' Web sites and
anywhere you get
condoms.

Checkups and Tune-ups

Women's health centers like Planned Parenthood provide discounted services
on pregnancy testing, birth-control pills, morning-after pills, surgical abortion, and
testing and treatment for STDs. Their fees are on a sliding scale in proportion to
your income. Gay men's health centers and even some sex clubs have free weekly
test days for HIV and other sexually transmitted diseases. General city health clin-
ics offer these services as well, but they're no fun to hang out in.

[Search Term: "free HIV testing" YourTown]
[Search Term: "free HIV screening" YourTown]
[Search Term: "women's health center" YourTown]

Inspirational Movies

File-sharing websites are good for more than just music—they're great for
porn. Much of it is copyrighted and therefore just as illegal to download and share
as popular music, so don't say I didn't warn you. Also, don't download anything
without virus protection software. In the real world and online world both, unpro-
tected sex can be dangerous to your equipment.

There are stores that sell used pornography—magazines, VHS tapes, and
DVDs—and they're not as nasty as you'd think. They tend not to have a Web pres-
ence, so you'll have to find them on your own. There is also plenty of used porn to
be bought on both commercial and sex-related auction websites.

Masterpiece Theater

Strip clubs are not cheap, but there are discounts to be had. Many offer midweek happy hour and/or early-bird specials with free admission and/or cheap drinks. The drinks are sometimes cheaper than at dive bars, with nudity included at no extra charge. Other strip clubs serve free or cheap lunch buffets. Look up websites for all the local strip clubs to research their specials. And while you're there, look around. Many of these joints have printable coupons for free admission on other weeknights.

[Search Term: "strip clubs" YourTown]

Should you find yourself wandering around the red-light district without a coupon in hand (it happens), there are still ways to get in for less than full price. Convenience stores near strip clubs have stacks of coupons good for discount admission; you just need to know enough to ask for them. Also, if you frequent any one club, you can buy a multivisit discount pass. Ask the bouncers if they sell a "pack" of tickets.

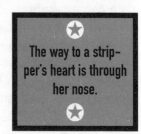

The way to a stripper's heart is through her nose.

SEX SELLS

Sex work pays great, whether you're actually having it with other people or not. Despite the negative hype, it's not terribly dangerous if you're smart about it. It's all about how comfortable you are doing it. You'll be able to find tons of free information on the Web about how to get started with any of the moneymakers below, so we'll skip the details here. Just remember, it's up to you to keep it safe and sane and on your terms.

Just like strip clubs, sex clubs have midweek and early-bird specials. (Unlike most strip clubs, however, some sex clubs have special prices for trannies.)

Hooking Assuming you don't want to work the corner, this means being an escort. You can advertise independently online or use a service to feel safer.

Pro: The pay is great.

Con: You actually have to put out, and the average client will be far from hot.

Erotic Massage Erotic massage is almost like regular massage, except you're usually both naked and you give him a hand job at the end.

Pro: You don't necessarily have to get massage-certified, and you can make clients shower first.

Con: It's a lot of work to schedule clients in your own studio, and if you do out-calls you'll have to lug that massage table around.

Voyeur Cams Voyeur cams are so very 1998. There are millions of them now, so the market is packed. Either get a gimmick (like a sorority cam or locker room cam), or just work as a "model" on someone else's camera site.
 Pro: You don't have to leave the house.
 Con: You can't ever leave the house.

Webmaster Become a porn Webmaster and charge a monthly or annual sub-scription fee for your movies or pictures. You'll need original models and movies to get any sort of large customer base.
 Pro: Even nerds can become pornographers.
 Con: It's a lot of work, and you won't necessarily make any money.

Pleasure Party Salesperson A pleasure party (a.k.a. passion party) is basically a Tupperware party except you sell massage oils and vibrators instead of plastic bowls.
 Pro: It's harmless and fun.
 Con: The money isn't that great. It's more like a hobby.

Spread Your Seed Become a sperm donor or egg donor. Men make money per "donation." Women make a lot more, but they have to undergo invasive surgery.
 Pro: The pay is good and the effort is low.
 Con: You'll have to meet rigorous qualifications—be smart, tall, not bald, and of a certain ethnicity. Also, you might end up having lots of kids you don't know about.

Used Goods There will always be a market for used (dirty) underpants, socks, and other intimate apparel. You can't officially sell them on eBay, but there are sev-eral other sites where you can.
 Pro: You wear socks and underwear anyway. Selling them is less effort than taking them to the Laundromat.
 Con: You have to include pictures of yourself in them to advertise them, so even though you're not doing pornography you're still doing pornography.

Porn Actor/Model You'll have to pose naked at the very least, or have sex on camera at the most.

Pro: If you're not ashamed of your body, why not get paid to show it off?

Con: The pictures/movies never go away. Goodbye, political career!

Fetish Assistant Help clients live out their fantasies of being beaten, or engage in things like crushing bugs or stepping in goo.

Pro: It's good money and you don't have to have sex with anybody.

Con: The clientele can get real creepy.

A Few Other Sex-Related Jobs:

★ Erotic fiction writer

★ Porn reviewer

★ Photographer or videographer

★ Nude houseboy

★ Sex advice columnist

★ Go-go boy or girl

★ Web designer, writer, or programmer for porn websites

★ Phone sex operator

★ Stripper

★ X-rated-cake decorator

★ Body hair waxer

★ Shoe shiner

★ Safe-sex educator

★ Spray-tan-business operator

★ Body piercer

★ Corset maker

★ Porn store clerk/mopper

CHAPTER 7 ★

Keeping Busy: Other Entertainment

Do you really need to be crammed into the backstage VIP area doing body shots out of strippers' navels every night? I mean, that's fun a couple of times a week, but don't you think you could broaden your horizons a little? There are plenty of ways to keep yourself entertained that don't end in you blacking out, yet are more active than sitting on your ass in front of the television. It probably wouldn't kill you to get some culture.

Perhaps more important than becoming a well-rounded person is finding more free stuff to do. You may not be generally interested in professional wrestling, but what if you got free tickets to the Ultimate Bitchslap XVIII? Of course you'd go. The same might be true of Shakespearean theater, comedy shows, art openings, and opera. If it's free, why not? And the entertainment you already know you enjoy, be it football games or books or whatever—you might do more often if it were less expensive.

THE LIST OF IT

Because this chapter covers a lot of ground—art, sports, television, books—there are a whole lot of email lists involved. You're probably sick of signing up for them, but you need to get over that. The more lists you're on, the more free stuff you get. Just sort through them in the morning while you're waiting for the hangover to go away and the coffee to kick in.

This first group of lists will give you the low-down on general entertainment. Activity-specific lists will come later. Just you wait.

Local Newspapers, Alternative Weeklies, Neighborhood Newspapers, and Local Magazines

Each type of rag specializes in different discounts. Daily newspapers advertise contests and giveaways for the upscale events like the symphony, opera, and expensive mainstream concert venues. Alternative weeklies such as The Boston Phoenix or SF Weekly promote free advance movie screenings and sponsor mid-size rock shows. Neighborhood papers list art studio events and store sales in the 'hood. Local glossy magazines like Philadelphia and Los Angeles throw high-end fashion and beauty parties with ticket giveaways and gift bags. Because the circulations are relatively small for these publications, you can win tickets to events on a regular basis.

Entertainment Listing Websites

Entertainment websites and email-only nightlife listing services give away a ton of tickets to clubs, liquor tastings, and small rock shows. These sites include nationwide companies like CitySearch.com (part of the family of companies that includes TicketMaster) and (America Online's) DigitalCity.com, ones that cater to a smaller subsets of cities like FlavorPill.com, and single-city websites (San Francisco has ones called Nitewise, Nitevibe, and IllStatic). Do a search for these types of sites and you'll find half a dozen you never knew about. Each one has some kind of hookup to promote.

[Search Term: Entertainment MyTown]

Other Websites, Bulletin Boards, and Event Calendars

Check the noncommercial sources of information too. You'll find 1,460,000 different "free things to do in Atlanta" Web pages, but most of them will list the same 10 tourist spots that have good views. Check community bulletin boards (like Google Groups), personal websites, and event calendars for information that's updated from day to day. It's on these pages that you'll find mostly small, offbeat, and (frequently) freaky and creative things to do. They won't get delivered to your inbox, but if you find them all and save them in your browser's "favorites," you can always scare up something to do on a Tuesday night.

[Search Term: "free things to do" MyTown]
[Search Term: wild things MyTown]
[Search Term: event listings MyTown]
[Search Term: event calendar MyTown]

BETTER THAN *CATS*: THEATER, OPERA, AND SYMPHONY

What do these things have in common? They're usually crazy expensive, and the same bunch of snobs goes to them. (On the other hand, not everybody can be club trash.) But what they also have in common are many opportunities to get around paying full price.

Sign up for email lists in the hopes of winning tickets or hearing about sales and promotions. Go to the websites for every theater company, dance troupe, and performing arts venue, the symphony, pops, and opera, and look for the newsletter link.

[Search Term: theater OR theater MyTown— capitalize "OR" to get both words]
[Search Term: dance MyTown]
[Search Term: "performing arts" MyTown]
[Search Term: symphony MyTown]

[Search Term: opera MyTown]
[Search Term: ballet MyTown]

Go When It's Cheap

Live performance venues sell matinee tickets to some plays, musical theater events, and other shows at ever so slightly reduced prices. Some productions are less expensive during the week than on the weekends. (Look for a seating-and-price chart online. It will lay everything out.) Many live theater performances offer one or two preview or dress rehearsal shows at the beginning of the run that sell for almost half price.

Go Where It's Cheaper

The actors, singers, musicians, and dancers on Broadway are generally going to be higher-caliber performers than those you'll find at the Broadville High School spring musical. On the other hand, at the average high-end show you're paying more for the schmaltz like rotating stages and gold-covered opera houses than you are for the performers.

Look not only in regional theater and off-Broadway (wherever your Broadway happens to be) but also at music and performing arts colleges. There are tons of student shows (which keeps them inexpensive), and they often need help ushering (which can make them free). Any of the tricks for getting into nightclubs or rock shows apply to theater and dance shows—if you help publicize the performance or get to know a player in it, you'll get in free.

★★★★★★★★★★★★★★★★★★★★★★★★★★★★★★★
Sneak In

You can sneak into performances after intermission if you don't mind missing the first half of the show. This is known as "second-acting." Find where the smokers go outside and try to blend in—dress nice and carry a Playbill (rolled up so that they can't see it's for Starlight Express from 1983). Then walk in and find a seat for Act 2.
★★★★★★★★★★★★★★★★★★★★★★★★★★★★★★★

The Student Discount

Use your student ID to get deep discounts on the most expensive cultural events in town.

★ The standard student discount is good at most performing arts shows. There may be a limit on the number of discount tickets sold per performance, so you'll

See Chapter 12 on how to get a student discount without being a student.

have to buy them soon after they go on sale.

★ "Student subscriptions" are like season tickets but at a much lower rate. Unlike season tickets, there are a limited number of these and they always sell out. Even if you're only planning to attend an event or two, you can sell off the rest to your friends for the other performances. Search online or call the theater to see if they offer these subscriptions and when they go on sale.

★ Student Rush and Senior Rush are day-of-show tickets available to people willing to wait in line. At most places, you show up at a prescribed morning time and to see how many spare tickets are available. They sell for a low cost—10 or 20 bucks apiece. At some theaters, there is an info line with a recording stating how many rush tickets will be available that day, so you'll know if you should bother or not. [Search Term: "student rush" MyTown]

Feel the Rush

You don't always have to be a student to get rush tickets. Some companies offer a combination of student tickets and a discount ticket lottery. Study the venue's website even if you're not in school.

Season tickets, whether for baseball or symphony season, are a better deal if you go frequently. You can divide up the tickets with a friend and decide which shows you want. It's the cultural version of buying in bulk.

Standing Room Only

Standing-room-only tickets do still exist, and they're still dirt cheap. Like student rush tickets, these are also offered first-come, first-served and available on the day of the show only. Most of the time you're only allowed one ticket per person, and they're cash-only.

If you get an SRO ticket and get inside the theater, immediately start being friendly and/or flirty with the ushers. If there are empty seats, they can put you in one. Sometimes you'll end up front and center in the VIP seats with the big cheeses sitting behind you.

Warning: Expect to stand a lot in the standing section. Wear sensible shoes.

Ushering

Though at the city symphony or opera the ushers are paid and wear tuxedos to work, many smaller venues (and all of the collegiate ones) rely on volunteers. They work as ushers seating patrons, ticket takers taking tickets, and security staff preventing people from going out emergency exits. In return for their help, the volunteers see the show for free that night. Some usher programs are so popular that you have to sign up to do them months in advance—even before the tickets go on sale.

On a sick day or while you're at work, spend some time researching venues. Check their websites and call the box office to inquire if they have volunteer usher programs. (They don't publicize the programs so well. They're an in-the-know hookup.) Then when you hear about an upcoming tour of The Lion King you'll know all the right numbers to call.

Give at the Office

Many of the uppity cultural performance companies need both ticket sales and major donations to stay operational. (It takes a lot of cash to keep the chandeliers lit.)

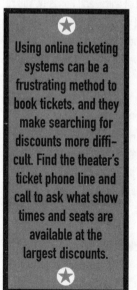

Using online ticketing systems can be a frustrating method to book tickets, and they make searching for discounts more difficult. Find the theater's ticket phone line and call to ask what show times and seats are available at the largest discounts.

There is a paid staff that works on fund-raising full-time—putting on charity galas and getting rich old ladies drunk at lunch to increase their donations. Still, there may be opportunities for you to volunteer at the office or at events to earn free tickets for your time. Look online for volunteer opportunities at specific companies. Find the number for the "development office" (or wherever you buy a membership) and ask the person on the phone for the inside scoop.

Also, a lot of companies have "friends and family" days. Those are performances for which friends and family of the staff can buy low-cost tickets. If you know anyone who works, volunteers for, or is in the local opera or symphony, ask if they'd let you know the next time the discount is offered.

Free Day

Sometimes the fancy-pants types are so kind as to perform for the general public rather than just the snoots. They don't want you messing up the theater, so the performances are often held in public parks. Check their calendars.

[Search Term: "free opera" YourTown]

[Search Term: "free symphony" YourTown]

[Search Term: "free Shakespeare" YourTown]
[Search Term: free "in the park" YourTown]

CABLE ACCESS

Sitting at home in front of the television is an important part of the rock and roll lifestyle—the part where you're too hungover to move. Sometimes you just don't have the energy to leave the house or the ambition to entertain yourself. And televisions are an inexpensive, one-time purchase.

It's when you order up cable and start paying 50 bucks a month that you're making a larger lifestyle choice. That's when you've crossed the line between watching TV when there is nothing better to do and deciding that you'd rather watch television than do something else. Think of all the better things you could do with that $500 a year and all the better things you could be doing with your time instead of sitting in front of the idiot box.

The List

Signing up for cable networks' email lists is a lot of work, and honestly, you're not going to get free cable for a year. More likely you'll win a limited-edition Six Feet Under mug, if anything. There are more contests and offers on the local affiliate channels for each network station. So you might do better with the local NBC affiliate rather than NBC.com.

If You Can't Be Convinced to Cut the Cord...

In the past you only had to decide whether to get cable, and then what extra channels to pay for. Now you've got to choose among satellite, regular, and digital cable, then carriers, then premium channels. It's not just a matter of price—some companies don't carry all the channels that you'd assume are on basic cable, and others give you national channels but not local ones. Take the following into consideration before you sign up.

★ Can you bundle it? Digital cable can be bundled with Internet service and sometimes land and wireless phone service also. (Can you say "monopoly"?) Bundling brings down the cost of each service.

★ Do you need local television channels? Some satellite services don't offer local channels, or if they do, they come at an extra cost.

★ Are you just getting it for movies? If so, Netflix or another DVD rental service will cost much less than basic cable plus movie channels.

★ Are you planning to get TiVo or other television hard drive? That will be another bill to pay each month. Perhaps renting the whole season of old television shows on

DVD is less expensive than recording them all and paying for two services to do it.

★ Can you see what you want somewhere else? Sports bars and restaurants play sports. Gay bars show popular sitcoms and cable hits. Any friend addicted to a cable show will be glad to have you over to watch it. Make it a weekly event.

★★★★★★★★★★★★★★★★★★★★★★★★★★★★★★★★★★
Hacker
Stealing cable is sick and wrong and if you do it you will burn forever in hell. So make sure not to get caught. Most people who steal cable buy basic cable then find a way to hack the box to get free premium channels. This usually works for a year, then the cable company finds a way to thwart the hackers, then you start all over. Educate yourself on the potential pit-falls (such as breaking your equipment) and downfalls (getting caught in a sting operation) of what you're doing and decide whether it's worth what you save.

Other people steal the cable from their neighbors or share it with them and split the bill. You can also do this with DSL to wire your whole building for one low price. It's still illegal, but not as easy for you to get caught.
★★★★★★★★★★★★★★★★★★★★★★★★★★★★★★★★★★

Download, Don't Subscribe
In these days of high-speed Internet and file-sharing applications, it's easy to download television shows, video clips, music videos, movies, and specials to watch on your computer monitor instead of your TV screen. You won't be able to find every show on every channel, but people always record the popular series and cable dramas.

The best shows and movies to watch on your monitor are cartoons. The resolution is lower, so the file sizes are smaller. You can find every episode of prime-time cartoons like The Simpsons, South Park, and King of the Hill online, in addition to some animated movies.

DISCOUNT CINEMA
Some people think of hitting the movie theater as a good group or date activity, but those people are crazy. You sit in the dark and don't talk; how is that social? And with ticket prices topping 10 bucks per film, going to the movies is no longer cheap entertainment.

Titanic Amounts of Spam
You've already signed up on the email announcement lists for your local news-

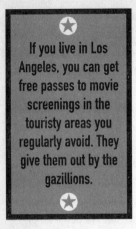

If you live in Los Angeles, you can get free passes to movie screenings in the touristy areas you regularly avoid. They give them out by the gazillions.

papers, radio stations, and television network affiliates. Those are the outlets that give away the majority of free passes to movies.

The movie studios themselves don't usually offer free movie passes—they leave that to the local venues. Occasionally you'll win promotional materials from their email lists, such as T-shirts and posters. The bigger studios (like Sony Pictures and Universal Studios) sponsor larger contests (like trips to movie premieres in Hollywood or New York, or vacations to the destinations where movies were filmed).

Some individual movie theaters have mailing lists that include information about sneak previews. To find them, look in the newspaper or on the Moviefone website for a list of all theaters in your area. Then search for the movie houses' individual websites and look for an email list.

[Search Term: movie studio websites]

[Search Term: movie theaters YourTown]

Sneak Previews and Advanced Screenings

Sneak previews are a buy-one, get-one-free package, where if you buy a ticket to a movie that's currently playing at a certain time, you'll be able to stay in the theater to watch an about-to-be-released movie a week or two before its opening day. They announce sneak previews in television or radio ads, but some movie websites like Moviefone's send out announcements about them as well. Join mailing lists for movie websites to see what you can get.

Movie ticket takers aren't so fussy about verification, so you can even create a fake student ID or use an expired one from 10 years ago.

Advanced screenings are pretty much the same thing, but you don't have to buy another movie ticket to get in. Local newspapers (especially alternative weeklies) and radio stations give away the tickets. Sometimes they treat the tickets like prizes you win, and other times they'll announce to everybody where they can go pick up tickets on a first-come, first-serve basis. Either way they give out hundreds more tickets than there are seats in the theater. You need to get to the show almost an hour in advance or you won't get in even with your ticket. Go early and bring a book.

Matinees

Matinee movies are discounted before 5 P.M. on weekdays and until noon on weekends. In the olden days (the 1990s) the standard daytime price was half that of a regular ticket. Now, you'll get in for 8 bucks instead of 10. Thanks for nothing, you Hollywood bastards!

Student Discounts

There are a few theaters in the world that offer matinee prices all day long to students who show ID.

[Search Term: movie theater student ID YourTown]

Friends With Hookups

Movie theaters extend professional courtesy to employees of other movie theaters. The free tickets they get make the lives of underpaid cinema employees a smidgen better. If you know anyone who works in a theater, hit them up for free admission—their manager just has to call another theater to get you both in. If you're the sort of (loser) person who sees every new film that comes out, you'll save about 50 bucks a month taking a part-time job at the local megaplex.

Once You're In, You're In

Ahh, the classics. In most places, your ticket gets ripped at the entrance to the building or to the wing of the theater—not to the individual movie. So once you're inside, you can stay as long as you want, moving from room to room and catching everything playing. With old movie houses being subdivided into smaller and smaller rooms, more movies are playing, so there is more of an opportunity to take advantage of this.

> ★
>
> Sometimes you can scam the student discount without owning an ID at all. Buy student-rate tickets in advance from regular ticket outlets. You're supposed to show proof of student ID at the will-call window to pick them up, but at many venues they don't actually check for it, and even if they do, they won't deny you the ticket if you say you forgot it.
>
> ★

★★★★★★★★★★★★★★★★★★★★★★★★★★★★★★★★★
Know When to Fold 'Em

In larger megaplex theaters you can get away with unlimited movies for the price of one. Fold your ticket along the perforation to make it look

like it was already ripped when you entered the theater. The door guy thinks you're returning from a trip to the restroom.

After watching the film, go outside and take your unfolded, "unused" ticket to the cashier's window and make up an excuse about why you were unable to attend the showing that you just attended. (Your wife went into labor, your car broke down, your dog ate your shoes.) Ask to exchange that ticket for one to a showing on a different day.

If they refuse, you already saw the movie, so you can't lose. If they say yes, when you come for the showing of the later movie, exchange it for one you haven't already seen.

Beyond the Multiplex

There are plenty of other (cheaper) places to see movies than inside a theater.

★ Free, city-sponsored outdoor movie summer nights. They set up a big screen in a public park, and everyone brings blankets to sit on (and wine to drink) while watching.

[Search Term: "summer movie series" YourTown]

[Search Term: "summer cinema" YourTown]

[Search Term: "outdoor movie night" YourTown]

[Search Term: "movies in the park" YourTown]

★ Some bars, restaurants, and especially breweries sponsor underground or indie-movie series as well.

[Search Term: "movie night" YourTown]

★ Colleges and universities show low-cost movie nights during the summer and sometimes year-round. Search for "film night" or "movie night" on local schools' websites.

★ Museums, galleries, and film archives show classic films and art films for less than full prices.

> ⭐
> **Buy in Bulk**
> Some movie theaters allow you to buy a pack of 10 advance tickets for a reduced price. You have to use the tickets before a certain date—something like six months from purchase.
> ⭐

[Search Term: "movie archive" YourTown]

[Search Term: "film archive" YourTown]

[Search Term: "television archive" YourTown]

[Search Term: gallery film YourTown]

Thanks, Boss

Some major corporations, hospitals, and universities sell discounted movie

tickets out of the human resources department to their staff and students. The tickets work like gift certificates—you can see any movie with them—so you can buy them in bulk and use them at a later date. Ask your H.R. representative or look around the employee programs section of their website.

Stating the Obvious
Eat before you go to the movies, or bring your own food.

HOME THEATER: MOVIE RENTALS

If you wait until movies come out on DVD, you'll not only pay less to see them, you'll get to avoid the crying babies, obnoxious teenagers, and people who leave their cell phones on, who all make the theater experience a true delight.

Free and Easy

Public libraries are more than places to take out books and watch the homeless nap; they're slowly moving into the digital age and renting out DVDs. Currently, most libraries have a stock of worn-out classic films and instructional shows on VHS. They probably won't have Spider-Man 12 the week it comes out on DVD, but borrowers can't be choosers. Catch up on your classics instead.

Rent in Bulk

Many video stores have bulk-rate plans. You pay for 20 rentals in advance at a discount rate.

Rent by Mail

Mail-in DVD rental services like Netflix will be the death of the corner video store. You pay a monthly fee to have a certain number of movies out at the same time. You never pay late fees, postage is included, and you never have to walk the block and a half to return them. If you rent a couple movies every week they're cheaper than the video store. Other companies are getting into the game by applying the same strategy but specializing in adult films (i.e., porn), foreign films, independent cinema, and video games.

If you've got too much time on your hands, try an exciting career as a movie extra. The pay is less than that of farmwork, and 90% of the time you just stand around, but if you're unemployed or on summer break it will give you a reason to leave the house. [Search Term: "movie extras" YourTown] [Search Term: "film extras" YourTown]

If you work for a huge corporation, take a good look at the fringe benefits on your human resources page. Hookups can include discounted movie tickets, amusement park passes, gift certificates, hotel rooms, lift tickets, and ski cabin rentals.

Warning: By the time this book comes out, this advice could be completely outdated.

Online Cinema

As with television shows, you can use file-sharing services to download and watch full-length movies on your monitor. Movies on DVD are over five gigabytes in size, but people scan them in and reduce them. Still, to see a standard movie at any worthwhile resolution takes up at least 600 megabytes of space on your hard drive. That not only leaves less room on your computer for your music collection—it takes a heck of a long time to download.

Warning: Every time you use a file-sharing application, a record executive kills a puppy.

Bring It On Home

If you're going to buy DVDs, you may as well buy them used. Look in used record shops first (since you probably spend too much time in them anyway), as they have good prices and return policies. If it's a blockbuster movie, check out video rental stores (like Blockbuster) a month after the movie came out on DVD, when they're selling off the extra copies. Also check the video area of thrift stores—nobody thinks to look there and you can find some gems on DVD amidst the piles of unused Thigh Master videos.

Once you've exhausted all the stores within walking distance, look online. You'll find anything you could want on eBay, in the used section of Amazon.com, or on any number of other used DVD websites. You'll have to pay postage, so make sure the total comes to less than the cost of a new copy.

[Search Term: used DVDs]

Lose the Late Fee
If you're turning in a movie late, put it in the drop box outside. Then next time you come in, claim that you turned it in early and they must not have emptied their box on time. Most video stores, even the chains, will let you get away with that once or twice.

The Interpersonal Loan

All your friends have DVDs too. Why rent when you can borrow?

ART GALLERIES AND MUSEUMS

Private galleries are free to enter, but most of them have just a single artist's work or a fairly small collection. Museums aren't overpriced, but they ain't cheap either. Time your life right so you hit the museums when they're free and the galleries when they're freely giving you drinks.

Sign Up

Museums don't enter you to win a Warhol when you sign up for their email lists—they don't give away anything, for that matter. But you'll benefit a bunch from gallery and art association e-mails. Galleries have regular openings with new art to enjoy along with the free wine and cheese.

> Warning: Some art can only be appreciated under the influence of alcohol.

Every time you go to a gallery, sign the register. Some spots are uppity and old-school, so they send out postcard announcements only. Also search online for every gallery in town and sign their email lists. You'll be able to hit several openings each week.

[Search Term: gallery YourTown]

[Search Term: "art fair" YourTown]

[Search Term: "art walk" YourTown]

[Search Term: "open studios" YourTown]

[Search Term: "galleries open late" YourTown]

[Search Term: "gallery opening" YourTown]

[Search Term: "art dealer association" YourTown]

FREE ART

That Time of the Month

Most museums have a monthly free day or a "pay what you wish" day. Study each museum's website or search for a list that someone else has already compiled.

[Search Term: "free day" museums YourTown]

Art on Sale

★ Some public museums have a discount time slot when they're open late, such as half-price admission after 6 P.M. on Thursdays.

★ Virtually all museums offer students and senior citizens discounts.

★ A few places will give you a buck off admission if you show proof that you took public transit to get there. Save your transfer.

Gallery-Hopping

Galleries are usually small and often snooty; you probably won't spend a lot of time in them. But art dealers associations in many different cities sponsor and coordinate monthly "first Thursdays" (or some other night) when multiple galleries stay open late to premiere new work. You can skip from one gallery to the next, sucking back wine and cheese at each. Also, they're good places to score dates with sexy freaks.

BLAH, BLAH, BLAH: TALKS, READINGS, AND LECTURES

I you're entertained by people talking at you, there are endless ways to keep yourself busy. There is always some author in town trying to hock her book, a social worker telling you how to live your life, a politician droning on about whatever, or some educator trying to educate you. This form of distraction is usually free or at least cheap.

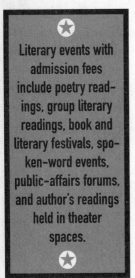

Literary events with admission fees include poetry readings, group literary readings, book and literary festivals, spoken-word events, public-affairs forums, and author's readings held in theater spaces.

What's the Word?

Most of the hard work in attending talks and lectures is in finding the good ones. Look for a website that lists readings around town. The best place for this is the major newspaper, but sometimes the alternative weeklies, arts organizations, and Web-only listing services post information as well. You can also look on the public library's website or on the websites of clubs in which you have interest, be they bird-watching or BDSM.

[Search Term: "literary events" YourTown]
[Search Term: "literary arts" YourTown]
[Search Term: "lecture series" YourTown]
[Search Term: "literary arts" YourTown]

Other Types of Talking Entertainment

★ Health and research lectures at hospitals and medical schools

★ Graduate-level lectures at local colleges and universities—look up the departmental calendars for your areas of interest

★ Government and political meetings. Sit in on gatherings for city or county supervisors, redevelopment committees, town planners, public-comment forums, etc.

★ Court trials and small claims court

★ Book clubs and writers' groups

★ Comedy clubs

★ Crazy, rambling homeless people

★ Drunks

BOOKS: READING WRITING

Books and magazines really aren't all that expensive, but that doesn't mean you should go ahead and pay for them.

Warning: if you don't pay for this book, all your hair will fall out.

Where the Books Are

I hope you don't think you're too good for the public library, because it's the best deal in town. It's got books, magazines, every newspaper around, and tons of other freebies. But let's stick to books for now.

Most of the library's collection is donated. This means it stocks all the romance novels and best-selling spy thrillers you could want. It's not so highbrow. Better yet, the local library system will deliver materials from any branch to your local branch for free. So even if your closest library in West Hollywood specializes in lesbian parenting, you can get Better Sex Through Scientology sent over from the main branch.

Your reading list isn't even limited to books the library currently carries. In some cities, you can put your name on a waiting list for the ones it doesn't yet carry. If it they ever come in, you'll get a call. Sweet!

Libraries are also rapidly advancing in technology, putting their catalogs online and allowing you to request materials in advance. Then you can double-park outside the local branch and run in to grab the stack waiting for you at the front desk. You can also renew books online when you're too lazy to get off the couch.

I Love the Library

Sure, homeless people shave in the bathroom and there always seems to be a creepy old man lurking about, but you can get so much free stuff at the library, it's totally worth the hassle.

★ Borrow books, videos, CDs, DVDs.

★ The intralibrary loan system will send materials to your local branch. It may be closer than the video store.

★ Again, request new books—if they ever come in, you'll get them first.

★ Fix your own damn sink using how-to books and videos.

★ Some libraries loan out art to hang in your apartment.

★ Reserve free meeting-room space.

★ Attend lecture series, ranging from community issues to pretentious academic crap.

★ Make your commute less hellacious by borrowing books on tape. (Some libraries allow members to download them in mp3 format.)

★ Learn a new language with instruction tapes and videos.

★ Rent videos about foreign lands for a stay-at-home vacation.

★ Get online for free at Internet terminals.

Free Text

By 2001 we'll all be using the metric system and everybody will read books online. Oops! That didn't happen. But there are tons of classic books (ones with expired copyrights) online that are free. Read them on your desktop while pretending to work, or save them to your PDA to study on the train during your commute. The texts have no formatting, but it's easy to import them into Microsoft Word or something and change the font. A recent gander at what's out there turned up The Scarlet Letter, everything by Shakespeare, Anna Karenina, and Assembly Language Programming for the Atari Computer.

Start at this site, which links to over 20,000 free texts:

http://onlinebooks.library.upenn.edu (Note that there's no "www.")

[Search Term: "full-text books"]

Cheap Books

Used bookstores are a lot like used clothing stores. Some sell vintage merchandise in mint condition at high prices. Others are like thrift stores, specializing in quantity over quality. Know the difference between "rare books" and "used books" and you'll do fine.

Speaking of thrift stores, check there for reading material as well. They're often organized by category, but only loosely, which makes for entertaining browsing when you don't have anything specific in mind. You won't find last year's best seller, but they often have tons of coffee-table picture books, self-help from the 1980s, and 200,000 copies of National Geographic. The prices are less than half of those at used bookstores, and the selection is better than at your neighbor's garage sale.

Borrow

"Read any good books lately?" you ask your friend.

"Why, yes," your friend replies. "I recently discovered the joys of this obscure author named John Grisham. You simply must read his work."

"Really," you say. "Might I borrow a book from your collection?"

Book Clubs

Commercial book clubs are like music clubs of old—you get the first five for 99 cents when you agree to purchase four more at regular price. The books are heavily discounted, but then again, the shipping is expensive. You might find book clubs useful if you read a lot of books in one genre, such as best sellers, romance novels, children's books, or history.

Book Money

You're not going to get rich selling books, but doing so is a great way to reduce your clutter and make enough cash to buy some new clutter. See Chapter 9 for the 411.

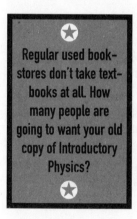

Regular used bookstores don't take textbooks at all. How many people are going to want your old copy of Introductory Physics?

Textbook Treasure

When selling college texts back to the bookstore at the end of the semester, do it on the way home from the final. Bookstores will only buy so many copies of each text, so it's best to be first in line. You can also sell your books to online companies such as BigWords.com. They'll pay for a lot of books that your school's store won't. (You may not get as good of a deal, but some money is better than none.) You just type in the ISBN number of each book and see what they offer.

[Search Term: "buy used textbooks"]

MAGAZINES
Sign Your Name

Magazine email lists are no good for getting free issues, but they do have good contests from their advertisers. You might as well join any list you can find.

The First One's Free

Many magazines will send you a free sample issue or two to entice you to subscribe. As the offer says, you can simply write "cancel" on the bill when it comes.

Consider It a Waiting Tax

The longer the dentist or doctor makes you sit in the waiting area before your appointment, the more magazines you can feel justified stealing.

Reduce, Reread, Recycle

Recycling day is a great day to look in your neighbors' bins for their tossed magazines. There's nothing quite like digging through the trash for Vogue.

And It's Free

The library has tons of magazines there for the reading. Just remember that you can't cut out the pictures to add to your Fabio fan collage.

Surfing Mags

Many publishers put a few articles from each issue on their websites. Some post the text of the entire issue after the next one is released. If you really read the magazines for the articles instead of the free perfume samples, then you might be able to find the text you want without subscribing.

Let It Lapse

Unless you can't stand to miss a single issue, let your subscription lapse. Then subscribe again to get the free goody package they offer to new subscribers.

CHEAP SHOTS: DISCOUNTS ON SPORTING EVENTS

Luckily, not all sports are golf, and not all sporting events neuter their fans like golf tournaments. Not only can you clap politely in between plays, you can scream obscenities at the players, get in fights with other crowd members, paint your beer belly and take off your shirt, and get wasted enough to vomit. That sounds like rock and roll to me.

Sign Up

Look for giveaways, free tickets, and other promotions on sports-themed news websites (like ESPN.com), in local newspapers, on local teams' websites, and on sports-radio websites.

[Search Term: sports YourTown]

When It's Cheap

In the beginning of the season you'll often find lower ticket prices to sporting events, especially when you're on the East Coast and the beginning of the season

is in freezing cold April. For other sports you'll find weekday and matinee pricing. Afternoon games are cheaper than night games, and some teams offer discounted Wednesday night games. (With $2 hot dogs!)

Where It's Cheap

Amateur sports are cheaper to watch than the pros. If you just want to get drunk and heckle, look into semipro, college, high school, and even intramural games.

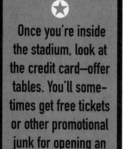

Once you're inside the stadium, look at the credit card—offer tables. You'll sometimes get free tickets or other promotional junk for opening an account. Then you can cancel the card once you get the tickets.

Season's Greetings

Season tickets are like a VIP pass, even when you're sitting in the bleacher seats. And knowing someone who has them is a lot cheaper than buying them yourself. Just brownnose him when you go to the games. When a friend hooks you up with an extra ticket, buy him beer and food and leave him with the impression that you're the best person he could ever want to go to a game with. Then he'll ask you again next time.

Steal Bases

Pay for a cheap seat, then switch to a better one once you're inside. Your best opportunity for upgrades comes during the unpopular games (more empty seats). Your success at this depends on the usher of the section you're trying to sneak into. But you can always bribe him. The cost of the bribe plus the original bleacher seat tickets will still be less than the seat price in the better section. And at worst you'll get kicked back to your original seats. You never get ejected entirely.

Group Membership

If you and your buddies go often, get some season tickets and split up the games among the group. If you're the person who takes charge to buy the tickets in the first place, the others will tend to give you first dibs on any games they signed up for but can't make.

Last-Minute Seats

Many people sell their extra tickets before games at less than face value—even when the game is sold-out. Check on community websites like CraigsList.org

or the bulletin boards on the team's website. You'll often find cheap tickets for sale by someone who doesn't want to bother scalping.

Drinking Indoors

If you're going to save money by smuggling in liquor, get a flask that's 100% plastic. Otherwise, you'll get busted by the metal detectors used to keep out terrorists. The detectors can even find the tiny metal caps of airplane bottles. You can find plastic flasks in drugstores.

Buying From a Scalper

When buying scalped tickets, be on the lookout for fakes. This shouldn't be a huge concern for the average game, but at popular games and events at large venues like Madison Square Garden, they'll be far more prevalent. Check for spelling and capitalization errors, check the quality of the paper, and look for a watermark or holographic band.

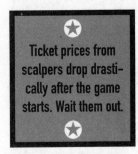

Ticket prices from scalpers drop drastically after the game starts. Wait them out.

Avoid the scalpers who are obvious pros, ruling the corner. Instead, buy from the guy looking to sell the seat next to him that his buddy didn't take, or from the dad with the crying kid. They'll not only have legitimate tickets, they're not going to gouge you.

Promos

Be on the lookout for promotional days. They'll be advertised on the team's or tournament's calendar. Sometimes they'll only give out junk like hats or noisemakers, but on other days they're ways to get at a discount. For example, a pro tennis tournament might offer a "bring a racket" day, where a donated racket earns you free admission inside. Used rackets cost 2 bucks at thrift stores. That's a lot cheaper than a $30 ticket.

Do It Yourself

Or you could just get off your ass and participate in some sports instead of watching other people do it. Playing alone (as in running or weight lifting) or with a team (with your friends or intramurally) is a lot less expensive than watching other people do the same thing.

OTHER FREE EVENTS AND ENTERTAINMENT

★ Take new cars for test-drives. Especially cars you could never really afford. Go when they're offering free stuff like ski tickets just for coming in.

★ Go window-shopping. Just because you can't buy something doesn't mean you can't look at it. Check out rich people's houses on open-house Sundays, or tour high-rise condominiums when they're first advertised.

★ Hit a street fair or festival. Most newspapers publish a list of all of them at the beginning of the summer.

[Search Term: "summer guide" YourTown]

[Search Term: "street fair" YourTown]

★ Check the chamber or commerce or tourist board website and take in all the free attractions you've managed to miss.

[Search Term: "tourist board" YourTown]

[Search Term: "chamber of commerce" YourTown]

[Search Term: "visitor guide" YourTown]

★ Go to cultural events sponsored by ethnic or foreign culture societies.

[Search Term: "cultural center" YourTown]

★ Go on a walking tour. Many walking tours are given for free by kindly (bored) citizens.

[Search Term: "free walking tour" YourTown]

★ Similarly, bicyclist clubs sponsor free bike tours, and bikes are inherently hipper than feet.

[Search Term: "bike tour" YourTown]

> Share a newspaper subscription with your neighbor. This works best when you go to work at different times so that you can each read it in your version of "morning."

★ Check out the farmers market. Even if you don't eat vegetables, there are always street performers to take in.

★ Attend a music festival—it could be jazz, blues, electroclash. These should also be listed in newspapers' summer guides.

[Search Term: "festival" YourTown]

★ Attend or perform at an open mike night. Every pseudo-bohemian coffee shop will have one. It's not always quality entertainment, but it's often free entertainment.

★ Try karaoke. Because most people need to get to a certain level of drunk before they'll take the stage, karaoke bars rarely charge performers. They make their cash on drinks. Sober show-offs can keep themselves in the spotlight for free.

Warning: Street fairs are free, but they gouge you on the churros.

Chapter 8 ★

Fancy Feasts: Saving on Sustenance

To some people, fine dining is fine living. They spend hours out at good restaurants talking with friends, pigging out on high-quality food, and being tended to hand and foot by the servers who act as personal valets. To others, food is just the junk that makes you fat and inhibits alcohol uptake. Either way, eating out can be extremely expensive. So can cooking at home if you buy all the fancy-brand ingredients. Whether you spend your time at Chez Pou-Pou, getting the poo-poo platter at the Chinese takeout, or just cooking up some crap at home, you can save big on food if you do it right.

PLAN OF A SNACK

You might not want to schedule your whole day around free Chex Mix, but snacks can make a place worth a drop-in on your way to somewhere else.

Supermarket Samples

To ensure maximum snackage, stop by the right grocery stores on the right days. The best spots for samples are warehouse-style "big box" food stores and gourmet groceries: Bulk-food supermarkets like Costco and Sam's Club put out a lot of food in their bakery sections, since they know it takes some convincing to get you to invest in a 300-pound box of doughnuts. High-end stores like organic groceries, cheese shops, and upscale food shops like Whole Foods serve up more stuff than at regular supermarkets—since they charge the biggest markup.

Saturday afternoons are prime time for samples. That's when busy moms take their time at the store, as opposed to rushing through on weeknights. (If you work on weekend days, do a run-through of the nearest grocery store on your coffee break.) Another good time to stop by the supermarket is around noon on weekdays. More and more, the stores try to sell fresh lunches and salads, and they're likely to give out samples of already prepared foods like pizza.

Art Openings

Gallery owners are often kind enough to put out cheese and crackers with which to cleanse patrons' pallets between glasses of the (free) wine. Even if you're not thrilled by the art, you can enjoy the crowd, the booze, and the food for free.

Make a project out of it—drive around doing comparison snacking from store to store.

Store Openings and Retail Block Parties

When retail stores throw special events, they usually offer catered hors d'oeuvres to get you to stay longer and shop. It's not easy to find these events listed online, but they're usually advertised in daily and weekly newspapers. Go early to get the good food before it's gone.

Factory Tours

During food-factory tours, you get a bird's-eye, behind-the-scenes, up-close-and-personal, in-your-face look of how something is made. And when all that whatever is done, you'll get to pig out on a bunch of that something. Specialty-food companies make tourist attractions out of their facilities, which usually include tastings of their products at the end. Candy companies like chocolate and jellybean makers, dessert manufacturers such as ice cream factories and bakeries, and other snack food companies like potato chip makers and doughnut factories are most likely to lead factory tours.

[Search Term: "factory tour" YourTown]

Wine Tastings

Some vineyards and wine stores provide a free meal or smaller snacks to accompany their wine tastings. Get on the mailing lists for all wineries and stores nearby. Is a free lunch worth a half-hour car ride? Maybe if you wash it down with six "samples" of wine.

[Search Terms: "wineries in" YourTown]
[Search Terms: "wine store" YourTown]
[Search Terms: "wine retailer" YourTown]
[Search Terms: "tasting room" YourTown]

★★★★★★★★★★★★★★★★★★★★★★★★★★★★
Food Lecture

Graduate-level schools constantly have talks and lectures that come with breakfast, lunch, dinner, or snacks. Though technically they're private events for students and faculty, they put the food out in the hallway so that any passerby can steal a sandwich on the way through. (That means you.) You'll make out like a bandit in medical schools because doctors supposedly don't have time to go out to eat. Other universities with graduate stu-

dents only, like law and business schools, are likely to set out stuff. Wander through the halls at lunchtime for the best chance of finding food—shortly after the meetings start at noon, the food is often left unattended.

Public Health
When they're sponsored by government agencies, medical information seminars, especially ones educating the public about health threats (like HIV and colon cancer), tend to have food for attendees. Skip the small nonprofit-sponsored meetings—they barely have cash for pens, let alone panini.

Party to Eat Hearty
Parties at your rich friends' houses should include some hors d'oeuvres. Even if the crowd sucks, you can suck down some chow. Your friends and coworkers who never have parties and the ones who live the farthest away will generally have the best spreads. They're not used to hosting so they get all Martha Stewart about it.

FOOD FOR FREE
Go Shorty, It's Your Birthday!
When it's your birthday (or when you say it is), make sure your coworkers know it. Tell them in advance and you might get a cake out of it, or spring it on them at the last minute and get taken out to lunch. If you're planning to quit before your next birthday, celebrate early. And when it's their birthday, express your regret at having "unbreakable" lunch plans.

At night your friends will want to take you out to dinner. To milk the occasion for more than one meal, tell friends that you have plans on your actual birthday with your boyfriend/family/plastic surgeon/whatever but the two of you should go out on Thursday instead. Pick out a different day for each friend and make the birthday magic last all week long.

Digging Through the Trash
You can look at Dumpster-diving in one of two ways: As rummaging through the garbage for food,

You can get a whole lot more for free on your birthday than just dinner. Do a generic Web search for things free on your birthday, then plan your special day around special prizes. Freebies you can find include drinks, movie admission, dessert, ski lift tickets, and tanning booth time. [Search Term: "free on your birthday" YourTown]

or liberating waste in a world where millions go hungry. Either way, the practice has become popular, so you'll have to decide whether it's worth fighting off hippies, hipsters, and homeless to do it.

Shops that have to throw out things at the end of the day are the sure bets—places like bagel shops, bakeries, and sandwich stores. Grocery stores have to get rid of food that expires, so sometimes you'll have luck there too. Check out back by the dumpsters. True trash connoisseurs learn the exact time of garbage takeout and intercept it on the way. There are now groups (with information online) that meet to go diving together for more than food—they prefer industrial materials and computer parts. Burrowing through Dumpsters is now a form of group bonding.

[Search Term "dumpster diving" YourTown]

> **Warning:** When someone asks where you got that sandwich, never answer "in the trash"—especially when it's true.

So Maybe This Is Stealing...

★ Bakeries deliver breakfast food to the doorsteps of downtown offices really early in the morning—you can take entire bags of bagels if you're up that early.

★ Hotels and motels usually put out a continental breakfast and sometimes lunch buffets in the conference rooms. Check them out without checking into the hotel.

★★★★★★★★★★★★★★★★★★★★★★★★★★★★★★★★★★
Restaurant Scams

The Dissatisfied Diner

It goes like this: You ask the waiter of a moderately good restaurant about a certain dish or for a recommendation. Then express concern over some aspect of it: "Is it spicy?", "Is that a strong-flavored fish?", etc. When the meal comes, slowly help yourself to less than half of it. When most people are finishing their dinners, stop eating and look dissatisfied. (True hipsters always look dissatisfied.) When the waitress asks about it, confirm your earlier suspicions: "I guess it was too spicy after all" or "It really wasn't what I was hoping for." She'll ask if she can bring you something else instead. (This is why you wait until halfway through—so that a replacement isn't practical.) You reply, "Oh, no thank you. I guess I'm done." Any good waitress will take the meal off your bill at that point, feeling guilty that her recommendation was not to your liking. Give her a good tip in return.

The Ghetto Classic

This old trick is "finding" a bug or hair in your meal halfway through. The restaurant gives you a refund or a new meal, with their apologies. I suppose this scam still works, but it's so cliché ("Waiter, there's a fly in my soup!") that they'll first assume you're lying. Instead, update your complaint in keeping with the times. Maybe you'll find a piece of chicken in your veggie burrito or think that your meal doesn't "taste organic," or you'll scream, "I said nonfat soy, but this is low-fat soy! Is this some kind of fucking joke?"

OTHER TIPS ON EATING OUT

Spend Your Money on Food

Avoid ordering alcoholic drinks or dessert at restaurants whenever possible—they're at least as expensive as the rest of your meal. Go to a bar before dinner and a coffee shop afterward. And the more locations you hit on your night out, the bigger the night out feels.

> Warning: if you get too drunk before dinner, you won't be able to taste your expensive meal. Grab a slice of pizza instead.

Please Don't Wine

Bring your own bottle of wine out with you to dinner. Restaurants mark up the price double per bottle, and even more on individual glasses. (So if you're ordering four or more individual glasses of wine, get a bottle instead.) Call first to ask if they have a corkage fee—some restaurants charge as much as $20 for the privilege of bringing your own.

> Warning: if you want to save face while bringing cheap wine to an expensive restaurant, drink it out of the paper bag it came in.

Fill Up on Bread

Eat all the bread, olives, or other free appetizers they put on your table and tell the waiter to keep 'em coming. There is a better chance you won't have room for dessert, and maybe you'll have enough of your meal left for a doggie bag.

Order the Soup

Soup is generally the least expensive thing on the menu. It's also a good bargain because you get bread as well as crackers with it. Make a meal out of the appetizer.

★★★★★★★★★★★★★★★★★★★★★★★★★★★★★★

How to Order Wine in a Restaurant

Ordering wine at a restaurant is overly complicated, showy, and ridiculously expensive—like planning a wedding. Here's the short list on how to do it:

1. Defer. If there is some pretentious wine snob at the table who wants to take charge, let him. But if you're worried that he's going to order a bottle from the expensive end of the list, take charge yourself.

2. Gather a consensus. Should we get a red? Do you prefer merlot or cabernet? This will get you to the section of the wine list where there are fewer variables.

3. Don't get the house wine. It's often the wine with the biggest markup, and it's the also stuff they're trying to unload.

4. Consultation. Once you choose your price range (you know, the next two bottles above the house wine in price), ask the waiter's opinion. "We were thinking of something along the lines of the Chateau du BouBou. Do you think that's a good choice?" He'll understand your price range and your taste preference, and hopefully be able to guide you within it. Or just skip it and pick one of those two.

> ⭐
> **Test Run**
> Caterers, especially ones that do lucrative weddings, host open-house tasting sessions for prospective clients. It's never too early to start planning your wedding, even if you haven't met the right guy yet.
> ⭐

5. Reception. When the wine comes:

a. The server will show you the bottle to confirm he grabbed the right one. A nod of the head confirms that it is.

b. Don't sniff the cork. Just look at it to ensure it's not crumbling or decayed. A nod of the head confirms that it's not.

c. Swirl slightly and taste. If you think it's good, a nod of the head confirms that it is.

d. If it's not—the wine smells musty or it has a rusty orange tint or it tastes nasty, ask the sommelier or waiter for a second opinion. "I'm not sure about this [color, taste, aroma], but I'm not familiar with this type of wine. Would you taste it for me?" Then go with his opinion.

★★★★★★★★★★★★★★★★★★★★★★★★★★★★★★

The Good Book

You know those little fat coupon books that your parents used to buy? (The most common ones of which you can now order on Entertainment.com.) They're actually full of good deals—but only when:

1. You have a car, because many of the places are in the outer parts of the city.

2. You're part of a couple. Most of the specials are two-for-one deals on admissions and meals.

3. You're really bored. Making full use of the book involves a lot of time looking at it. Some of the deals aren't worth it at all—half off a baked potato at Wendy's? Come on.

GROUP DYNAMICS

Going out for a group dinner at a good restaurant almost always costs far more than you want, especially when you split the bill evenly like civilized people. There is always one Pretentious Patrick who sets a bad pattern—ordering an expensive bottle of wine or a top-shelf martini, getting a $20 seafood appetizer, or just generally selecting stuff above the level you can afford. Then everyone else follows suit, since they're going to be partially paying for it anyway. Here's how to avoid getting sucked into that pattern, or how to get out of it when it's too late.

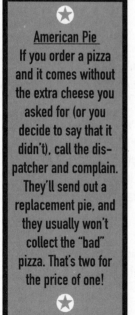

American Pie

If you order a pizza and it comes without the extra cheese you asked for (or you decide to say that it didn't), call the dispatcher and complain. They'll send out a replacement pie, and they usually won't collect the "bad" pizza. That's two for the price of one!

Steer Clear

Don't commit to dinner at someplace expensive in the first place. When your friends are trying to come up with a good place to go out, guide them toward fun dining as opposed to fine dining. Go to an Ethiopian restaurant where you eat with your hands, a messy barbecue, or an big old-style family pizza parlor instead.

Get Out of It

If your friends have already chosen the spot and it's not in the budget, don't commit to it. You'll end up blowing your booze money for the week, especially if the occasion is a friend's birthday where you'll have to chip in for their meal as well. (That doesn't mean you can't treat your friend to a free meal, though. Tell her you'll take her out for lunch that day instead. You'll get away with spending $50 less.)

But some people put up a stink when you try to be honest, and it's usually easier to lie in the first place. Say yes, then cancel the day before, citing work or a family member coming to town for a last-minute visit. Or just stop by at the end of the meal for a drink with everybody. After dinner you can talk them all into going out to a bar, and it'll seem like you were there for the whole night.

Speak Up Early

So you couldn't get out of it, and you're sitting at a table with six people in Prada talking about pashmina, and you're sporting Puma and thinking about poverty. Make it clear to the poseurs that you won't be paying for them to show off who can eat the most expensive entrée. During the time when everybody is looking at the menu and discussing their options, announce to no one in particular, "I'm going to take it easy on the meal tonight. I'm saving for [some really cool vacation or object]." Then talk about the cool thing to make it stick in their heads: "Yeah, I hear Tahiti is great in the monsoon season" or something like that. When the check comes, they'll know you're paying less than the rest.

Do the Math

If you fear they're going to split the check evenly, put yourself in charge of adding it up. Calculate the total, including the tip, then employ some of the following tactics:

1. Act "considerate" by saying, "OK, it should be about 35 each with the tip, but Sally just had the salad so she should pay less. Maybe we should put in a little more or less than 35 depending on what we ordered?" Hopefully there won't be another cheap bastard like you at the table so you can put in less.

2. Collect the money. In the best situation, your friends will all overcompensate. Ask aloud, "Does anyone need change?" Then your share is just the remaining amount.

3. If you really want to be a cheap bastard, put down your credit card, collect cash from your friends, and go light on the tip. Nobody can see the tip amount you write on the credit card bill.

MOOCHING OFF THE MASSES

Some food you buy, some food you steal, and some food you mooch. You can think of it as getting more than your fair share, or you can leave the morality of it to the pope.

My, What a Big Plastic Container You Have

When you go to a potluck-type dinner party, bring a really big Tupperware container with your contribution. Then rave about all the food. Coincidentally, you have a large container in which to bring home everyone else's delicious extras. The same is true at work—always keep extra baggies and containers in your desk for other people's leftovers.

Party's-Over Leftovers

It's so nice of you to help clean up at the end of your friend's party where there is tons of food left over, not that it's the reason you stayed so long. And since it will all go bad and never be eaten if it's refrigerated, you're really doing the host a favor by taking it home.

Interview for the Meal

Job interviews in some industries are always conducted over a free lunch. Perhaps you should apply for some of those jobs.

Support Your Stomach

Many support groups like those for alcoholics and sex addicts have coffee and snacks during their meetings. You know you're going to develop a horrible addiction someday. You may as well get a head start on your recovery.

Other Clubs

Perhaps it's a sign that our lives continue to grow increasingly isolated, even as innovations in technology purport to bring us closer together, that there are social clubs for everything these days. (Or perhaps I'm full of shit.) There are groups for fiction writers, over-50 divorcees, political discussions, expecting fathers, transgender scooter riders (for real), Web developers, teenage knitters (yes), philosophers, film buffs, Francophiles, nudists, ad infinitum. Most of these meetings take place at people's homes, and most hosts tend to put out snacks.

The ones most likely to have the best food are the culture-related groups because those are always more about showing off than learning anything new. ("I first tried these canapés in a charming little bistro in Burgundy!") Other safe bets are the events held in private homes in the suburbs, as opposed to cramped apartments in the city. You get treated more like a dinner guest than a menacing moocher there.

WHERE FOOD IS CHEAP
Box Lunch

The "big box" stores like Wal-Mart, Ikea, and Costco tend to have small cafe-terias inside, because Americans shouldn't have to endure two hours of shopping without a snack in the middle. Usually they sell patriotic food like hot dogs and pizza (though Ikea is patriotic to Sweden) at super-low prices. They're not places to go for a Mother's Day brunch, but they're great for a $5 workday lunch.

Get Religion

Several Eastern religious groups run restaurants that serve low-cost vegetar-ian meals. The Hare Krishna organization, for example, operates cafeteria-style restaurants in several cities throughout the world. Some organizations use free meals as a recruiting tool. Other restaurants just wear their religion on their sleeve, making Buddhist vegan meals at regular prices.

[Search Term "Krishna cafeteria" YourTown]

[Search Term "Buddhist restaurant" YourTown]

[Search Term "free vegetarian dinner" YourTown]

Get Schooled

Your local culinary academy probably sells fancy feasts for a fraction of the normal price. The student chefs prepare the food while other students serve it in the on-site dining room. At some schools, the price of the meal depends on which class is serving it—the freshmen's is less expensive than the seniors'.

[Search Term "culinary academy" YourTown]

WHEN FOOD IS CHEAP
Lunching

The time to hit the new trendy restaurant is during lunch. You can get nearly the same meal for nearly half price when you go there during the day. Not only do you get the food for less money, you have bragging rights about having been to Chez Merde before everyone else.

Even run-of-the-mill restaurants are better deals during the day. You'll get free rice with your meal, a buffet for the price of one dinner dish, or sometimes the same menu as dinner but with lower prices. Even if you don't have time to sit down during lunch, you can always get it as take out and nuke it for dinner.

A Sandwich in Every Beer

It's no miracle to find a bar that put out bowls of overly salty pretzels or pop-

corn to make patrons thirstier—go to any dive bar in the hooker district. True ninja sleuths can track down venues that actually serve free hot meals. In the olden days many bars set up small buffets at happy hour to keep after-work drinkers from leaving to get dinner, but those are now few and far between.

There are two types of venues that sometimes uphold this fine historical tradition, and they're on opposite ends of the societal spectrum. The first are bars that cater to construction-worker and other blue-collar crowds, who usually get off work between 3 and 4 in the afternoon. The food these dives put out is along the lines of hot dogs or chips and salsa. Happy hour ends early (usually by 6 P.M.) because it begins at 3 or 4. Check out the bars down by the docks or the little construction worker hangouts downtown.

On the other side of the tracks are the upscale bars with fancy foods. You pay good money for the drinks, but the food is free. They're places where newspapermen and politicians hang out—old, smoky bars with lots of brass and wood, where they serve 50 kinds of bourbon and scotch whiskey. In these joints the food can be anything from brie and crackers to quesadillas to chicken wings, but it's usually semi-greasy and filling. The bars are almost always located downtown, though you can find a few of them in the snooty neighborhoods where they don't have to worry about the homeless and hipsters stopping by to clean out the buffet.

[Search Term "happy hour buffet" YourTown]

[Search Term "happy hour snacks" YourTown]

★★★★★★★★★★★★★★★★★★★★★★★★★★★★★★★★★★★★
Happy-Hour Nutrition
Need a little dairy in your diet? Order a white Russian! Worried about scurvy? Get some orange wedges with that cocktail! Clever boozers can fulfill their daily nutritional requirements from only bar snacks. You may have to skip around town from bar to bar to acquire all the different food groups, but the walk will count toward your daily recommended amount of exercise.

★★★★★★★★★★★★★★★★★★★★★★★★★★★★★★★★★★★★

AT THE END OF THE DAY
Though you can dig through Dumpsters to find same-day culinary cast-offs from restaurants that throw out their food at the end of the day, you can also buy this food before it hits the trash at reduced rates.

Fishy Proposition

Sushi restaurants sometimes discount or give away their fish during the last half hour of the night. Show up before closing and place a small order. Then hopefully the chef will offer up other treats for cheap or free.

Warning: Don't order seafood on Mondays. it's left over from Friday.

Lunchtime Lefties

Downtown sandwich shops that close at 5-ish sometimes sell reduced-rate food after 3-ish. Go out for a cigarette break and explore your options—you can buy dinner at less than lunch prices.

Beggar King

Some fast-food restaurants give away any pre-made sandwiches in the last few minutes before closing (after the staff has all had their share). If you've got the late-night munchies, check it out. Go inside the place rather than the drive-through, and be as friendly as possible with the counter staff.

In states where happy-hour drink specials are illegal, bars compensate with free-food incentives.

Farmers Markdown

Farmers market vendors greatly reduce their prices as they begin to pack up at the end of the day. The leftovers will be picked-over, mushy, overripe fruits and vegetables, but those are great for canning or baking into pies. The vendors will most likely be unwilling to break up large packages, so you might find yourself stuck with a 50-pound bag of mostly rotten carrots. It may break your back carrying it to the car, but at least it'll be good for your eyesight.

Not Quite Day-Old Bread

Bakeries also sell their leftovers for less in the final hour of the day, especially on big-volume days like Sundays. You may be able to get a whole bag of rolls for the price of two. Refrigerate or freeze them when you get home to make them last all week.

SCREW THE COUPONS: PRACTICAL FOOD SHOPPING TIPS

Grocery shopping can best be described as a "hellish nightmare." Between the lady with 12 Ritalin-deprived kids running around, the oblivious grand-

mother with her cart sitting sideways across the isle, and the whipped guy on the cell phone reading off all 30 potential yogurt flavors to his girlfriend, the company ain't pretty. City people have to deal with schlepping their bags back home on the bus, and in the suburbs you have to dodge shopping carts in a parking lot full of bad drivers in soccer tanks.

On the other hand, eating out every meal is glam and convenient, but also expensive as hell. You can easily pay $12 for the same plate of pasta you can make at home for a buck-fifty. So suck it up, get your goods at the MegaSuperMart, and use the money you save to buy a drink to calm your nerves afterward. Here are some tips on getting through the ordeal.

Snack-N-Shop
Start at the bulk bins—you can grab a bag, put it in the kiddie holder of your cart, and chow while you shop. It seems that most stores have moved their snack bins to the back-middle of the store to prevent this, but nobody says you have to shop in order.

Coupons, Schmoupons

It's not worth your time to wade through the paper in the hopes that something you actually eat goes on sale. Newspaper coupons are usually for name-brand foods and new products. Store brands are always less expensive, so at best the coupon brings the name-brand product down to the price you normally pay. But if you can't tolerate store-brand peanut butter, it's less effort to look online for "Skippy coupon" than to scan the Sunday paper. Many websites now offer printable coupons that'll save your time as well as money.

Go Late, Go Full

Go shopping right after you eat so that you're stuffed full and not tempted by the bakery smell. Shop hungry and you're more likely to come back with a 5-gallon tub of Cheez Whiz and a 10-pound bag of Doritos.

You may find shopping late at night to be a more pleasant experience, utterly lacking in screaming children. And since most major supermarkets are open 24 hours, you can hit them at 3 in the morning on your way back from the club. (And you'll also be the best-dressed person in the store.)

Warning: You'll never be the drunkest person in the frozen-pizza aisle.

Think Big

Wholesale stores like Costco, Food Club, and Sam's Club charge an annual membership fee. Go in with some friends on one, and make sure that one of those friends has a car. Food shopping, like sex, is much better in a group. It's always a good deal to buy in bulk as long as you've got the closet space to store a 36-pack of toilet paper and the freezer space to hold half a cow's worth of beef. Or split up the big goods (and the cost) with your friends back at your apartment.

Whether you join a warehouse store on your own or in a group, you can save some cash at the end of the membership year by letting it expire. Make one large last stocking trip before it does, then wait a month or two until you rejoin. You get a free couple months' savings.

Riding the bus with six bags of groceries is never fun. If you shop at the supermarket, you'll save enough over the convenience store to treat yourself to a cab ride home.

Think Small

Surprisingly, some foods are cheaper in drugstore chains than they are in the supermarket. (And sometimes they're closer too.) You can find low-cost loaves of bread, canned goods, and snack foods at Walgreens without having to drive all the way to Wal-Mart. Check out that food aisle you always skip when you're in the drugstore. There are bargains to be had.

You'll also find good prices at some little neighborhood ethnic stores. They're great places to get bargain fruits and vegetables—though you won't know what half of them are since they're grown in South America and labeled in Chinese. You'll also get good deals on not-so-perishables—curry spices at Indian stores, tortillas at Mexican stores, rice at Asian shops, and so on. Stalk little old ladies of any nationality and they'll lead you to the best, cheapest spot.

★★★★★★★★★★★★★★★★★★★★★★★★★★★★★★★★

Eating In

There are 14 million better places to learn how to cook than in this book. Let's just state the facts.

★ Eating in costs less than eating out.

★ You can find 273 different recipes for every dish you might possibly want to make, all available online at sites like Epicurious.com and

Cooks.com. There is no need to buy a cookbook ever again.

★ The more you compliment your roommate on what a great cook he is, the more he'll cook for you.

<u>Grandma's Tips for a Successful Potluck</u>

★ Make sure you have enough plates, glasses, and utensils.

★ Instruct guests to bring a meal, salad, or dessert to share, and "something to drink" so that you get wine out of it too.

★ Cook something with a lot of bulk that doesn't cost much, like a deluxe salad or vat of soup. Put out candles or something so they don't realize you're cheap.

★ Do the dishes while everyone is still there. People will want to take home clean containers, so they'll leave you lots of leftovers.

LUNCH BREAK: FOOD AT WORK
Bring It

Even if you manage to spend only $5 each weekday going out for lunch, that's well over 1,000 bucks each year, and with that kind of cash you could almost buy half an Hermès yoga mat. Pack a lunch instead. If you're lazy (and I think you are), make up a big batch of pasta or a rice dish on Sunday to split it up into plastic containers for each day of the week. Then you can just grab one and go on the way out the door each day. Heck, even microwavable lunch entrées are less expensive than eating out. Buy a crate of them next time you're at Trader Joe's.

> **Warning:** Make sure to get outside during the day. Eating at your desk is totally dot-com.

Two for the Cost of None

If your boss or client (or anyone else, for that matter) treats you to a work lunch, turn that one meal into two. Order a huge appetizer. Then when your entrée comes you'll already be halfway full. Take the leftovers home in a doggie bag for dinner.

Over-order

If you're the schlub in charge of phoning in the order for other people's lunches, arrange some for yourself. "Accidentally" order way too much and you'll be sure there's some left over for you at the end. Keep a couple of plastic Tupperware-type containers in your desk for these situations.

Play Your Cards Right

You don't have to be a big-spender VIP to get something like a frequent-burrito-eater's card. Every 10th one is free, and they really don't take up too much space in your wallet.

Warehouse food store memberships are a parent's dream gift. It's practical, like underwear. Start dropping hints.

Be a Bean Counter

Those daily $3 lattes really add up. You can spend more on one drink at Starbucks than a whole meal at the Chinese takeout. Caffeine can easily be a more expensive addiction than nicotine. But don't do anything stupid and rash like giving it up.

★ Make it at home. For 30 bucks you can buy a coffeemaker at the local drugstore with a timer that doubles as an alarm clock.

★ Get a no-spill mug for the commute. Don't let the lack of an idiotproof container hold you back. They only cost 3 bucks, and if you lose it, it's no big thing.

★ Look for specials. Prices on beans vary hugely from store to store. Or if you're a coffee snob, check online for your favorite blend. Even with shipping costs it's probably less expensive than buying it at the gourmet bean shop.

★ Get a machine at work. Try to convince your boss that you'll all take care of cleaning the coffeemaker if she pays for the beans.

Caffeine pills keep you awake, but they don't hit you the same as coffee. They work better in the long-term than for a quick jolt (and snorting them is not recommended), so they're best left to the truckers and cramming students who need them most.

★ If she won't, form a coffee pool with your coworkers. Choose one person per week to be responsible for cleaning the pot and keeping the milk and sugar stocked. Pool money for the cost of coffee so that nobody gets stuck having to buy it on their shift every time. (And if you put yourself in charge of buying the beans, you can totally embezzle some funds.)

★ Or bring a thermos for your personal stash. You won't spill during your morning commute, you can make it just how you like it (with Baileys), and it will stay warm all day.

CHAPTER 9★

Fun Money: Earning Extra Income and Selling Your Stuff

Chances are your job sucks. You're overeducated, underemployed, or unemployed altogether, and totally bored out of your mind. Or maybe you're following your artistic dream and starving to death. In any case, you probably don't have a job you like that also pays well. Who does?

This chapter lists ways of making more money, from selling off your excess stuff to two-timing at your day job to finding freelance employment. You can use the extra cash to buy antidepressants with which to numb yourself to the pain of being a nameless cog in the corporate machine.

Scalping Seats

Here are a few tips on making money by marking up ticket prices.

★ Scalping tickets is completely legal in some parts of cyberspace and in several states. Depending on where you live and work, you may have to operate as an individual or instead be a business with a license to scalp. Some auction websites ban scalping. Others allow it as long as you're not selling only tickets—you must list a baseball hat plus two free tickets to the Super Bowl for $2,000. In particular, eBay has a page that outlines what you can sell, to whom you can sell it, and how much profit you're allowed to make per ticket. Search for "prohibited items" on its help page.

★ Scalping is a bad way to earn good karma, and getting caught by the cops is no fun, so you might want to treat it more as a hobby than a career. Scalp tickets to get into shows you already want to see but don't want to pay for. Buy three and use one for yourself, making enough profit from the other two to do so.

★ You'll make the best money on rock shows when you buy tickets to small venues where small bands that are about to become the next big thing are scheduled to play. The tickets are cheaper and sell out faster so you can take more risks, and people will pay four times the face value to catch a soon-to-be huge group in an intimate venue before the nationwide tour starts.

Warning: Make sure they're shows that will sell out, or you'll be stuck with extras.

★ Scalp tickets online on community websites, on the band or team's bulletin board, or on auction websites. It's harder to get caught when you're doing it one-on-one in email. If that doesn't work, sell them outside the show.

★ You can scalp reservations for trendy restaurants. As reservations don't cost money, you'll get paid just for a phone call. When a hot new restaurant opens up, call and make a reservation for two people. Then as it gets closer to the dinner date, advertise the reservation for sale. Keep in mind that some restaurants take a credit card number as a reservation confirmation and will charge you if nobody shows up. Make sure you charge at least as much as the penalty for the reservation so you won't lose out even if the person you sold it to doesn't show up.

QUICK CASH

Sometimes, long before payday, you accidentally spend all your money on drugs, and then you don't have any left for rent. Oops! Below are some ways to get fast cash from selling your stuff.

Music and Movies

Go through your CD and DVD collection and pull out all the stuff you never listen to or watch anymore.

★ Call first to make sure the store is buying. Some places limit their buying hours to certain slots. Ask what music they buy as well—if they're dance-only and your collection is thrashcore, you can probably skip that store.

★ Some places still buy cassettes and VHS tapes. You won't get much money for them, but it's not like you play them anyway.

★ When you're selling vinyl records, take them to the appropriate specialty store for your record's genre (classical music, dance music, jazz). If you've got a prime selection of vintage acid house or something like that, you might do better putting them online for auction so that the hard-core collectors can fight over them.

★ Be friendly to the store's buyer. If you look shifty like you stole the collection, you won't get as much money. Personality impacts buying price.

★ "Old" is not the same as "vintage." Your grandma's records may be worth a ton, or they may weigh a ton and be worth nothing. When in doubt, call first and name a few titles before you go schlepping them around.

★ Put something good on top. "Good" means not a Top 40 CD or the one you got for free for subscribing to Details, but also not a totally unknown band that doesn't play outside their garage. Something underground but popular. Once you have them thinking you're a connoisseur, they're more likely to give you a buck for the mainstream crap at the bottom of the pile that they wouldn't normally take.

★ If at first you don't succeed, try another store.

Sell Your Books

★ The same rules for records apply to books: Be nice to the buyer and start with your winners.

★ Before you spend time and effort carrying a 50-pound sack of books around town, find out which used bookstores will buy them and when their "buying hours" are.

★ Also ask if they buy the type of tomes you're selling—hardcover versus paperback, photography books, textbooks, best sellers, or whatever categories they classify books under. Some bookstores won't buy anything that's not a first-edition Chaucer, some won't pay for paperbacks, some carry science fiction exclusively, and some are only for literary snobs.

★ Ask your local homeless guy which stores buy the most books. He'll know.

★ You'll only be able to sell textbooks to college bookstores at the beginning or end of the semester (the end is better), or to an online textbook reseller.

Sell Your Clothes

Selling your clothes to vintage stores can be an exercise in rejection. You go from store to store trying to pawn off that $100 sweater only to have the buyers laugh at you for even thinking it was once cool. (It happens.) There is a point when the effort and humiliation isn't worth the 10 bucks you'll make. Treat selling clothing like a business transaction and you'll do fine.

★ Be nice to the clerk. Start with the best. (You should know this by now.)

★ They want labels. You won't get much of anything for a Gap shirt, but even an old, ripped Gucci might bring in a good amount.

★ Call in advance. Vintage-clothing stores have odd buying hours.

★ For more tips, see later in this chapter.

Sidewalk Sale

Sidewalk sales work best on sunny weekend days at brunch time when your sidewalk is in a high-traffic part of town. They take up a lot more time and effort than just selling stuff to the used book and music stores, but you'll also make more money on the same junk.

★ Sell books, CDs, fun clothing, small furniture like end tables, plant holders, CD organizers, chairs and stools, sporting goods, plants in pots, and games.

★ Don't bother selling electronics if there is no outlet to plug them in to demonstrate that they work.

★ Avoid looking like a crackhead trying to sell empty cassette tape cases and used socks for another rock. Put a sheet on the ground and your stuff on top of that. Bring a chair to sit in while you sell.

★ Put prices on items or groups of them, like "All CDs $2.00." It makes life easier for everyone.

★ Hang out and be social with people rather than giving the hard sell.

★ Be prepared to bargain.

SELLING STUFF ONLINE

Once upon a time, selling stuff on eBay was easy money. You could advertise a half-eaten Twinkie on there and turn a profit. But these days there are a million old ladies hocking antiques and hipsters selling ironic T-shirts. The seller's marketplace is packed, and if you ask too much for your Hooters baby tee then buyers can bid on one of the other 40 of them being sold concurrently. You know you're not going to make millions selling on eBay when there are 30 different books called Make Millions Selling on eBay.

What to Sell

Throw out the notion that you'll buy stuff at garage sales or thrift stores and sell it on eBay. Not only does that involve too much time for too little profit, there are plenty of bored housewives who do it already—and they're much better at it than you. By the time you show up to Thrift World they've already picked over the entire store and taken everything worth any money.

That being said, there are a few categories of items worth buying to resell when you come across them, and a few other ways to make money being proactive.

Collectibles

If you just so happen to be an expert in much-sought-after mid-century Zimbabwean ceramics, you can go sifting through the pottery section of thrift stores in the hopes of identifying some treasure among the trash, but generally you have to know too much to resell antiques online. Instead, look for collectible kitsch items like My Little Pony figurines, old Coca-Cola crap, and artwork with bug-eyed children. The best collectibles to sell are those brands, companies, or cultural concepts that are no longer in existence, like Le Tigre shirts, Pets.com swag, and How to Lambada videos.

Close Enough

You're not going to make a profit reselling pants bought at Old Navy, because

anybody can shop at an Old Navy. It's when you're in proximity to one-of-a-kind people, places, and things that you may have something unique to sell. For example, if you live near a landmark like the World's Biggest Ball of Dryer Lint, you can sell items from its gift store on eBay and turn a profit. If you live in a famous author's hometown and it's easy to find autographed books of theirs, sell them at a marked-up rate. The same goes for antiques that originated in your area—Vermont handcrafted wicker televisions and the like.

Promotional Swag

It's hard to lose money selling promotional stuff online, since you don't pay anything for it in the first place. Some people with good hookups have managed to pay their rent auctioning off movie posters and other Hollywood junk they get from publicists. And there is so very much swag in the world that accompanies any sort of launch—of a movie, a CD, a flavor of soda, a family reunion. You'll get good money for music and movie items when the music and movies are still new releases. But the real cash comes from antique tchotchkes—you could pay your tuition with what you'd get for a vintage Apple Computer T-shirt or a toy that came in Quisp cereal.

Autographed Things

When somebody who did something signs the thing they did, the value of said thing increases. Things include books, celebrity photos (or napkins), sporting goods, and rock and roll paraphernalia such as CDs and spandex pants. "But wait a minute, I don't live in Detroit!" you say. Don't worry; people tour. Get your sports stuff autographed at a game, music stuff signed at record store in-store appearances, and books signed at book signings. For celebrities, you'll just have to move to Hollywood. You can sell the goods not only on eBay but also on fan bulletin boards—there you've got an audience interested by default.

> ★
> One way to get free movie posters or other popular advertisements you see on the side of bus stops, in the subway, and on other bulletin boards is to contact the company that rents out the ad space. The name and number of that company is always on the frame of the poster. Ask if you can have a particular ad when they're done with it. Then go sell it online.
> ★

Services

Auction websites don't limit themselves to objects alone. Use them to cross-list

any services you have for sale, such as résumé writing, typing, graphic design, customizing or alterations, photography. Sell an hour of your time for whatever you charge. ("One hour of proofreading for $20," for example.) Then you can use the connections you get there to booster your off-line business.

Crafts

Turn your hobby into a source of income. Any craft project you make at home can be sold online. (Well, maybe not ice sculptures.) To make your crafts stand out, offer to customize the color scheme, fabric, etc., based on the client's request.

Make Your Listing Stand Out

There are about 4 bajillion other auctions going on for items similar to yours. People need to be able to find what you're selling, then you've got to convince them to bid on it. The best way to do that is to search for similar items to yours, study the lists of best sellers, and copy their format. But here are the basics.

★ In the auction title, always include the name brand or designer label—and the size, if it's clothing. Put as much information in the title as possible.

★ When calculating your minimum price, make sure to add in the eBay listing fee and possibly a PayPal fee.

★ List the shipping price separately. If you have time to research it, offer fast options (like FedEx) and slow (regular mail).

★ Start the bidding at a low price, but at an amount you'd take if you had to.

★ Make your item description as long and detailed as humanly possible. Include the condition, physical dimensions, color, text on the label, weight—everything.

★ Use as many synonyms for what you're listing as possible in the text, so that people searching for it under different terms will be able to find it. Maybe your item is a "Mounted Small-Mouth Bass"; your description should include the phrases fishing, trophy, kitsch art, hunting, taxidermy, wall-mounted, and other distinctions. Also, use different forms of each of the key words in the text—fish, hunt, fishes, trophies.

★ Always describe at least one minor flaw in whatever you're selling—this makes you seem honest. Try to include a close-up picture of the flaw.

★ You must post pictures of your item—even pictures of tickets. The more pictures the better.

★ If you're auctioning more than one item at the same time, offer to combine shipping. That will not only seem like a bonus to the buyer, it will encourage them to look at your other auctions.

★ Be incredibly nice and friendly, even with jerks. A bad user-feedback comment can screw you on future auctions.

HOME ECONOMICS: MAKE MONEY BY VISITING YOUR PARENTS

In today's economy, your parents should be thankful that you're not moving back in with them—though that would save you a ton of money. So why not get a little bit more out of your next visit than just a bunch of meals?

Steal Stuff

Your parents probably have a ton of crap stored somewhere that they don't need. Ransack the basement, garage, and guest room. Take it all with you when you leave, then sell it online. Look for:

★ Used clothing, jewelry, watches, books, and shoes

★ Your childhood games and room decorations (like posters of teen idols)

★ Cheesy artwork and sculpture

★ Musical instruments (from when you used to want to play the clarinet)

Getting Gifts

Regardless of how much you steal, you'll also want your parents to buy you new stuff during your visit. The best way to accomplish that is to "forget" some clothing. Don't pack any underwear; take a trip to Target with Mom instead. If it's hot out, only bring your long-sleeved shirts and winter jacket. If you're going to the beach, use your trip as an excuse to get a new swimsuit. Any good parent will pay for them while you're there.

When visiting someone with free laundry facilities, bring only dirty clothes on your visit and leave with only clean ones.

Your parents want to help you get ahead in your career, primarily so that you'll stop stealing all their jewelry each time you visit. Gush over how cool your parents' speakerphone or fax machine is. Drop hints about how their printer would really help your home office—maybe they could treat themselves to a new one and give you their old model? Mention that you don't have any interview clothes; parents love to buy suits for their children.

Warning: if your parents are divorced, your mom will make you do work around the house instead of taking you out to buy you stuff. Have her visit you instead.

Thrift-Selling

If your parents live in South Middle of Nowhere, use your visit as an opportunity to buy clothing at rural thrift stores, then later sell it to vintage shops in your city. Before you go on vacation, find out what the stores near you are buying. Some chain thrift stores, such as Buffalo Exchange, have websites that list specific clothing they'll buy. You can call or stop by other stores to ask. They may want items like Levi's denim jeans, Lacoste shirts, 1920s suit jackets, top hats, Fendi sunglasses, and the like. Try to find those items on the dollar rack in squaresville and sell them back in hipster city for 5.

OCCASIONAL WORK

It's good money when you can get it.

Focus Groups

Consumer focus groups pay anywhere from $25 to $75 per hour. They usually begin after 5 P.M., so you don't have to skip work. The "work" you do for them usually involves sitting around a table to express your opinion on new products or redesigns for old ones; the usability of websites; or (if you're lucky) the taste of new kinds of food and liquor. They're fun, easy, and the pay is great. The only hard part is getting accepted into the group.

Search online for local market research companies that perform focus group testing. Hopefully someone else will have done the work and you'll find a website that lists all of them in your area. Fill out each site's demographic form to get on its announcement list. You want to make yourself sound like a good match for studies, so fill out "yes" for almost every answer.

Exaggerate. When they ask about your car, you can fill information for the car you used to have. Pets? If your girlfriend has a parakeet, then so do you. And so on. Exaggerate your income level a bit—product makers usually want high-end consumers' opinions more than those of the everyman.

Before you're chosen for a particular study, someone from the market research company will call or email you with additional questions. Ideally, they'll tell you what the group is about ("men with asthma," "car owners," "users of public transit") so that you'll know how to best answer the questions. Exaggerate here too. When they ask how often you drink premium vodka, the answer is "Every day." Take the bus? Every day. Go on vacation to the Caribbean? Every day. You are an expert in whatever they want.

They'll also ask the last time you did a focus group. Round up to at least six months. If they offer you a "floater" position, take it—it pays better. You agree to be

an alternate in case not enough people show up to one group or another, and often you'll get sent home with a fat check without having to do anything. (Bring a book.)

[Search Term: "focus group" YourTown]

House-sitting and Pet-sitting

House-sitting is like vacationing in someone else's life. You get to live in their house, sleep in their bed, eat their food, walk their dog, and water their plants. (Note: Do not sleep with their dog and eat the plants.) But since most people will ask their friends to do this, it's not easy work to find. In addition, most house-sitting agencies charge listing fees on their websites, with no guarantees that you'll earn your money back.

One good way to make your services known to the general public is to put a house-sitting résumé online. (Use the free website space you get with your Internet connection. It's not worth paying for.) Title that page something like "House-sitting, apartment-sitting, pet-sitting, and plant-sitting in YourTown." Make it look like a résumé—say that you will provide excellent references; list all the towns where you are available to sit rather than just the city core.

You can also get proactive about it. Contact real estate agents and ask about working as a sitter and caretaker of houses that are empty while being up for sale. You may have to mow the lawn and vacuum daily as well as be available for agents' last-minute drop-ins at any time. Call your local real estate offices and see what they say.

⭐

Rent Your Apartment as a Hotel

If you live alone in a big, non-rat-infested studio apartment or one-bedroom, you may be able to rent it out to nearby companies or universities to house visiting speakers and consultants. Call up the human resources department and inquire.

⭐

Make Your Apartment Famous!

Try to rent out your place for movie shoots, television shows, and commercials—it pays great and you don't have to do anything once you sign the contract. Your pad should have the following two features to make it a good fit: It should either be on the ground floor or have a service elevator—there needs to be easy access for big film equipment. And you should have large rooms and high ceilings. They jam a lot of stuff into your small space.

In order to sell your spot to location scouts, you'll want to put together a portfolio. Include the basics—location, dimensions, the building's history, any carved woods or exposed bricks or other

architectural embellishments. Also include tons of pictures—every room from every (good) angle, the view of the building from the street, the view from the windows. Try to make it interesting.

Then find out where to list it. Look up "film office," "production company," and "location scout" in your town for possible spots. Often you'll find the city's film commission to be the best starting place. It'll have resources and forms to fill out. It's worth a shot.

Rent Your Body to Science

Medical research studies usually pay great, and all you have to do is take a pill and get your blood drawn 30 times in four hours. The studies are run by hospitals, universities, private research laboratories, and psychiatric hospitals. They can involve anything from a simple blood test to a month in the hospital. You might even get paid just to sleep.

First, search online for studies. You'll find a lot of them at www.clinicaltrials.gov. If you don't get good results searching online, try walking through the hallways at any local medical schools. They'll frequently post flyers for people to be scientific-study subjects, if such ads aren't posted on the Internet.

[Search Term: "clinical trials" YourTown]

[Search Term: "healthy adults" YourTown]

[Search Term: "healthy subjects" YourTown]

[Search Term: "clinical research" YourTown]

MONEY ON THE SIDE

Whether you've got no income or one you want to supplement, it's always good to keep your eye out for additional cash-making opportunities. You can put the extra dough toward something useful like your retirement plan or liposuction. Everyone has some sort of spare expertise that they can sell. The following are jobs you should be able to do during the day when you don't have a job, or on nights, weekends, and "sick days" when you do.

Jack-of-all-trades

Advertise your services as a handyman on bulletin boards online, in large-apartment-building lobbies, and in places where things must be assembled, such as bicycle shops and hardware stores. If you're skilled at repair or just following directions, you can make good money. If you're desperate, try advertising your services as a furniture assembler in the parking lot of Ikea; Lord knows figuring out those language-free directions can be hard. You can also be available to run

errands like standing in line for concert tickets, delivering dry cleaning, and grocery shopping.

Voice Actor

Do you have a deep, sexy voice? Are you good at impressions? Can you bark like a dog in bed? All those qualities can carry over into a part-time career as a voice actor. You'll find plenty of information in bookstores and online on how to get started.

Taxi!

Rent yourself out as a designated driver for party people. Send email to DJs to offer them chauffeur service between parties. You might try getting an ad on a nightlife website. Charge by the hour, with an extra-mileage fee if your fare is going far.

If you have a large car or van, offer your services as a mover or hauler, especially during college back-to-school time. Post flyers around schools, on bulletin boards, or hover around Home Depot hocking your services. If your van is big enough, try to get hooked up with an assemble-it-yourself furniture store such as a futon warehouse. It'll refer clients to you to make deliveries and assembly.

Computer Repair

You've probably got some neighbors who can't use a computer for more than typing. Sell your services for a low fee (like 30 bucks an hour) and post an ad in your apartment building's lobby and around the neighborhood. Call it "Community Computer Repair" or something down-home like that. Since you're not a licensed repair technician, stick to giving software instruction, helping with new hardware, and hooking up Internet connections.

Bill yourself as a "Privacy and Virus-Protection Specialist." Install firewall and antivirus software for crazy amounts of cash.

The Personal Party Chef

If you're a good cook, advertise your low-cost services for parties. Call yourself a "personal chef" rather than a "caterer," and advertise in interesting places like grocery store bulletin boards. Make it seem like you're a starving artist and this is how you support yourself. Everyone likes to help out a starving artist.

Down-home Cooking

Fancy little delis and small, expensive grocery stores often buy gourmet goods from independent bakers. You'll have the best shot if you can offer something unique—vegan baked goods, home-made fudge, designer candies, gourmet dog treats, and so on.

Gopher

Run errands or act as a personal assistant for busy businesspeople. Offer home accounting (pay bills, enter information into spreadsheet pro-grams), typing, mailing, picking up the dry clean-ing, and other chores. You'll probably need a car.

Sew Me

If you've got a sewing machine and know how to use it, advertise your skills online in chat rooms and on sewing-shop bulletin boards. Put up posters in thrift stores and Laundromats to promote your alterations. Offer to cus-tom-make or customize people's Halloween costumes starting in early October.

Yard Work

You don't have to be 13 or an illegal immi-grant to do yard work. When you see your neighbors (or land-lord), make an offer to cut the lawn, water plants, do minor land-scaping, shovel snow, etc. You can get paid in cash or get a rent reduction from your landlord.

Alterna-tours

For the start-up cost of a website and book you can make money leading city tours for both tourists and locals. Pick up a book or two on some saucy subject, create a flyer and website, and you're good to go. Some possible tour topics include pirates, vampires, ghosts, sexual history (in the red-light districts), celebrity homes, dead celebrities, literary tours (beat poets, society writers' hangouts), musical history (like where famous people played or lived, or the local historical jazz or bluegrass district), movie scenes (locations from one movie around town, or multiple movies within a smaller area), animal attacks, murders, and mobsters/mafia.

Treasure Hunt

Urban treasure hunts are the new bar crawls. Teams compete for prizes by racing around the city on foot to solve riddles and to collect proof that they've been to a spot (such as making a rubbing of a certain tombstone or writing down the date on a building's cornerstone). It's a much more ambitious project to run one of these

games than just a simple walking tour (you'll need a staff), but you can at least use the same information.

Tarot and Palm Readings

With a rudimentary knowledge of these not so psychic skills you can sell readings in mellow bars, chill-out rooms of clubs (where you'll get in free), coffee-/teahouses and cafés, in the park on sunny days, and at outdoor bars. You can also advertise your services for parties.

Cater Waiter

These guys get great hookups. There is some start-up cost, as many companies require you wear a near-tuxedo outfit with black shoes, pants, a jacket, etc. The work isn't steady, but the hourly wage is pretty good and you get to take home tons of freebies.

The life of the party "Party motivators" are good-looking people paid to mingle, get people having fun, and warm up the dance floor. If that's what you do at parties anyway, you might as well earn money for it.

Game Girl

Become a tester of new video games and put your stoner lifestyle to work. Look at each video game company's website to see if it's hiring. Search for the word "tester"—it may be under the quality assurance department's job listings. These jobs are either quick (several hours over a weekend), or else they're long and intensive when a game is near release. In that case, you work overtime hours for a couple of weeks. It's a good time to "take a vacation" from your other job.

TEACHING AND TUTORING

You don't need a Ph.D. in aromapsychology to teach people stuff. We all have hands-on skills or expertise in something, even if that something is beating people up. There are plenty of teaching environments that don't include university students or screaming children, such as adult education centers, craft shops, writers workshops, intramural sports leagues, gyms, trade schools, and language schools. And anything that can be taught in a group can also be taught in a private setting, so make sure you offer your services both in a class setting and as a private instructor or tutor.

Art and Crafts

Teach art either to adults at craft centers (pottery and ceramics stores, glass-blowing centers, yarn stores) or, better yet, to kids: The requirements are a lot less

rigorous that way. Examples: papier-mâché, pottery, papermaking, ethnic crafts, woodworking for girls, knitting for boys.

Technology Classes

People rush to buy any new shiny electric gadget they see, even if they can't figure out how to use it on their own. Feel free to charge exorbitant prices for training classes. Examples: digital photography, DVD recording, surround sound, all-in-one remote controls.

Social Skills

Teach basic social skills at adult education centers.

Examples: "Gay Dating 101," "Networking for Divorcées," "Pickup Lines That Work."

Diet, Health, and Exercise

Play to trendy new age treatments, diets, exercise programs, and health fears. You can become an expert in the subject (read one book) and teach it.

Examples: "Understanding Atkins"; "Kabbalah Study Session"; "Understanding Your Sun Sign"; "How to Avoid Mad Cow Disease/Anthrax/SARS"; "Ergonomics Workshop."

Coaching

You're not going to get rich coaching Little League, but you can make some cash giving private lessons to the children of rich people.

Examples: tennis, golf, swimming, baseball, soccer.

If you're an expert in anything remotely academic, you can teach it as a class for an online university. Look up the requirements to see if you qualify for any of those "Get Your Degree Online" places that send you spam. (Maybe they'll give you a free Ph.D.)

Linguist

If you're a native speaker of a foreign language, you can easily become a tutor or teacher. The easiest job is a paid language partner, where advanced students pay you to talk to them. It's a lot like dating an old guy for his money.

Tutor

Find an online tutor-referral service. It'll take a cut of your hourly pay. Then make a private arrangement with the kid's parents and cut out the middleman.

Cooking With Class

Run a small cooking class out of your own kitchen or be a personal instructor in theirs. You'll get more business when you train people in trendy foods, as opposed to old standards.

Examples: "slow foods," Chilean sea bass, low-carb cakes, East African cuisine, vegan desserts.

Describe Your Day Job

You are automatically an expert in whatever it is you do for your day job because you're doing it professionally. Share your expertise for fun and profit.

Examples: "Breaking Into [your field]"; "Computer Training in [software you use at work]"; "Careers in [your career]."

Music Lessons

If you play it, teach it.

Examples: piano lessons, guitar lessons, singing lessons.

TWO-TIMING WHILE YOU'RE AT WORK

Remember: Your job sucks. You're probably sitting at a desk performing pointless repetitive tasks that in the end only make more money for an already rich white boomer who says you can't have a raise because the market is bad while his free stock incentives allow him to buy a second yacht that's larger than your parents' first house. (Do I sound bitter?) If he can keep himself living the high life, why shouldn't you be able to slack off a bit to make a second income to support yourself? Keep yourself in the rock and roll lifestyle to which you've become accustomed—after all, you can assume your boss is doing it, so he's leading by example.

Sell Stuff to Your Coworkers

Sell Amway goods or other cosmetics (Mary Kay, Avon), Tupperware, sex toys, jewelry, or your personal craft projects to your fellow oppressees. They'll feel obligated to buy from you, and they get to shop while on the clock. If you're supposed to buy their daughters' Girl Scout cookies, then they can buy your Magic Air Sanitizer.

Survey Says!

Do online surveys while on the clock. Some of these are scams, but others will mail you coupons, gift certificates, and product samples to reward you for your time. (That is, your boss's time.)

Trailer Trash

There are a few websites that pay you in movie tickets if you watch movie trailers and comment on them. Like surveys, these are often scams, however.

Searching for Money

Same with search engines. Some give you "rewards" for using their ad-laden search tools.

Two-timing Ho

Pimp yourself out as a consultant for another company while on the clock at your job. You can resell your skills, be they typing, document-formatting, grant writing, writing computer code, or whatever. And nobody will notice your infidelity because the work looks like your regular tasks.

Pleasant Supplies

Stealing office supplies is as American as apple pie and trash TV.

★ Don't limit your corporate theft to only pens and paper. A quick perusal of the local office supply superstore's catalog reveals the following pilferable items: air fresheners; answering machines; batteries; blank CDs; bookshelves; bottled water; briefcases; brooms, mops, and dusters; can openers; clocks; coffeepots; coffee, creamer, and tea; dictionaries; digital cameras; dish soap; easels; Ethernet cards, modems, and zip disks; extension cords; fabric protector; fax machines; film; glitter; hangers and coat racks; humidifiers; air filters and fans; insect killer; lamps; laundry detergent; lint rollers; magazine racks; microwaves; mini fridges; padlocks; paint; Palm Pilots; paper to make iron-ons; photocopiers; projectors and movie screens; safes/cash boxes; space heaters; sports equipment (like basketballs, baseballs, and volleyballs); storage containers; televisions; toilet paper; paper towels; dishes, cups, and silverware; trash bags; vacuum cleaners; VCRs; and nightclub wristbands.

★ Smaller office supply companies give incentives in the form of free gifts to the person who does the ordering—if that's you, look into it. Convince your boss to switch companies, get an employee reward for saving money, and collect a kickback from the supplier.

★ The company car or van is also an office supply. Use it on weekends to get stuff from Ikea or to move apartments.

★ Computer printers are a rip-off. They charge you only 50 bucks for the machine but 30 for each ink cartridge. Buy your home printer the same model as the one at work and pilfer ink from there.

Make Work Work for You

★ Have your boss pay for classes. Company policies vary widely in what classes they'll sponsor, but look into it anyway. Even if it's a class you don't want to take, you'll get a student ID out of the experience and a reason to leave the office early twice a week.

★ Make long-distance calls on the company dime.

★ When you go on vacation, mark it on your time sheet as sick leave instead. When you quit a job (or get fired), they have to pay out vacation days, but sick days just go away.

★ If you complete all your tasks in a timely manner, your boss will give you only more tasks to complete. When being given additional work, say that you won't have time to do it, then do most of it anyway. You'll get a raise twice as fast.

★ Or say, "I don't think I can do a good job on that project with that deadline. Can you extend the deadline or else delegate it to someone with more time to work on it?" Chances are it will become someone else's problem.

★ If your email application will let you schedule delayed e-mails, time them to go out during lunch and late at night. You'll look like you're working longer than you really are.

★ Take home software. This allows you to "work from home" even though you're only working on increasing the size of your software collection.

★ If you're freelancing for a living in a profession like writing or Web design, or if you're a student, try to get a job as a night receptionist. Many of those positions give you very little work to do and allow a lot time to surf the Internet, write your master's thesis, do freelance work, or read Cosmo.

★ Always have an excuse to leave on time—you have to pick the kids up at 6, you're taking a night class, you have to catch your carpool, your friend is in from out of town, whatever. Unpaid overtime is for suckers.

Chapter 10 ★

Save Your Money for Rehab: Dirty Discounts and Other Easy Ways to Save

This chapter should be pretty boring, OK? The immediate ways to save money on your rock star lifestyle—getting in and getting wasted for free—are far more exciting than getting a good price on your DSL connection. But the more you save on the stuff that's not fun, the more you have to spend on the stuff that is.

GOVERNMENT MONEY

Most of the time, your tax money goes toward paying politicians and building bombs. But some of the time, you're poor and could use a little help from Uncle Sam. And as with any rich relative, you want to take advantage of his generosity until he gets pissed and cuts you off completely.

Unemployment

Get laid off? Fired? Quit? Any way you find yourself without a job, you can likely collect unemployment benefits. Though, technically, you're only eligible for the government money when you've been laid off due to downsizing, in most cases you can get paid for doing nothing even when you were fired for doing nothing at your job.

When you apply for benefits the state sends a notice to your former employer asking for confirmation that you were laid off. Only if the human resources troll contests it are you denied the payout. Many (smaller) companies don't bother rebutting your claim even if you had quit or were canned. As long as you worked somewhere for at least six months before you left, you can always apply and see what happens.

Riding It Out

In order to keep the checks coming, you have to submit documentation that you're actively seeking employment. They will occasionally ask for the names and addresses of places to which you've applied, and they'll call those companies to verify what you wrote. If your goal is to hang out and cash checks rather than find a new job, just apply to positions you'll never get. Submit your résumé online (and save stamps) for the position as president of OilTech.

Since unemployment will barely cover your rent, you might have to do freelance or temp work to supplement your income. Yet for every dollar of income you report honestly, that dollar will be subtracted from your benefit check for the week (and successive weeks, if it's more than your weekly benefit amount). But should you choose to report that extra income (even though you probably won't get caught if you don't), your honesty will extend your run on the dole. The money they don't pay you that week stays in your unemployment account. So as long as you don't find a real job, your checks will keep coming longer than the standard six months of payment.

GA (Ghetto Assistance)

Being on general assistance, a.k.a. welfare, is not as glamorous and exciting as it sounds. The effort to get accepted to the program and stay on it involves a lot more than living in a trailer and popping out children. The money is too little to live on, they make you jump through hoops, and the people you meet are not spectacular.

First you must prove that you have no liquid assets. You can own a Ferrari, but if you have more than $200 in your bank account or own an IRA, you're out of luck. Try to find the qualifications for GA online (so you can move your funds around or cash them out) before wasting time going into the office. The office is not fun.

Should you be lucky enough to meet the initial qualifications, the good times are just beginning. You'll have to wait an hour or more for most of your scheduled appointments, in a waiting room filled with crack whores and other unwashed masses. You'll have to take classes in things like "Dress for Success" and "Résumé Writing," geared for people who wear paper bags and dropped out of school in third grade. You'll be assigned a counselor to see at 7:30 A.M. at least weekly. And to keep getting the checks you have to perform public-service chores like washing out city buses. In other words, it ain't worth it.

> Warning: Don't bring a six-pack in to the welfare office to drink while waiting for your appointment. They search your bags at the door, so bring a small flask instead.

UTILITIES

If you're unemployed, working for peanuts, or only working part-time, you may qualify for utility savings on all of your gas, electric, and telephone bills. The qualifying income levels are absurdly low, but the utility companies usually approve all requests without checking the paperwork. Look on the websites of your providers or call the companies to ask about low-income discounts.

Product Freebies

Write to companies to tell them how much you love their products or how disappointed you were in them. They'll often send coupons for free items in the mail even if they don't actually read your letter. You can do this while biding time in the unemployment line or while you're supposed to be working. Examples:

★ Your ice cream didn't have enough chocolate chunks in it.

★ Request a new flavor of coffee from the chain.

★ Your batteries died after only one week of use.

★ Your cereal didn't have enough marshmallows.

★ Your ecstasy pill was cut with too much speed. (Kidding!)

★★★★★★★★★★★★★★★★★★★★★★★★★★★★★★★★★★★★★★★

Internet and Phone Service
Internet

Internet service, unlike television cable, is on a trend toward decreased costs and increased delivery speeds. Regardless of the service (dial-up, DSL, T1) for which you sign up, don't agree to any contract more than a year in length. The technology is improving and the costs are dropping every year, so don't lock yourself in for two.

There is also a growing underground urban movement of free wireless Internet networks. One person assembles an antenna that anyone within a close range can use for free Internet access. If you're lucky enough to be in the shadow of a neighbor's service, you can just drop your Internet service provider. And if you're lucky enough to be rich, host an antenna yourself.

[Search Term: "free wireless" YourTown]

[Search Term: "free wireless LAN" YourTown]

Another option for wireless access is a neighbor who doesn't set a password on his wireless router, allowing you to bum off his signal. He may call it "stealing his bandwidth," but you can call it a "stupidity tax."

Or go to where the Internet is. Most cafés these days offer wireless service. The question is whether that service is free or if you need to pay for an account to use it. Also, check nearby universities, libraries, and bookstores—they might also give it away.

Cell Phone

Cell phone plans and providers are messy and evil. Every company has a differ-

ent plan, pricing scheme, and roaming range. Some try to get you to upgrade to a new network (which requires a new phone) before there are enough antennas to give reception. All of them try to lock you into two-year contracts instead of keeping your business through customer satisfaction. No matter what service you choose, you always feel like you're getting screwed...unless you can scam a discount.

Your employer should probably pay for your cell phone. To make that happen, get your bosses dependent on contacting you via your cell. (Some people get all paranoid that their boss is going to call at all hours of the day, but it's not like you don't have caller ID—you can choose not to answer.) Keep telling them to call you on it when you're in transit or working from home so they start to think nothing of it. List it on your email signature line along with your office phone number.

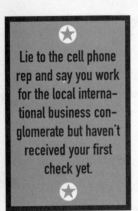

Lie to the cell phone rep and say you work for the local international business conglomerate but haven't received your first check yet.

When you've got them hooked, ask your bosses to pay for your service, since you use it for work so much. If they say no, tell them that they'll no longer be able to contact you that way in the future, since the minutes cost you money. If they still say no, you can at least write it off as a business expense for your income taxes.

You can also tag along on a company's discount even if the company doesn't pay for your service. Large multistate companies, universities, and government agencies work out deep discounts with cell phone providers. You may be able to get 10% off your monthly bill just by telling the sales rep where you work. At most you'll have to show a business card for proof. Tell the salesperson in the cell phone store (it works better in person than on the phone) that you heard they offer a "national account discount" for your company.

The display phones in cell phone stores sometimes really work, and you can use them to make long-distance calls.

Set Sail

Should you drop your telephone landline and just use a cell? Yes, unless:

★ Your cell phone doesn't get good reception in your house. You don't want to have to stand with your head out the window to talk.

★ You have a dial-up or DSL Internet connection that uses your standard phone line.

★ You have multiple people using one phone line. If you each have a cell phone, it might be cheaper to stick with the old technology because you'll share the cost.

★ You have a door buzzer that rings your telephone instead of a bell. Sometimes these work with cellphones, but check to be sure.

★ You have a fax machine you use at home.

★ You have a home security system that uses the phone line.

★ You have a digital video recorder like TiVo that connects through the phone line at night to update program schedules.

Bundle

Using one communications company for your cable, Internet provider, long-distance, cellular service, and local telephone services is a bad thing in terms of fostering already evil communications monopolies. On the other hand, you can get a better deal when you bundle your services, and you're going to hell anyway, so you may as well bow before Beelzebub. See what he's offering.

Long Distance

Soon enough, everyone will use their cellular phones for long-distance calling; most cell phone contracts have cheap nationwide calling options. If you use a cell exclusively, consider dropping the long-distance service on your landline—you could avoid paying minimum fees that many of those plans charge.

And with email, why are you calling long-distance anyway? Tell your grandma to get AOL or you'll never speak to her again.

REDUCING YOUR RENT

If you're a true party professional, it doesn't matter what kind of squalor you live in, because you don't spend any time at home. But living in a hovel is better in theory than it is in the real world. It's nice to have a comfortable home in which to sleep, throw parties, host sexual partners, and run a meth lab.

If housing rental prices drop in your area, ask your landlord for a rent reduction. The cost to him of putting an apartment on the market will probably be more than the 50-bucks-a month reduction you're asking for. The best time to request one when your lease is up and there are other units in your building that have been sitting empty for more than a month.

Work for your land-lord and shave a little off your rent. Volunteer to be in charge of the garbage area, shovel the sidewalk in winter, or clean the common areas weekly in exchange for a lowered monthly rate. Or do smaller errands like painting or cleaning for a one-time discount.

Moving Out

If you're willing to change apartments, you might as well keep moving to cheaper ones. Get a roommate or move in with one—especially if she lives in a rent-controlled unit. (Then you can refuse to shower for three months, force her out, and keep paying the lower rate.)

Or live where it's cheaper. Rents are low where danger is high. But if you have a car and you get an apartment with a garage, you won't have to actually connect with the people in the neighborhood. (Unless you can hear them screaming outside your window.)

There are all sorts of illegal places to live, including office buildings, warehouse spaces not zoned for sleeping, and your girlfriend's dorm room. They may not have heat or plumbing, and you'll have to sneak around and you'll get caught eventually, but in the meantime, rent will be dirt cheap.

Servant's Quarters

Some jobs will hook you up with free rent and a tiny salary on top of it. They're perfect for right after college or when you're spending all your time creating your fiction masterpiece.

★ Superintendent/handyman/apartment manager

★ Live-in cook

★ Live-in housekeeper or maid

★ Nanny

★ Personal assistant/writer's assistant

GIVE ME SOME CREDIT

Credit cards are very handy until you have to pay them back.

Lower Your Rate

You don't have to switch to a different card to

Tenants' Rights
It takes several months to legally evict a nonpaying tenant from an apartment. So if you're a tenant who doesn't want to pay for several months' rent (and you're leaving the state so they can't come track you down), stop sending in those checks.

get a lower interest rate. Call up your card's customer service and tell them that you're thinking about switching unless you can get a better deal. If they say no, then switch.

Back and Forth

Most of us are bombarded by offers for new credit cards. And most of the new cards allow you to transfer balances from other cards to theirs, with no interest payments for up to six months. Six months later you can transfer it back to the original card with the same deal. This is not a good long-term strategy to improve your credit rating, but it can save you a few hundred bucks in interest while you pay off your debt.

Membership Benefits

Beyond the ability to buy things you can't afford, credit cards can come with other kickbacks. Gold and platinum cards automatically double the warranty on products you buy with them. You can get reduced rates at rental car agencies, and they'll automatically cover part of the insurance that the rental agencies overcharge for. With some cards you can collect frequent flyer miles, while some pay you in gift certificates to Amazon.com or other stores, and still others give you "cash back" on purchases. Switch to the card that best suits your lifestyle.

Late Payment

If you're going to be late with your monthly payment by a few days, call the credit card agency and say you didn't get your bill in the mail. They'll usually exempt you from paying the late fee once. This works for bills in general: electricity, telephone, cell phone, and others.

MEMBERS ONLY

When you're heavily into anything—gardening, art, books, sports, crafts, drinking, whatever—look into membership in a local or national organization. Beyond any of that "like-minded community" crapola, these groups negotiate good discounts on related events and admissions. What are you into? A few examples follow.

★ With your arboretum society membership you get discounts at local gardening stores.

★ Museum membership is good for a discount in art supply stores.

★ "Friends of the Library" type groups get first pick on book sales at the public library and regular discounts at private bookstores.

★ The local vegetarians society hooks you up with discounts on veggie restaurants.

★ All kinds of team memberships, even for college intramurals, are good for discounts at sports stores.

The best way to find out about these discounts is to work backward from what you want. Going to be buying a lot of lumber? Search online for "Discount at Home Depot" or wherever you expect to buy it. The search will return not just Home Depot's website but also a list of societies with membership benefits. (You can also try calling the store, but the cashier may not know the benefits offhand.) Join the club with the lowest membership fee and best hookups.

DON'T BANK ON IT

Most banks are better at taking your money than they are at giving you access to it. Not only do they make interest on your cash as it sits in their safes, they charge you a monthly fee to hold it. Then there are additional charges for speaking with a teller, paying bills by phone or by Internet, using ATM machines that aren't theirs, or opening a savings account. But there are a couple ways to avoid all that.

Look into a no-fee checking account. Some banks are offering true free checking accounts because they're waking up to the fact that people don't want to pay 20 bucks a month for their services.

Even banks that do charge for checking, savings, online banking, and other services give all that away for free if you have direct deposit for your paychecks. Some temp agencies and freelance companies will do direct deposit. Ask the human resources department about it.

GETTIN' AROUND

Any type of transportation has disadvantages. The subway or bus is cheap, but it doesn't necessarily run all night, and it takes forever to get anywhere. Owning a car can be convenient, but it's always expensive, and it turns people into freaks—they're always talking about parking spaces and trying not to drive drunk. Hailing a cab is easy, but it's only practical when you live close enough that the ride won't cost you more than a pair of sneakers. There are more options than those three, and ways to save on each.

Free Shuttles

Universities, large corporations, and hospitals with multiple sites often run free shuttles for their staff, students, and patients between various campuses and to and from public-transportation stops. If you live anywhere near a large institution,

search its website for the "shuttle" or "parking and transportation" pages. They may ask for a staff or student ID when you board the shuttle. Just lie and say you have an appointment or interview, or that you forgot your badge. It helps if you're not dressed for the Insane Clown Posse show.

Cab Alternatives

Rather than hailing a taxi and paying the meter rate, look for other rental vehicles like limos and airport shuttles. They'll often pick up fares and pocket the cash, and they cost less for longer rides. If you see one near where you're waiting, walk up and ask if it would be willing to take you to your destination. Work out the price before you get in.

Pedal Power

Biking around the city is free, and it adds a thrilling element of danger to your commute. Consider pedaling to work during the day and out to the clubs at night. Ask the human resources person about bike-to-work programs with incentives such as spaces to lock your bike indoors and showers at work.

When you ride it out to clubs, lock your bike to a parking meter near the entrance, where the bouncer can see it—that should prevent it from getting stolen. Put your helmet in the coat check, then go fix your hair.

Car Shares

Community car-share programs have been popping up all over the country in recent years. Most of these programs work the same: They control a fleet of cars for a collective of users to borrow for short-time periods. You pay a small monthly fee to use the service, plus a cost per mile and per hour when you take out a car. (You don't have to pay for gas.) You sign up online for a rental time and your electronic key automatically works during the hours for which you've reserved the car.

These programs are most economical when you run short round-trip errands that require a car weekly—grocery shopping, laundry, hitting the big stores like Wal-Mart and Target, and going to crosstown events. They don't work so well for longer day trips or overnight use—you're better off using a regular car rental service in that case. And since you pay a monthly fee, you need to use it at least a couple times a month to make it worth your while.

[Search Term: "car share" YourTown]

Save on the Subway

If you commute by bus or subway every day, it's always less expensive to buy

Recommend a Friend
Many service busi-
nesses will give you a
kickback if you refer
a repeat-business
customer to them.
Some that do are
hairdressers, dentists,
insurance agents, eye
doctors, dry cleaners,
and gyms.Whenever
someone asks you for
a recommendation,
call up the place you
recommended and
ask if there is a
reward plan. You
should be able to
weasel something
free out of it.

a commuter card. Even if you don't, you can often buy bulk-rate subway and bus tokens that don't expire at the end of the month. You might be able to buy them at certain subway stations only, but they're worth the trip—not only can they save you a buck or two on a pack of 10, but a token takes up less space in your wallet than a dollar and two quarters.

Some companies offer "commuter coupon" programs. With these you get some sort of check good toward a subway card, bridge tolls, or light rail fares. If your workplace doesn't offer one yet, make the suggestion. It gets the checks at a discount rate and you get a free ride. Even if you live one block from the office, you can use the card when you go out drinking after work, or you can sell it for a profit.

Pool Rules

Carpooling is ideal for people who go into work and leave at the exact same hours every day. (And wouldn't it be nice to have a job like that?) Every city now has some kind of website or phone-in program to connect people with rides. Other than savings on gas for your car, by commuting in bulk you get to use the carpool lane and sometimes save on tolls.

Many companies also sponsor vanpools, which are basically paid carpools. They make scheduled runs (like a bus route does) and leave throughout the morning and evening commute times rather than just once per day. These work best for suburban-living city workers. Even if your company doesn't have one, maybe a larger company nearby does.

[Search Term: carpool YourTown]
[Search Term: vanpool YourTown]

Taxi!

It's not so easy to sweet-talk a cab driver into stopping the meter early. (Having a nice rack helps, though.) One trick is to try to make one cabbie your personal driver: When you're in a taxi and you've got a good rapport going with the driver,

ask him for his personal card. Then when you need cabs from that point on, call him instead of the dispatcher. After a few trips (during which you're generous with the tips), he may become generous with fare reductions.

The easier way to reduce cab costs is to split the ride. Always look into sharing a cab home from the airport; the bulk of the cost is getting into town from the terminal. But you can also share locally—when you're waiting for a taxi at a cab stand or near a bus stop, make an offer to the others waiting: "Anyone want to split a cab to [your destination]?" Most people don't mind paying 3 bucks to avoid public transit.

Reasons to Not Own a Car...

★ Expense. Beyond the cost of the machinery, there is insurance, registration fees, repairs, parking lot costs, parking tickets, and gas.

★ Exercise. You'll burn more calories by walking, taking a bike, or standing on the subway than sitting on your ass in your car. (Except when you have to shovel the thing out of the snow.)

★ Shoveling the thing out of the snow.

★ If you don't need a car to commute to work, you can rent one every weekend and the cost will come out to about the same as owning your own.

★ An expensive car is a nice accessory that the people inside the club never see.

★ You'll never drink and drive when you don't drive.

But If You Do...

Do your research. There are ways to save on every expense associated with car ownership.

★ Buy a used piece of crap. It's less likely to be stolen, and the insurance is cheaper. And a new car loses about 3 grand in value the minute you drive it off the lot.

The Christmas Spirit
After the holidays large stores have extremely liberal return policies on clothing. They'll take anything as a return just to keep the line moving—even if you bought it two years ago or the store doesn't sell what you're returning. Downscale department stores will pay a set price for things that didn't come from them: For example, any long-sleeved shirt is worth 20 bucks. That's a great way to get rid of all the ugly or otherwise unreturnable sweaters your parents gave you.

★ If you're not good at haggling, look into hiring a professional car buyer. They'll do it for you.

★ Smaller cars are more fuel-efficient and easier to park.

★ Consult your friends, then the Internet, for recommendations on auto mechanics.

★ Insurance is a horrible rip-off, but it's the law. Shop around and let the insurance agents jump through hoops for you. Ask about all their discounts—nonsmoker, safe-driver, low-mileage, and so on.

★ Find a gas station price-listing website and use it to get the cheapest fuel in town. Some warehouse stores also sell discount gas. That's another reason to get a membership. [Search Term: compare gasoline prices YourTown]

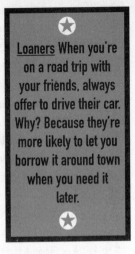

Loaners When you're on a road trip with your friends, always offer to drive their car. Why? Because they're more likely to let you borrow it around town when you need it later.

Warning: Big-ass SUVs are a sign of insecurity. Stuff a sock in your pants and save yourself $30,000.

Chapter 11★

Feeling Groovy: Exercise and Health Care

Though Joe Notglam may think that club trash like us need to spend all day sleeping off the previous night's fun, that's usually not the case. Many of the people packing the dance floors and mosh pits at night are far more physically fit than people whose idea of exercise is walking their dog around the block twice a day.

Not all rock and roll lifestyles are active, however. (What rock critic doesn't have a beer gut, and how many skinny goth kids can actually ride a bicycle, let alone carry it up a flight of stairs?) But being in shape and partying go well together, no matter how differently the two lifestyles are perceived. Here's why:

★ When you work out regularly, you have more energy, which enables you to stay out later.

★ And you'll win more dance battles.

★ And you sleep better when you get home.

★ You sweat out the toxins you ingested the previous night when you work out the next morning.

★ Exercise helps relieve a hangover.

★ You can wear tighter, sheerer, or just less clothing period once you're in better shape.

★ And spend less on that clothing. Half-shirts = half price!

★ If you do it right, exercise costs next to nothing.

★ Sweating is great for your skin.

★ If you exercise outdoors, you can get some sun and avoid having that ghostly club-trash pallor.

★ Exercise is good for your mental health too. You care less about the little annoyances in life when you've just run 12 miles.

GETTING GOUGED AT THE GYM

Most people seem to think that "getting some exercise" is synonymous with "joining a gym." That's a load of hooey. Gym memberships are pricey, costing at least 30 bucks a month for the cheapest place with the broken equipment and the mold in the shower room. You'd be less likely to bring home a fungus if you spent that $350 a year on a good hooker.

See, the gym is a fine place to exercise if time is of the essence and money is

not, but something tells me that's not the case for you. You can get just as good of a workout at home or out in public—and without paying at all.

First One's Free

Many gyms offer no-cost one-week memberships to entice you to join. They'll give you a tour, schedule you time with a personal trainer, and generally blow sunshine up your ass. But memberships in gyms are notoriously hard to end (some require a full month's notice sent by certified letter, for example), and the membership representatives are one step up from used car salesmen on the slime chain.

So go ahead and try that free membership at each place in town, moving on to the next gym after each week's expires. Depending on the size of your city, you can get several months' worth of workouts without paying—enough to get you through the winter, when outdoor recreation is not so much fun.

During the free week and afterward, the membership rep will call you to see how you liked it. If you don't want to be disturbed, give her a fake phone number.

Even gyms that don't advertise a free week of workouts will usually let you try the place out for one day. Tell the membership rep that you heard this was a good place and were thinking of joining. Ask if they have a free week's membership. If they say no, ask if you can try it for that day, since you, coincidentally, have your workout clothes in your car. If they tell you that you have to pay the per-day fee, kindly tell them to go screw themselves.

Surprising Real-life Equivalents of Gym Equipment

The treadmill = the ground
The pool = oceans, lakes, ponds, rivers
The steam room = the shower
The stairclimber = the stairs
Free weights = heavy things
The rowing machine = a rowboat
The ski machine = skiing
The pull-up bar = monkey bars
The abdominal board = the ground plus gravity
The exercise cycle = a bicycle and a hill
The exercise mat = a towel on the floor

WORKING OUT AT HOME

Unless you're a body sculptor who needs to make his lateral delts two millimeters bigger to come into proportion with his anterior glutes, you really don't need all the fancy equipment in one of those gyms designed to make you think you're working out just because you're pressing buttons on a machine. If you just want to get in shape, you can do it all from home or around the neighborhood.

Running is some of the best and cheapest aerobic exercise around. All you need is a decent pair of sneakers. Other ways to get your blood pumping are **bicycling** (to and from work, for example), **roller-skating or -blading,** playing **active sports** (like the company softball team), and even **dancing** in dark discos (or around the house in your underwear).

Inside the apartment, close the blinds and do some good old-fashioned **calisthenics** like in high school. You remember them—jumping jacks, squat thrusts, sit-ups, push-ups, and other stuff from PE class. The easiest way to get good results is to watch one of the daily **aerobics** workout shows on TV and follow along: use your VCR or TiVo to record the shows and proceed at your leisure. Or, should you want to buy a workout tape, look in thrift stores. They usually have stacks of them donated by people who stopped trying.

Used sporting good stores are good for a lot more than weights—you can buy everything from scuba gear to baseball gloves to rackets that only need restringing.

If you want to bulk up rather than slim down, you can **make or buy free weights.** For example, a broomstick with two filled gallon water bottles is your barbell. (Each gallon of water weighs 8.33 pounds.) Those jugs can also work as your dumbbells, or you can substitute other heavy things like dictionaries or bags of cat food.

Of course, that's a very Rocky kind of DIY, but it's not very glam. Even if you invest in a set of free weights, they'll only cost the same as cost two to three months' worth of a gym membership. Start out with only **dumbbells**—you can do nearly everything with them that you can with a barbell. A bench will cost another couple hundred bucks, and you've got to have someplace to keep it in the house. So save that for later.

With any exercise equipment, it's easy to **find it used.** Thrift stores have endless stacks of weights, and sometimes weight benches. You only need to buy the bars new. You can also get everything at used sporting goods stores for less than half the sticker price; it's not as if weights stop working after they've been

used a few times. Should you actually consider buying one of those all-in-one exercise machines, try renting one first. You can get it at fitness equipment rental stores and try it before you buy it.

Need workout advice? There are endless sites on the Web. Most of the major fitness magazines put online a few nutrition and fitness articles from each issue. Many websites post full workouts with pictures. Already have those printed out or else you'll be running back and forth from your monitor to see what to do next. There are usually stacks of workout books in thrift stores, but some of them are dated.

[Search Term: "no weight workout"]

[Search Term: "home workout"]

[Search Term: "gym-free workout"]

[Search Term: "fitness magazines"]

Warning: Today's Tae Bo is tomorrow's Ultimate Pilates.

GET OUT OF THE HOUSE

Maybe you just don't want to work out at home—you live in a shoe box or your roommates laugh at your leg warmers. There are plenty of other places to get fit that cost less than the gym.

Thrifty When Wet

If you're a swimmer, check the community pool. Some venues charge a daily fee, but it can be as low as $2 per session.

[Search Term: "community pool" YourTown]

[Search Term: "public pool" YourTown]

Get Rec'd

Community recreation centers can be palatial buildings or cement-walled dumps depending on the neighborhoods they're in and the state of their budgets. Some have tennis and racquetball courts, weight rooms, a gymnasium, volleyball courts, and look fully equipped. Others look like a scene out of a prison movie. They're worth investigating to see what's available. You can usually find cursory information on your local government's website. Look up "recreation and parks" for your town, then search for "facilities" within the site.

Park Places

Your local public park is a good place to go for runs and bike rides, but there are more opportunities than just traffic-free trails. In the 1970s many parks put in

exercise courses, where you're supposed to run 200 feet between different exercise areas. There are also lakes, ponds, and reservoirs attached to parks in rural communities, providing opportunities to **swim.**

Beyond that, you can get a full upper-body workout at the **children's playground.** Monkey bars, inclined poles that hold up the swings, ropes, and other types of equipment to hang from abound in playgrounds. Lest you think that they're too easy, since kids can do them, keep in mind that it's a heck of a lot harder to suspend 200 pounds than it is 80.

OK, JOIN THE GYM

If you're convinced that you need a gym to get in shape, or you live in Omaha where it snows nine months out of the year and snowshoeing is not your ideal outdoor exercise, then at least join wisely.

Many parks bar adults without children from using playgrounds, in order to keep out baby snatchers. Excluding people kind of takes the "public" out of "public park," but if you explain what you're doing to the kindly police officers, they'll usually let you stay.

Work Exchange

Some health clubs (private clubs rather than chains) will allow you to work a few hours a week in exchange for free access. You might staff the front desk, babysit in the child care room, collect towels, or something similar—you'd be surprised at how many deluxe rooftop hotels sponsor these types of programs. Private studios for yoga, karate, dance, and the like often offer the same deals. You sign people in for classes at the front door, then lock up and join the group 10 minutes into the class.

Corporate Coupons

Large companies frequently negotiate group discount rates at nearby fitness centers; these are something like $10 off the monthly fee that the general public pays. If your company doesn't have a corporate discount set up yet, ask your human resources person to do it, or inquire yourself, no matter if you're the only person in the program.

Joe College

Universities sometimes open their gyms to the general public for a fee, and their rates are often lower than other fitness centers'. Some require that you live

within a certain distance of the school in order to join, but you wouldn't go to a place on the other side of town anyway. Call your local college to see if it offers memberships or open-gym times.

Off-peak

Busy gyms have reduced-price membership rates for off-peak hours. The downtown fitness centers lower their rates when you agree to go during business hours. University gyms do just the opposite, with discount times later in the evening, after the students have left campus.

Fee-Free

When joining any gym, watch for hidden fees. Some places charge extra if you want to use their towels. Some have free fitness classes (yoga, aerobics) with membership, while others charge extra for them. Still others charge you for a rented locker versus a day-use one on which you hang your own lock. Ask about all of these before you sign something.

Plead Poverty

The YMCA offers "scholarships," which are discounted memberships, to low-income people. Ask at the membership desk for an application.

Stay in School, Fool!

See the next chapter for information on different ways to save on a gym membership, private classes, and team sports by participating in them at community colleges. Good stuff!

CLASS ACTS

If you're more interested in group fitness than lifting weights, do a circuit of free trials at exercise centers. Many studios for yoga, Pilates, Feldenkrais, and the like offer a first class for free (see the list below). They might also sell a new-client discount card—something like 10 visits within 10 days costs 10 bucks. You can hit every studio in town before you have to pay full price.

[Search Term: "free class" YourTown]
[Search Term: "first class free" YourTown]

Potentially Free First Classes

★ Aerobics ★ Belly dancing ★ Boot camp fitness programs ★ Boxing ★

Capoeira ★ Dance ★ Feldenkrais ★ Fencing ★ Hapkido ★ Jujitsu ★ Judo ★ Karate ★ Krav maga ★ Kung fu ★ Pilates ★ Tae kwon do ★ Tai chi ★ Yoga

Goal!!!!!

If it's group action that brings you satisfaction, look into amateur leagues in your hometown. The best ones are sponsored by your work or local bar. The leagues are not insanely competitive (usually), and they're always cheap or free. The sponsor chips in for the umpire fee and, often, postgame beers.

Outdoor sports teams like baseball and soccer usually practice and play in public parks. In addition, middle schools, high schools, and even churches rent out their gymnasiums at night for indoor leagues like basketball and volleyball; these are also pretty inexpensive.

[Search Term: "intramural [name of your sport]" YourTown]

And finally, community colleges offer team sports as physical education classes. On the plus side, they're not very expensive, you know that there will always be enough team members to play, and you get free coaching and a student ID. On the negative side, they might make your run warm-up laps, the practices are often during work hours, and there's no free beer at the end.

FREE OR CHEAP HEALTH CARE

Health care is not fun to think about, read about, or receive, unless we're talking about a free morphine drip. It's a horrible rip-off and the whole industry needs to be overhauled, yet it's a basic necessity that no one should be denied. It's included in this book because it is so expensive and so few people working in nightlife or living the life can afford it. Also, we tend to fall down a lot more than other people.

Part-Time Plus

If you're underemployed or working a job that doesn't provide health care, look into changing that. Contrary to popular perception, there are restaurants, retail companies, and even temp agencies that offer health benefits. You have to pay for them, but not nearly as much as you would on your own. The companies most likely to give them to you are the earthy-crunchy ones like organic grocery stores and vegetarian restaurants. Temp agencies usually list on their websites if they provide health insurance. To qualify, you have to work a certain number of months for them full-time.

There are a lot of boring office jobs that provide health insurance to part-time employees for working as few as 20 hours per week; universities and government agencies are the most likely to. Nonprofit agencies are also big on free health

insurance. If you're just looking for a part-time-schmo desk job, you might as well look for one in a place with good perks.

Getting Laid (Off)

If you've recently lost your job, avoid signing up for COBRA until you apply for something else. COBRA guarantees that you'll be able to get health care between jobs, but you'll be paying for it at the rate of something like $150-plus per month. The only upside to COBRA is that it can't deny you coverage for a preexisting condition (like schizophrenia), and your monthly medications are still covered at a low rate. Instead, apply for catastrophic health insurance first, and sign up for COBRA if you're denied.

In Case of Emergency

Catastrophic health insurance plans have monthly fees as low as 20 bucks but with a big deductible at around $3,000 or $5,000—meaning that the insurance company won't pay anything until you spend that deductible amount out of your pocket. If you get only the flu or break your ankle in a platform shoe–related injury, these plans are no good at all to get, but if you fall off a cliff and have to be helicoptered to the hospital, you'll be glad you did. They're also useful if you're into adventure/extreme sports or hiking, and you can usually sucker your parents into paying if the other option is you being uninsured.

Dentists sometimes offer initial cleanings at a discount to get you to switch to their office. Ask about the discount, but make sure it's a "cleaning" and not a free "exam"—of course they're going to look in your mouth before they start sticking tools in it. That's like when a hairstylist offers a "free consultation."

Union! Union! Union!

Should you not want to change your job just to get health insurance, look into joining a union: Writers, hotel employees, restaurant workers, and self-employed people have one. You pay an annual membership fee to the union and get cheaper health care than paying independently. It's still expensive—over $100 a month plus the annual fee—but if you sense a liver failure coming on then you're better safe than sorry.

Yet Another Reason to Stay in School

Health care at universities and community colleges generally consists of a stu-

dent health center staffed by nurse practitioners, but they can still give you penicillin to clear up that "little problem." (See Chapter 12 for more info.)

Internet Medicine

There's nothing better than online medical websites to calm your hypochondriac propensities. Sites like WebMD.com can save you expensive trips to the doctor when you're not sure if you're having a heart attack or just heartburn. Check them first (unless it's an obvious life-or-death emergency) to see if you really need to go to the hospital or to just take a Tums.

Some sportswear companies use consumers to test their products and give feedback. If they accept you as a tester, you'll get free stuff in exchange. Not a bad deal. [Search Term: "wear test program"]

You can also buy vitamins and prescription drugs online at a discount. To make sure you're getting the real deal rather than the Online Viagra Warehouse, check the National Association of Boards of Pharmacy website (www.nabp.net). Click on the link to VIPPS (Verified Internet Pharmacy Practice Sites); it has a list of certified online pharmacies.

Free MDs for You and Me

Most cities sponsor free health clinics to serve low-income types like us. Unfortunately, they're overrun with homeless drug addicts (like us) and it's hard to get an appointment. Most all of them have "urgent care" clinic times—when you can get in to see a physician after a long wait. You wouldn't really want to go to one if you're bleeding, but it might be able to get you the necessary medication to clear up your ear infection. After an initial meeting you can get added to its roster and be seen as a regular patient.

[Search Term: "Community Health center" YourTown]

Negotiate

You can bargain with your dentist or orthodontist if you don't have dental insurance. Not only do they charge people less who are without it, they'll sometimes cut a deal for major work like root canals. Plead poverty and see what they say.

Chapter 12★

Fringe Benefits: College Kickbacks & Faux-lanthropy

Going to school or doing volunteer work is supposed to make you a better person, but being a better person is far from mandatory. If you do stuff right, you'll get a lot more out of these endeavors than you put in.

STAY IN SCHOOL FOREVER—EDUCATIONAL DISCOUNTS

Don't skip this chapter just because you're not in college and you're over 30 and you don't want to learn anything. None of these obstacles stand in the way of getting a student ID, which is a magical discount pass that can save you hundreds of dollars a year on food, entertainment, travel, and a whole lot of other stuff. And if you do decide to broaden your mind, your presence on the campus also grants you access to the school's pool, health center, music studios, and much more. So keep reading and maybe you'll learn something after all.

All the Discounts, None of the Homework

It's not only possible to get a student ID without attending classes—it's pretty damn easy. Go to your local (or any) community college website and sign up for a class. Pay for it with your credit card. Some schools will instantly mail you a confirmation with a perforated, thick paper student ID. Others will mail you a registration sticker to put on a photo ID that you have to go on campus to get. So go get one.

After you've enrolled and have your ID, cancel the class before the "last day to drop" deadline. You'll get a refund for the class, but you can hold onto the ID to use for personal gain. Some schools charge a small fee for online registration, a student activities fee, student health center fee, or a penalty for withdrawing, so you might want to look that up before you spend too much.

As an alternative, you can make a fake. Most places that ask for a student ID don't study it too carefully, so if you've got a good printer and some card stock, you can easily produce proof that you attend the Southern Northeastern University.

Keep reading to learn about all the places you can use your ID. But first, a few reasons to skip the scam and take classes for real.

CC101

Community colleges are cheap, the classes are easy, and they're usually located

close to where you live or work. Depending on the state in which you live, classes can cost as little at 30 bucks apiece. In most cases you'll pay more for your books than you will the tuition. And unlike four-year institutions, you don't have to pay for five courses when you only want to take one. Many of the classes are designed and scheduled with working people in mind: For example, maybe they're held only once a week and begin at after-work hours.

Brain Stuff

There are a million academic reasons to take community college courses, whether you've already got a degree or not.

★ Learn a language for your trip abroad, or learn to better communicate with the lovely ladies of the local Chinese laundry.

★ Take a writing class and use it as an excuse to start that autobiography tentatively titled I Spit in Your Burger: Confessions of a Fry Cook.

★ Force yourself to read more than CD liner notes—take a literature class.

★ Tackle a 17th-century art history course and learn how to bore your dates.

★ Finally get some computer skills, like learning to build your band's website.

★ Or just learn about a topic you've been interested in for a while, from African-American studies to zoology.

CAREER STUFF
Stating the Obvious

If you don't already have a college degree, getting one may net you a raise. This is especially true in big, stodgy corporate offices where it doesn't so much matter what work you actually do but how qualified you are in general. If you have a Ph.D. in theoretical physics, you'll be paid at the going rate for theoretical physicists even if you work in the mail room.

And if you're looking to switch careers, it can't hurt your résumé to have taken a few classes in your new field of interest. Your bachelor's in medieval English literature won't do much good in netting you that job selling semiconductors, so those one or two entry-level physics classes will be better than nothing.

Warning: Most students taking management classes are jerks.

Making Connections

Though all the professors at Harvard might have doctorate degrees (from Harvard), people in academia don't necessarily have good connections in industry. At community colleges the opposite is true. Most of the instructors have full-time

jobs and are teaching out of generosity and a love of the subject. Others are retired professionals looking to share their knowledge and keep themselves busy.

This is good news for people looking for practical career advice. If you impress your professor, she can give you a recommendation for a job, help you score an internship, or share tips on where to look. Some teachers pick the cream of the crop to hire at their own companies. At the very least, working professionals will give you a realistic low-down on what careers in their field are really like, and if a thorough understanding of gender studies will guarantee a lifetime of fruitful employment.

Free School

Though there is an increasing trend toward stinginess in the corporate world, many companies still chip in for tuition reimbursement. Rather than pay a set percentage of your course costs, they'll usually set a cap on how much they'll contribute per year. Thus, the cheaper the classes, the more of them you'll be able to squeeze in.

You should also see if The Man will let you take classes on company time. The lower down you are on the corporate ladder, the more likely your kindly boss will let you leave to attend lecture during the day. That's like getting paid to not be at work. Sweet!

Warning: The "reimbursement" part of "tuition reimbursement" means you have to put up your money to pay for the class, then they'll pay you back if (and only if) you actually pass.

Internmentships

Academic internships at private companies are just plain wrong. You pay money to a school for permission to work for free for a corporation. You pay in cash, then you pay in labor. At the end of the internship you have experience at the very least, but if you shine at the job it'll often hire you on full-time. Despite the free work they're getting, most corporations that hire interns do so only through school programs and won't take people off the street.

Regardless of how screwed up the system is, internships are pretty good entryways into the specific companies for which you toil. The big, big downside is that they're almost always unpaid, and you have to work during work hours. The faculty adviser of your major's internship program should be able to tell you if they've been able to connect past interns with companies that operate at night, early in the morning, or on weekends.

Postpone the Loans

The easiest way to get a deferment on the student loans you already owe is to sign up for more classes. You don't need to be in a graduate degree program—sign up for ceramics and the deferment is valid. You have to enroll in school at least half-time, which usually means just two courses. That can add up to a lot of homework, but on the other hand, you don't actually have to get a passing grade in the courses.

SCHOOL IS GOOD FOR YOUR HEALTH
Free Drugs

If you sign up for just one course, you'll get a student ID. And with that ID you have access to the student health center. Granted, it's not an HMO and you're not going to get free brain surgery from the nurse practitioners there, but when you can't afford health insurance, it's better than nothing. It provides first aid; treatment for common illnesses like flu and strep throat; immunization shots; tests for all sorts of fun diseases (including STDs); and free condoms. It usually offers mental health services, so you can get free short-term therapy if being poor makes you depressed. Some schools will perform eye exams and/or offer discounts on frames at optometrist's offices. Other schools refer students to various medical specialists who give student rates on their services.

There are a couple of other ways to put off paying your student loans. If you're currently collecting unemployment, you fill out a simple form. But the unemployed deferment only lasts for so long. You can also postpone loans by being really, really poor. The "economic hardship" deferment requires something like an annual income of less than 15 grand, which wouldn't even cover the rent on a room in a crack house.

No Gym Membership

That same student ID may be all you need for full access of the gym facilities during off-peak hours. Crowded colleges, on the other hand, may make you enroll in a class to use the weight room, pool, or certain equipment. This still costs far less than a gym membership elsewhere. The price of the advanced swimming class might be 50 bucks, but that's good for three days a week over four months. There isn't a gym around that can beat that price.

Other fitness classes (like fencing, aerobics, self-defense, or stretching) as well as activities (from archery to volleyball) will also be far cheaper than signing up to

private studios. You can pay $10 a pop for a private yoga studio class, or take an entire semester's worth at a city college for the price of two weeks.

STUDENT DISCOUNTS

If you work it right, the student discount can save you at least half the cost of the class. Search around the Web to see what's available. Anywhere there is an admission fee, there may be a student rate. Always ask.

[Search Term: "student discount" YourTown]
[Search Term: "student rate" YourTown]
[Search Term: "student rush" YourTown]
[Search Term: "student ID" YourTown]

Flash your ID for discounts and reduced admission at all of the following:

Culture
★ Art museums
★ History museums
★ Dance performances
★ Theater, professional or otherwise
★ The symphony and opera
★ Magazines and journal subscriptions

Entertainment
★ Zoos and aquariums
★ Movie tickets (matinee prices all day)
★ Conferences and conventions
★ Parks with entry fees, like flower conservatories and bonsai gardens

Travel
★ Plane tickets
★ Train tickets
★ Bus tickets
★ Hotel and hostel costs

Textbooks are less expensive in other countries, even for the exact same editions. Go to the foreign version of Amazon.com (Amazon.co.uk) and look around. They can be as cheap as half price.

If you live or work near a college campus, pick up the campus newspaper. They have great coupons for local businesses, on-campus and off-.

★ Ecotours through nature organizations
★ Tourist-trap rides, museums, and attractions
[Search Term: "student travel" YourTown]

Goods

★ Educational versions of software, which are the same as the regular versions at half the price
★ Special back-to-school sales for students only—they have these at furniture stores (like Ikea), bike shops, and futon outlets
★ Discounts for stores and restaurants near campus

An online search for "student subscription" will turn up more than discount magazines. That term also applies to season tickets to the opera or symphony, sold at a student rate.

Services

★ Discounted parking near the school
★ Fitness centers—reduced-cost exercise classes at private studios, for yoga, self-defense, massage, etc.

Social Distortions

Unemployed people complain about being broke, and people with jobs complain about being trapped because they're afraid to quit in the crappy economy. But everyone can benefit from a low-cost class or two or three. It's amazing how quickly the creative juices start flowing when someone else is directing your education.

Another way to stay sane when you're jobless is to join a student organization, whether a language clubs, a break-dancing workshop, or working at the radio station, or in groups ranging from Abundant Life Christian Fellowship to Women United (WHO ROCK!).

An All-Access Pass

There are also benefits of access in taking certain classes. You might not need an introductory class in photography, but if you take one, you'll get free unlimited darkroom access for three months. How ya like it now?

★ A photography class gets you off-hours darkroom access.
★ Woodworking classes allow you into the tool shop.
★ A sewing class gives you access to the high-end machines.
★ A digital-video class comes with permission to use the school's high-

powered computers. And you can sometimes take home a copy of expensive digital video—editing software.

★ Same with digital-music classes.

★ Dance classes can get you studio access.

★ Music lessons or classes allow you to rent the soundproof rehearsal rooms.

★ Recording or producing courses score you free studio time to work on your band's demo tape.

VOLUNTEERING: MILKING HUMAN KINDNESS

Volunteering has a bad reputation as something that's good for you. Sure, you might do something nice for old people or the homeless or whatever, but all that tingly sense of well-being stuff is one insignificant part of it. Use volunteer projects as a way to get nice things for yourself, from food and liquor to dates and jobs.

[Search Term: volunteering YourTown]

Free Food

When you're working in a soup kitchen, preparing bag lunches for the homeless, or picking up donated leftovers from restaurants, you've got a free license to eat on the job. But many other projects reward volunteers with breakfast, lunch, or snacks while they're working. You're probably not going to go away from the day stuffed full of filet mignon, but you might get a pizza for your efforts.

Cheap Exercise

After a day digging holes in which to plant trees, you'll find yourself sore from the workout. Plenty of volunteer jobs, especially the weekend ones where you clean up the park or do landscaping around public museums, allow you to put some muscle into your work. Then you won't feel obligated to drag your fat ass to the gym.

Free Admission

Use a volunteer project as a way to get in for free to art and history museums, aquariums, and zoos. The big public art and animal houses use volunteer crews to do landscaping work like weeding and planting, outdoor cleanup, and sometimes cool crap like feeding eucalyptus to the koala bears. After you finish a couple hours' worth of work, you can go inside the sites without paying, or you can stay inside if that's where you had been working in the first place. Most of the museums and attractions that host work parties also have free-admission days once a month, but they're often during the week and during work hours. Volunteering will get you in on the weekends.

[Search Term: volunteer PlaceYouWantToGetInto]

Yet More Free Admission

Film festivals and music festivals use hundreds of volunteers because there are so many simultaneous events to manage. And because there are too many volunteers to properly supervise, nobody will notice that you've left your post to see the show instead of working it.

A Good View of the Good Life

Foo-foo organizations like Friends of the Opera like their swanky members-only black-tie balls. Volunteers work at these events doing registration, security, giving out gift bags, and all that. If you want to see tuxes without paying the buckses, sign up to volunteer for the party. (And steal one of the gift bags on your way out.)

Résumé Fluffer

You might be able to trick potential employers into forgetting about your felony conviction if you put down your volunteer activities in the "Outside Interests" section of your résumé. Beyond that, your time serving others may help you fill in some holes in your skill set. Pushing a wheelchair at the Special Olympics counts as "leadership skills," and any team project you've done means you "work well in a group environment."

Pay Off Parking Tickets

In many cities, you can pay off your parking tickets in volunteer work instead of cash. They value the labor at something like 5 bucks an hour, so you'll have to put in a ton of time before you get rid of your debt. But heck, you're there for the food anyway.

Relics From the Relics

The thing about working with elderly people is that they're terribly lonely and will give you their possessions to bribe you into staying another hour. That's not to say you should extort them, but there's nothing wrong with benefiting from their generosity.

Beer

When you volunteer to collect entry donations at street festivals and fairs, you'll usually get unlimited access to refills at the beer truck. Fill 'er up! You might also get tickets for the rides or food too.

Plants

A plant that's considered a weed in the Africa section of your local arboretum may be a beautiful flower from the scented Polynesian flower display nearby. You can leave volunteer gardening events with a bag full of exotic starter "weeds" for your apartment.

Clothes

Not that you need another ugly free T-shirt, but you can always get them at big volunteer events like Earth Day and beach cleanups.

Networking

Oddly, most volunteers are working people with little free time rather than unemployed people with tons of it. If you're desperate for a job, the more employed people you interact with, the better.

Dates

Attention, heterosexual males! Something like 80% of people who volunteer are women. And only a small fraction of those are coupled. Gay men can score (most anywhere, but also) at gay film festivals, health organizations, and AIDS fund-raisers.

An Excuse

Most of you lazy sluts would stay in bed all day on Saturday nursing your hang-overs if you didn't have a reason to get up. Volunteering gives you a reason to get out of bed, get outside, and get some sun to cover up your ghostly pallor and greasy skin.

Conclusion

So, kids, what have we learned?

I hope you've absorbed dozens—dare I say hundreds?—of practical ways to save on luxuries and life essentials like sex, booze, bars, shows, fashion, parties, and food. The list of tips is long (and it took me forever to write), but I'm not going to pretend it's exhaustive. People are always coming up with great new scams, and other people are always finding ways to thwart them. Much of the enclosed material I found using the following set of strategies:

Do Your Research

You should be able to find a discount on almost anything if you look hard enough. Read up and ask around.

Work for It

Whether you promote, volunteer, or get paid, you can get inside if you're willing to help out.

Make Convenient Friends

The more people you know, the more free stuff you get. Everyone has some kind of hookup, so get to know everyone.

You can also use these strategies to save money in areas of your life not covered in this book. They can help you get ahead in your career, save on travel, and cut down on household and other expenses. Handy!

Now, surely you will have noticed that there is some very bad advice in this book scattered amidst all the good. If you went crazy and followed everything I've said to the letter, you'd eventually get banned from all the venues you scammed, alienate all your friends, and possibly wind up in jail. And while those can be fun and worthwhile side projects, that's not the main point of this book. It's not about what you should do; it's what you can do.

Any way you choose to go about it, and no matter how far you take it, don't take this process too seriously. The point is to have fun trying.

Rock on!

—Camper

Shout-outs

To the scammers, liars, line skippers, scalpers, Dumpster divers, thieves, smart shoppers, smooth talkers, artfags, moochers, poseurs, trendoids, retail sluts, groupies, freeloaders, cheapskates, cheap drunks, and easy lays who inspired me through your actions or shared your secrets with me directly—Thank You.

You are all horrible people living sinful lives, and that's why we hang out.

Special thanks to Patrick for the extra help.

Index

Accessorizing...................................34–38
Art galleries................................125–126
Art openings.............76, 106, 112, 135
B.Y.O.B.........................49, 61, 62, 65, 71
Bar parties.....................................94–96
Beer bust..77
Books, buying.............................127–129
 selling.................................153, 155
 stealing157
Cable.............................118–119, 174
CDs, acquiring....................2, 4, 7, 12
 borrowing..................................128
 selling.................................153, 155
Cell phone service...................171, 173
Coat check..7
Coffee ...150
Condoms....................................108–109
Credit cards..............................174–175
Dive bars.....................79–80, 86, 145
Drag queens....................15, 16, 35, 95
Drug dealing................................99–100
Dumpster diving................137–138, 145
Flask..............................8, 132, 170
Focus groups..............................158–159
Food shopping..........................146–148
Gambling (and drinking)..............81–82
Gay bars..................................77, 80
 free cable at119
 free condoms at..................108–109
Gold lamé. ...42
Gold-digging.............................105–107
Government assistance............169–170
Ground score ...7
Guest list, theirs........1, 5, 12–13, 23, 28
 yours......................................49–50

Gym membership..............183–184, 194
Haircuts..46–47
Hair model ...47
Hand stamp, copying..........................20
Hangover helpers..........................78–79
Happy hour.................73–74, 75, 110
 free food during145
Health care................................187–189
Hoochie ...14
House-sitting159
Internet service.................118–119, 171
Kegger..52–54
Lectures.....................................126–127
Lunch, free................110, 136–138, 143
 saving on.............................149–150
Magazines...................................129–130
Medical research160
Mooching....................................142–143
Movie rental.............................123–125
Museums....................................125–126
Name-dropping....................................18
Office supplies166
Online selling.............................154–157
Open bar.............................69, 77, 87
Opera..........................114, 115, 117
Party-crashing.............................68–71
Party punch..............................66–67
Potluck dinners149
Press pass (make your own).29
Rent...173–174
Rounds, buying..............................92–94
Scalping tickets.........................151–152
Sex work.....................................110–112
Smoking...8–9
Sports...............103, 130–132, 183, 187
Strip clubs ..110
Student discount.......115–116, 195–196
Swag..2, 155
Symphony.....................................114–117
Teaching and tutoring...............163–165

Theater......................................114–117
Theme parties.............................58–61
Thrift shopping............................38–41
Trash, digging through.............137–138
Trivia contests.............................90–91
Unemployment...........................169–171
Ushering......................................117
Utilities.....................................170–171
Wine, ordering140
Wine tastings.................................. 136